Streampunks

Streampunks

YouTube and the Rebels Remaking Media

ROBERT KYNCL

with Maany Peyvan

HARPER
BUSINESS

An Imprint of HarperCollins*Publishers*

HarperCollins books may be purchased for educational, business, or sales promotional use. For information, please email the Special Markets Department at SPsales@harpercollins.com.

FIRST EDITION

Designed by Bonni Leon-Berman

Library of Congress Cataloging-in-Publication Data

Kyncl, Robert, and Maany Peyvan.
Streampunks: YouTube and the rebels remaking media / Robert Kyncl with Maany Peyvan.
p. cm.
ISBN 978-0-06-265773-2
1. YouTube (Electronic resource). 2. Mass media. 3. Internet—entertainment. 4. Webcasting. 5. Streaming technology (Telecommunications). 6. Digital media—Technological innovations. 7. Internet videos—Social aspects.
PN1992.927.Y68 K96 2017
006.7'876—dc23
2017020051

17 18 19 20 21 LSC 10 9 8 7 6 5 4 3 2 1

To the kid out there filming a video on a smartphone who will one day become the biggest entertainer in the world

Contents

Contents

Introduction

There's nothing on TV.

No, really, where I grew up there actually wasn't. I was born behind the Iron Curtain, in Communist Czechoslovakia, in 1970. By the time I was a teenager, my choices for entertainment were—to put it mildly—bleak. Books were censored by the Office of Press and Information; we had only one newspaper, *Rudé Právo*, the official paper of the Communist Party; and the state controlled the radio, the airwaves, the cinemas, and the symphonies. It was illegal for a private company to print a publication or broadcast a signal. It was illegal to reproduce more than eleven printed copies of anything. And it was illegal for a band to perform without a license.

Faced with those options, I had only one choice: to get creative.

I obtained books through *samizdat*, the underground distribution network that began under Nazi occupation (*1984* was an early favorite of mine). I bent the antenna of my transistor radio just so, in order to hear bands such as Bon Jovi, Scorpions, and Tears for Fears come in scrambled over the airwaves from West Germany. And if I was lucky, I would get my hands on a bootlegged VHS tape that friends of mine somehow managed to smuggle into the country.

I can still remember the first Western film I ever watched: *The Terminator*. But because there was no money for proper subtitling or dubbing into Czech, one person did the voice-over for every character in the film. It was, by any standard, a terrible viewing

ix

experience. But it didn't matter. My friends and I watched it three times in a row.

Today I look at my two teenage daughters and the ways they have to entertain themselves. I look at the limitless number of books they can read on their tablets (though they prefer hard copies from Amazon). I look at the thousands of outlets they can browse through on their phones to get news. I look at the millions of songs they can listen to on Spotify, the thousands of films and shows they can watch on Netflix, and the hundreds of channels they can lean back and watch on our satellite TV package. I look at all of that, and think about how their options for entertainment vastly outnumber those I had growing up. Hell, they vastly outnumber the options that kids growing up in America had just ten years ago. But even with an ocean of media before them, I see how they choose to spend a significant amount of their free time: watching YouTube.

In less than one generation, we've reached a point where what we watch, read, and listen to is no longer determined solely by states or corporate monopolies but by us. With the creation of YouTube, for the first time people were given access to free, instant, global distribution of video. While streaming services such as Netflix, Hulu, and Spotify have done an incredible job distributing traditional content in new ways, open platforms such as YouTube have changed who is able to produce, distribute, and consume media. All of a sudden *anyone* in the world could share a video with *everyone* in the world.

Over just one decade, that freedom has had far-ranging implications throughout the media industry. It has redefined what it means to be a celebrity and who can become one. It has thrust new people into the spotlight who understand that fame has changed. It has elevated the importance of engaging fans directly, rather than keeping them at a remove. And it has led to the emergence of a much more

diverse and opinionated cast of stars who stand out from the inoffensive, inauthentic stars of previous generations.

That freedom has also altered our idea of what entertainment can be. It has unleashed entirely novel yet staggeringly popular genres of content, from beauty vlogging to video game commentary to unboxing videos. It has shrunk our world, exposing us to media from other countries that had long been hidden behind borders. And it has given billions of people the opportunity to watch videos based on their individual interests, rather than having to satisfy themselves with entertainment manufactured for the masses.

And that freedom has changed the rules of the industries that have been built to entertain and inform us. It has changed the way we watch the news, empowering citizen journalists from Ferguson to Syria to document injustice for the world to witness. It has helped elevate advertising into an art form, turning commercials into must-see clips. And it has resuscitated the music video, giving aspiring musicians a new way to break into the mainstream.

When I look at my life today, it couldn't feel further away from my youth behind the Iron Curtain. I grew up dreaming of the West but got only an occasional uncensored glimpse of it. Now, as the chief business officer of YouTube, my job is to help bring information and entertainment to over a billion people around the world, including many in countries whose governments try to limit that access. And rather than offer a glimpse of the world, YouTube holds up a mirror to the entire human experience, reflecting all of our joys, all of our struggles, all of our news, and all of our history.

Today, 1.5 billion people turn to YouTube every single month to watch the largest library of video ever assembled whenever they want, wherever they want, on any device they want. Some come to watch the latest viral hit, music video, or late-night clip. Some come to catch up on news or sports. Some come to learn something new

or indulge an interest. Some even come just to watch ads. But most people visit YouTube to watch something they can't find anywhere else: a generation of auteurs and entertainers who have built their success on the platform, inspired by the challenge to share their creativity with the world.

I call these trailblazers *streampunks*.

I didn't write this book to provide an origin story about YouTube. I didn't write it to paint another corporate portrait of a Silicon Valley upstart that's trying to "disrupt an industry" or "rewrite the rules." I wrote it because I wanted to tell the story of an incredibly talented collection of creators and entrepreneurs who've used YouTube to do amazing things. Some of them draw audiences larger than those of hit TV shows. Some of them have built thriving businesses. But all of them together are fundamentally transforming how media works.

Through their stories, I hope to describe that transformation. I hope to highlight the tactics they've used to prosper. I hope to provide an honest depiction of the difficult challenges they have faced along the way. And I hope to articulate what their success means for the future of media.

Above all, I hope I'm able to create something that connects with audiences, entertains them, and makes them feel part of a growing movement.

After all, streampunks do that every day.

Streampunks

1

Rise of the Streampunks

Your Orientation to a New Class of Creators

THEY COME IN cameras first.

The doors of a soundstage in New York's Chelsea neighborhood swing open, and more than a hundred of the most successful entertainers of the digital age flood into the room, their phones held high to capture the moment while the Calvin Harris track "How Deep Is Your Love" booms over the sound system. Their ages, which span decades, seem to dictate how quickly they enter the room. The youngest, those in their late teens, rush in to get the best seats toward the front of a wide stage. The older Millennials come in behind them, prizing the opportunity to interact with each other over the chance to sit up front. The last to come through are the Gen Xers, the "elders" of YouTube, and you can spot them almost instantly; they're the only ones with backpacks. But whether young

or (relatively) old, almost all of these streampunks record their entrance to later share the moment with millions of their fans from around the world.

This is the YouTube Creator Summit, and it is one of the most privileged gatherings in entertainment. Every year, we at YouTube host the most popular personalities on the platform for a whirlwind few days in New York, where they get to socialize with one another while hearing inspirational talks from some of the leading creative voices in entertainment. It's Davos for the digital set.

The Summit is one of the few times these creators spend off the clock. Most spend their entire year either working on new videos for their channels or engaging with their fans. Sometimes that engagement is sanctioned, during fan meetups or conventions, but most often it's spontaneous and fueled by sightings and subsequent tweets. When word got out on social media (as it inevitably does) that more than 100 top YouTubers were in New York for the Summit, dozens of eager teenagers lined the block of their hotel for their chance at a prized selfie. And unlike many mainstream celebrities, who shy away from the public and keep their fans at arm's length, YouTube creators tend to work the crowd. Their success is due in large part to their accessibility in the digital world, which translates into expectations of accessibility in the physical world.

Perhaps the break the Summit affords is why the creators look so at ease on this April morning in New York, clapping in surprise and breaking into smiles as many meet each other for the first time. Maybe that's why they start to put their cameras down after capturing that initial shot and start to embrace each other. It's a global crowd, but they recognize each other regardless, as Tyler Oakley, one of the most popular creators in the United States, hugs Brits Dan Howell and Phil Lester (all three of them are best-selling authors). Though most creators eventually sit with their compatriots,

in these first five minutes there is an overwhelming sense of respect as they exchange greetings with their peers from around the world. You can sense the camaraderie between them, as if they all play for the same team.

And the truth is, no matter where they're from, they look more alike than different. They look like people who are doing what they want to be doing for a living and don't have to answer to anyone but themselves. They wear the rarest sneakers, the sharpest athleisure, the Brooklyn- and Berlin-based labels that are as relevant in fashion today as any you'd find in Milan. Or they just wear the global creative uniform of jeans and a T-shirt. So many have tattoos or dyed hair that the ones who don't seem like the exceptions.

Perhaps the best hair in the room belongs to Mark "Markiplier" Fischbach (dyed Kool-Aid red) and Seán "Jacksepticeye" McLoughlin (mint green), the most popular gaming creators from the United States and Ireland, respectively. For many people unfamiliar with YouTube, the success of Mark and Seán, who primarily film themselves playing video games, is difficult to comprehend. But their model—wherein creators offer spontaneous reactions and commentary as they stream themselves playing different gaming titles—is employed by thousands of people around the world. These gamers fuel a massive-attention engine, with hundreds of millions of people spending hundreds of millions of minutes watching people play video games every single day.

But the gamers aren't the only ones in the room making content you wouldn't expect to see in your average prime-time lineup. They're joined by lifestyle gurus such as Bethany Mota, Raye Boyce, and Dulce Candy Ruiz, who offer hair and makeup tutorials and lifestyle tips to their viewers. Vloggers such as Casey Neistat are commanding TV-size audiences by sharing scenes from their daily lives while offering their viewpoints direct to camera. And

gadget gurus like Lewis Hilsenteger, who regularly averages a million views a video on his channel *Unbox Therapy*, give fans a taste of consumer gratification without having to open their wallets by revealing—or "unboxing"—the latest tech products.

The genres these creators represent—gameplay commentary, beauty tutorials, unboxing—had never been seen on TV. No executive, including those of us at YouTube, would have guessed that these genres, along with several other novel content categories, would become some of our most popular.

In fact, try placing yourself in the seat of a network studio head. If someone came to you and said they wanted to film a show of themselves nailing trick shots, braiding his or her daughter's hair, or filming cool things with a 4K high-speed camera in superslow motion, would you give that person the green light? Probably not. But that's exactly how the members of the sports collective *Dude Perfect*, the family behind *Cute Girls Hairstyles*, and the creators of *The Slow Mo Guys* racked up millions of subscribers to their channels and find themselves at the Summit today.

The stars of these original channels are joined in the room by creators who are reinventing familiar TV tropes for modern audiences. The British chefs from *Sorted Food* don't just host cooking shows, they listen intently to the feedback of their viewers to prepare the dishes fans are clamoring for, with turnaround times measured in days, not seasons. Destin Sandlin, an engineer from Alabama, hosts a series called *Smarter Every Day*, in which he explains the physics behind topics as varied as space travel and laser tattoo removal; the series runs far more often than the educational content that airs on PBS on Saturday mornings or the occasional shows on TLC that are still focused on learning. Jamal Edwards founded the digital music network SBTV on YouTube when he was just sixteen years old, showcasing the East London grime scene

that MTV had largely ignored (eventually launching Ed Sheeran's career in the process). And Cenk Uygur, the founder of *The Young Turks*, created the first Internet video news show in 2002; it's now the largest online news show in the world.

In addition to content you wouldn't see on TV, a glance across the room reveals faces you wouldn't typically see on the air, either. Amid controversies about diversity in Hollywood such as #Oscar-SoWhite, YouTube creators tend to provide a much more accurate reflection of the cultures they represent. Lilly Singh, better known to her fans as ||Superwoman||, rose to fame by embracing her immigrant origins and impersonating her Indian parents in sketch videos (I take back what I said, *she* has the best hair in the room). Her friend and occasional collaborator "sWooZie," aka Adande Thorne, made waves when he interviewed President Barack Obama about topics such as police violence and racial profiling in 2016 after the final State of the Union address of his presidency. Wesley Chan, Ted Fu, and Philip Wang, of the production company Wong Fu, are determined to create series and films that feature Asian American casts, long a blind spot in Hollywood. And Sami Slimani, a lifestyle guru with Tunisian roots who goes by the name "HerrTutorial," is one of the most popular YouTubers in Germany.

The global nature of YouTube can't be emphasized enough, with nearly 80 percent of its traffic coming from outside the United States. In the past, a TV series that made its way from one country to another was a rare occurrence, typically a BBC hit that was then exported around the globe. On YouTube, the members of the comedy troupe Porta dos Fundos are going a long way to redefine sketch comedy in their native country of Brazil, but their videos are also being viewed by tens of millions of people in Europe and Asia. HolaSoyGerman, one of YouTube's most popular creators, has nearly as many fans in the United States as he does

in his native Chile. And nearly everyone knows that YouTube's most viewed video of all time is Psy's "Gangnam Style," a K-pop song about a neighborhood in Seoul sung mostly in Korean.

Music has long been a core part of YouTube's appeal. The platform has become a powerful source of discovery for fans interested in new music, as well as record labels interested in new talent. Justin Bieber was discovered on YouTube at the age of twelve after an enterprising music executive named Scooter Braun spotted footage of him at a Canadian talent show; three years later Justin was selling out Madison Square Garden. Macklemore was another artist who burst to fame when his video "Thrift Shop" took him from YouTube sensation to Best Rap Album Grammy Award winner. Joining these now-mainstream artists are the independent, homegrown YouTube groups such as Pentatonix and Boyce Avenue, whose cover videos and original recordings have helped them mint platinum records and top charts around the world.

Digital success has translated most strikingly to the publishing world. A quarter of the creators at the Summit have written best-selling books, from Tyler Oakley's collection of funny stories, *Binge,* to boxed-wine enthusiast Hannah Hart's cookbook, *My Drunk Kitchen.* Zoe "Zoella" Sugg, a vlogger who lives in Brighton, wrote the fastest-selling debut novel in UK history, beating out J. K. Rowling. But by far the most famous author in the room is John Green, whose book *The Fault in Our Stars* is one of the best-selling books of all time and was optioned into a chart-topping film adaptation.

The film industry is increasingly casting its gaze to YouTube for talent. Both Pentatonix and German YouTube comedian/actor/DJ Flula Borg were given significant roles in the box-office smash *Pitch Perfect 2.* In 2009, a Uruguayan director named Fede Alvarez uploaded a short film called "Panic Attack!" about an alien invasion

that he made for $300; three days later, his in-box was full of invitations to Hollywood studios, and five weeks later, he had a deal reportedly worth $30 million to direct a slate of films, including a remake of *The Evil Dead*. And the Oscar-winning director Barbara Kopple recently released a documentary about YouTuber Gigi Gorgeous's gender transition, which premiered at Sundance.

On TV, the story is much the same, with YouTube creators not only starring in shows but writing, producing, and occasionally directing them as well. When Rachel Bloom won a Golden Globe for her performance in the musical comedy *Crazy Ex-Girlfriend*, a TV series she also created, she thanked her cocreator, the writer Aline Brosh McKenna, who had discovered her from the humorous music videos she had uploaded to YouTube. That was a similar path to the one Issa Rae followed, transitioning from her hit YouTube series, *The Misadventures of Awkward Black Girl*, to her HBO series, *Insecure*. And Colleen Ballinger's obnoxious character Miranda Sings was a mainstay on YouTube before she starred in and produced her own Netflix Original series, *Haters Back Off.*

If all of this is news to you, you might have been surprised at the results of a recent *Variety* survey, which asked American high schoolers to name their favorite celebrities. It was YouTubers who held the top six spots in that survey, ranking above names such as Taylor Swift, Johnny Depp, and Leonardo DiCaprio. In fact, surveys yielded similar results in Mexico, Brazil, the United Kingdom, and even Finland (where twelve of the top twenty most popular celebrities were YouTube creators!).

Those surveys begin making sense once you start asking teens and Millennials about their relationships to their favorite YouTube creators and how those bonds differ from their relationships to traditional celebrities. When we surveyed our teen and Millennial subscribers, 40 percent told us that YouTubers understood them better

than their friends or family.* But a whopping 60 percent of them told us that a creator has changed their life or view of the world.

Perhaps that's why traditional TV stars are increasingly using YouTube as a way to connect to a younger generation of viewers. In the 1990s, the late-night wars were a battle fought between two networks during one time slot. Today, the battlefield has shifted online, with Jimmy Fallon and Stephen Colbert joining Conan O'Brien, Jimmy Kimmel, James Corden, Trevor Noah, Samantha Bee, and Seth Meyers as late-night stars racking up views every hour of every day. Indeed the format of late night itself has changed, moving away from what felt like rehearsed promotional interviews to a series of skits that we can snack on individually during a quick mobile break.

The world of sports is undergoing a similar transformation. YouTube has long been the home of highlights, the place to catch last night's can't-miss dunk or the latest gravity-bending goal. More and more, we're also getting to see what happens off the court as well, with behind-the-scenes footage and training camp film being shared online. And forward-thinking sports leagues such as the NBA and NFL are increasingly sharing archival footage of old games on YouTube, giving the truly devoted fans among us yet another way to enjoy the sports we love. Today's generation of sports fans can now watch MJ in his prime as easily as they can see Steph Curry in his.

Even advertising has found new life online. You may think of commercials as something you can skip on YouTube, but in fact content created by brands accounts for some of the most popular videos on the platform every single year. A new generation of Mad men and women, motivated by the fact that commercials can extend beyond the limits of the average thirty-second spot, are creat-

* With two teen daughters, I suppose I can relate.

ing some of the most brilliant advertisements ever seen. The Super Bowl used to be the only time people tuned in just to watch ads. Today, they do so every day. In fact, brands have started running prospective Super Bowl ads on YouTube *first* as part of our annual "Ad Blitz," so they can choose the most popular spot to air during the big game.

And so the world of YouTube extends far beyond this Chelsea soundstage, encompassing Madison Avenue and Madison Square Garden, the Thirty Mile Zone of Hollywood (yes, that's what TMZ stands for), and the foreign film capitals of Bollywood and Nollywood. It's connected to every music capital, from Nashville to Berlin to Seoul, and to national capitals, too, offering up the latest news from Washington, London, Brussels, and Moscow. It attracts talent from every corner of the earth, with tens of millions of aspiring creators in places as far afield as Rio and Nairobi, Dubai and Mumbai, Tokyo and Tel Aviv. It even reaches back into the past, providing the most comprehensive archive of human history to date, keeping records of events both banal and transcendent, from trips to the zoo to trips to the moon.

The enormity of what's happening on YouTube is why I felt compelled to join it. Prior to YouTube, I had worked at Mutual Film Company (a movie financier) and HBO before decamping to Netflix. It was there that I found a passion for what the Internet could bring to entertainment, helping lead the company's transition from a mail-order DVD business to a streaming subscription service. But it was YouTube's open and global nature, its limitless potential, and its global presence that led me firmly to believe that it represented the future of entertainment. When I was given an opportunity to help YouTube shape its future and attract even more great content, I leapt at the chance.

And now it's time for me to take the stage and kick off this day

of inspiration for our top YouTubers, where they'll hear about creativity from the Coen brothers, about successful show running from Aziz Ansari, where they'll cook with Rachael Ray, discuss trends in comedy with the women from *Broad City*, and tell stories with the team behind *The Moth*. As luck would have it, I have some good news to share, as Interpublic, one of the largest advertising agencies in the world, has just announced that it will shift $250 million from its budget for TV commercials over to YouTube. With TV ratings declining and YouTube's reach growing at incredible speed, many in the press call it a sign of things to come.

Armed with that bit of knowledge, I go up to the microphone: "Welcome to the most powerful, influential, and hippest room in media."

||Superwoman|| Comes to the Supermarket

Why Shelf Space Is the Key to Understanding How the Media Industry Works Today

IF YOU GRADUATED from college before President Obama took office, you're probably asking yourself a few questions now, such as how the hell did this happen? Who are Markiplier and ||Superwoman||? How is it that these creators—many of whom you've possibly never heard of—are outearning actors, topping charts, selling out stadiums, and interviewing presidents and prime ministers? And how were they even able to establish their popularity in the first place?

These questions reflect a growing sense of confusion about what we collectively watch. Twenty years ago, the answer was simple: we watched TV. As recently as 1998, more than 20 percent of American

households with TVs were watching *Seinfeld* every single week and seemingly everyone knew George, Jerry, Elaine, and Kramer by name. But since then, no show has been able to assemble that large an audience. In fact, the kind of ubiquity that *Seinfeld* enjoyed is now likely impossible, with more great shows competing for our attention than ever before.

Every day, it seems as though there's a new series to discover. Between cable and digital services such as Netflix, Hulu, and Amazon Prime, more than five hundred new original series are slated to premiere in 2017—three hundred more than in 2009—and that's not even including the more than four hundred hours of video that are uploaded to YouTube every minute.

With so many options, fewer of us are watching the same thing. And even if we are, we're not watching it at the same time. In the past you could reliably find a new show on your cable or satellite box and watch the premiere along with everyone else. Now you might need a Smart TV or a monthly subscription to a specific service, and you *still* may end up ten episodes behind your neighbor who already binge-watched it.

What we watch, when we watch, how we watch—all of that has changed dramatically since the turn of the century, and that change only seems to be getting faster. But if you want to make sense of it, the thing you really need to understand is your local supermarket.

———

Whether you realize it or not, when you walk into a grocery store, the products you see on the shelves are the winners of a stiff competition. A spot on a supermarket shelf—or better yet, a shelf at a big international chain such as Walmart or Costco—guarantees that millions of customers have a chance to see your product and

potentially buy it. No matter what you've heard about the growth of online retail, the truth is that the vast majority of the world's spending still happens within brick-and-mortar stores, and getting your product into those stores is still the best way to guarantee some level of awareness and sales.

Now, to get your product on that shelf requires a negotiation with those large retailers. And one of the best ways to increase your leverage in a negotiation is to bring several products to the table. Over the past century, consumer packaged-goods companies such as Procter & Gamble and food companies such as Nestlé have transformed from small companies selling a few items into massive multinational conglomerates with dozens of well-known brands and thousands of products. Some of those products they create themselves, but the majority have been accumulated through acquisitions of other companies. And they use the popularity of their biggest sellers—such as Tide or Kit Kats—to negotiate for better spots on the shelf and also to ensure that stores stock their new or lesser-known products.

Retailers don't stand still, though. In the face of this growing leverage, they also merge and grow and acquire new chains and locations, mostly to benefit from larger economies of scale but also to gain a better bargaining position relative to their suppliers. They can use this strength to do a number of things, from limiting the number of new, untested products they accept to negotiating with suppliers for lower prices. Back and forth these negotiations go, a constant arm-wrestling match between producers and sellers as each side tries to bulk up to hold off the other.

In almost striking similarity, this is how the television industry works today. Cable and satellite operators such as Comcast and DirecTV have only a certain number of channels they can offer in a pay TV bundle, like the limited number of shelves a retailer has to offer in any store. Media companies such as Fox and Disney

assemble lineups of their channels (products, in our analogy) and negotiate with the cable and satellite companies for placement.

Just as with producers and retailers, the same dynamic that applies in the supermarket has taken hold in media. Networks began to acquire new channels (for example, ABC buying ESPN or NBC buying Telemundo), dramatically expanding their program lineups to improve their negotiating position with cable and satellite distributors. In response, a wave of consolidation took place in the cable and satellite industry, transforming it from one that was largely made up of local and regional businesses into one in which only a handful of players exist (anyone who has tried to comparison-shop for cable knows all too well how few options there really are).

As a result of all this consolidation of networks and distributors, a handful of very large media conglomerates, controlled by just a few people, determined what the majority of people watched. For decades, those moguls served as the gatekeepers of mass media. They weren't elected or chosen, but a few of them—less than a dozen—held massive cultural power based on their ability to decide what got made and what got seen.

Thankfully, we can turn to TV for a perfect illustration of these dynamics. In one of the most memorable episodes of *Seinfeld*, George and Jerry are sitting in a boardroom with executives from NBC, pitching the network an idea for a new television show. Jerry begins to explain the concept, but George, in a supreme bout of misplaced confidence, interrupts him.

"If I may, Jerry . . . I think I can sum up the show for you in one word," he tells the head of NBC. "Nothing. The show is about nothing."

"Nothing?" the exec asks.

"Nothing," George answers.

The head of NBC isn't so impressed with the idea. Confused, he asks, "Well, why am I watching it?"

George, frustrated, shoots back, "Because it's on TV!"

"Not yet," the head of NBC reminds him.*

That one brilliant exchange explains four decades of the television industry in ten seconds. What George said was completely true: until the 1990s and the expansion of cable TV, most people had access to only four major channels in the United States and even fewer options if they lived in other countries. That meant that for the most part, you watched whatever was on TV, the same way you bought the products that were sold at your local supermarket. Sometimes what was on was a critically acclaimed show with popular appeal, such as *Seinfeld*. And sometimes it was *Joe Millionaire*.

As for who determined what was on, that scene also nails it. It was usually a white man, usually well educated, usually working in New York, usually sitting in a well-appointed office. If you wanted to create a show, you had to somehow get into that office to pitch your idea to a network. That network exec then had to agree to green-light a pilot episode of that show. Based on how the pilot was received, that show would then have to compete against other shows for the limited number of time slots on any channel. And that channel would have to be included in most people's cable bundle for the show to even have the chance to be seen.

Though I've spoken about television, this mogul-dominated model applied just as well to other forms of mass media, such as film, print, and music. Any situation where there was limited shelf space (literally, in the case of books, CDs, and DVDs; figuratively, in the case of cable bandwidth or broadcast spectrum) meant that both the producers and the distributors of content had to negotiate for placement, leading to greater consolidation within the industry and greater power in the hands of fewer gatekeepers.

* If you're having trouble imagining this, you can find the clip on YouTube.

Then along came the Internet. It brought with it many things: email, instant messaging, Pets.com—but perhaps the most significant thing it brought was an infinite amount of shelf space. If you want to sell your product, you don't have to fight to get it stocked at your local supermarket, you can put it up on Amazon or Etsy along with a nearly infinite selection of other products, or even sell it directly on your own website. If you want to get your music heard or your show seen, you don't have to audition for a music exec in New York or Los Angeles or London, you can post it online to YouTube and have the potential to reach more than a billion people. You no longer have to play the game, you can embrace the streampunk ethos, self-publish, and be discovered. And no gatekeeper can stand in your way.

This new dynamic began with print media and blogs, but then, in 2005, it took hold in video. On a cloudy day in San Diego, two friends stood in front of the elephant pen at the local zoo and filmed the very first clip that would appear on a new video-hosting website. It starred Jawed Karim, a young man in a large jacket making a childish joke: "The cool thing about these guys is that they have really, really, really long . . . trunks." And it was utterly unremarkable: nineteen seconds of unsteady footage shot on a camcorder in low definition.

But the idea behind the site that Jawed and his friends and former Paypal coworkers, Chad Hurley and Steve Chen, created to host that video *was* remarkable, and its power lay in its pitch: broadcast yourself. Share a video of yourself on YouTube and anyone with an Internet connection could easily find it.

It sounds difficult to believe now, but before YouTube, the act of putting something you filmed online was a nightmare. It meant taking a camcorder cassette to your local minimall, having it digitized

and burned onto a CD, and then paying to upload the video files to a private server or hosting site. Honestly, you probably would have had an easier time pitching it to a network executive.

But then along came a site that was willing to host that video for free, for anyone, forever. YouTube offered instant global distribution, allowing anyone to share something that everyone could watch. YouTube gave you a little room on the shelf, a little space on the dial, and since then, the media industry has never been the same.

For decades, the media industry was predicated on the idea that a handful of network execs knew best what millions of people would find entertaining or newsworthy. But with the emergence of YouTube and other open platforms, we've learned that people's interests are far more diverse and unique than those execs ever imagined. And we've also seen that people are far more open to discovering new voices rather than relying on anointed ones. The overwhelming popularity of Markiplier's gaming videos, ||Superwoman||'s sketches, or Pentatonix's music is proof that there is more talent in the world than Hollywood has ever let through the door and more demand for entertainment that doesn't look or sound like what already exists on the airwaves.

And many of these independent creators outcompete the pros! In several cases, more people are choosing to watch YouTubers than TV shows that talk about similar issues. The same thing that independent cinema showed us in the early 1990s is proving itself true with television: voices outside the system can often be more compelling than those within it.

We assume that the media industry is different from other industries; that the principles of a free market have less sway and that we need moguls to bless what we enjoy. But the success of independent creators on open platforms such as YouTube suggests

that the same economic rules apply to media as they do to any other industry.

———

Around the time of YouTube's launch, I was working at Netflix. Having worked my way up from a talent agency mail room to jobs at Mutual Film Company and HBO, I joined Netflix convinced that the company would revolutionize home entertainment and upend rental chains such as Blockbuster. And in the early 2000s, that vision came to life. But once the company's DVD mail-order business had really established itself, I began to get a little bored.

One day, my boss, Reed Hastings, asked for a volunteer to help lead a new side project: instead of mailing out physical DVDs to customers, could we figure out a way for our customers to view films and TV shows digitally, over the Internet? Now, volunteering to lead a new initiative is a very stupid thing to do at Netflix. The company's culture prides itself on relentless focus, dispassionately eliminating business initiatives that are not core to the overall strategy. You can work on something for years only to find that project mothballed during a quick meeting. But I was hungry for a challenge, so I offered to take on the new project. I was the only volunteer.

It wasn't the first time that Netflix had evaluated an Internet-only option, but only in the mid-2000s did data speeds and bandwidth costs finally reach the point where asking users to download an entire movie online no longer seemed like a crazy idea. The initial thinking was that we would create and supply customers with a "Netflix box" that they could use to download movies overnight to watch the next day. It was incredibly difficult to acquire the download rights to movies, just as it was difficult to create the new box and service, but by 2005, we were finally ready to launch.

||Superwoman|| Comes to the Supermarket

Then I saw YouTube for the first time. More precisely, I saw grainy videos of snowboarding accidents and people lighting their kitchens on fire, and I saw that those videos were attracting massive viewership numbers, making YouTube one of the fastest-growing sites on the Internet. We at Netflix—along with everyone else in the industry at the time—were focused on delivering movies to people in the highest quality available. But YouTube clearly demonstrated that people were willing to trade fidelity for convenience and speed. Witnessing the popularity of YouTube was a revelation. And it caused us to stop our launch and pivot to a service that would allow consumers to stream movies remotely instead of downloading them. That pivot took two long years, during which we had to renegotiate all our rights and build an entirely new architecture to host and serve content. We had to transform our "Netflix box" from a hard drive that would download video to one that would stream it.* But finally, in 2007, we launched Netflix streaming because we saw the potential that YouTube presented.

Every month, YouTube seemed to be growing faster, launching in new markets, increasing its number of views and attracting more and more people to share videos. In 2011, when I left Netflix to join YouTube, around forty hours of video were being uploaded every minute. In 2017, the number has grown over tenfold.

But as powerful as YouTube's idea of free, global distribution of video was, I don't think it alone was enough to lead to the streampunk era we live in now. I think there were three other developments that have been core to explaining the success of stars such as ||Superwoman||.

The first has to do with a decision YouTube made very early in its history: to pay its creators.

* Weeks before the launch of its streaming service, Netflix spun off the "box" into its own company, called Roku; again, a demonstration of the company's strong desire to focus on its core competencies.

Any new-media venture suffers from the same issue: How can it provide content that will attract viewers? That's true whether you're starting a blog, a magazine, a TV network, or a video-streaming service. Your first instinct may be to pay someone noteworthy to create content for you, using an established brand to attract attention to yours.

When YouTube first started, its approach was no different. In addition to hosting all the videos that users uploaded, YouTube signed deals with NBC as well as smaller players such as CollegeHumor .com, giving them a share of advertising revenue in return for content they uploaded to the site.

But then YouTube made a novel decision: in 2007, it launched the Partner Program, extending the sharing of ad revenue to creators of all kinds, not just to established media companies. If you reached a certain number of views or subscribers, you could give YouTube the right to sell advertising against your videos and receive the majority of the money it earned from your channel's traffic.

If you speak to people who were at YouTube in those early days, the creation of the Partner Program wasn't primarily a business decision. Instead it was about fulfilling the egalitarian promise of anyone being able to create content.

George Strompolos, currently the CEO of the media company Fullscreen, helped create the Partner Program. He told me that the company "wanted to ensure that YouTube would be a home for new voices, not just to get seen but hopefully to generate some income and earn a full-time living." It was one thing to give people an opportunity to connect with an audience; it was another to give them a paycheck.

There's a lot of discussion today about the sharing economy and what companies such as Uber, Lyft, and TaskRabbit owe to their employees. But long before there was a sharing economy, there was a social economy. That economy functions because users supply

content (posts, tweets, pics, snaps, vines, or videos), people tune in in massive numbers to see that content, and advertisers pay to run ads against that content to get their products in front of viewers. Without the voluntary contributions of billions of people, the social economy would collapse. But sadly, to date, YouTube is the only significant player in the social economy that pays all its creators a share of the advertising revenue their content generates.

In just over a decade, the scale of YouTube's partner payments has become massive. Though some paychecks are smaller than others, to date we've paid out billions of dollars to content creators of all sizes. That money has helped anchor the growth of several new-media properties, from Vice to BuzzFeed to George's company, Fullscreen. It has helped bolster the bottom lines of traditional media companies and music labels (we've paid out $3 billion to the music industry alone). And it's created an entire business-to-business layer of service-oriented firms that provide the infrastructure for Internet video to thrive, offering rights management support, data analysis, and specialized ad technology.

But the most significant consequence of YouTube's revenue sharing has been the democratization of the job of Internet content creator. Every month, we deposit money into the accounts of millions of creators around the world. That money is what helps a streampunk get his or her start. It's what changes the act of making videos from a hobby to a trade. It's what transforms a career in entertainment from an option available only to the well connected or very lucky to a path that is open to almost anyone.

The other thing that money allows creators to do is invest in the quality of their videos, at a time when the cost of video and sound production has dramatically decreased. To me, that's the second major development that has enabled streampunks to become as popular as they are. In a bit of good fortune, Apple decided to add a built-in

iSight camera in all its computers and laptops the same year that YouTube was founded, a move replicated by other computer makers. Without that early proliferation of webcams, a lot of YouTube's content in those first few years wouldn't have been possible to make.

The smartphone led to yet another evolution in video capture, putting ever-higher-resolution cameras in all of our hands. Samsung was the first manufacturer to release a phone that could capture HD-quality footage, back in 2009, creating a new industry standard. GoPro soon followed with its own line of portable HD cameras, leading to an explosion of footage from viewpoints no one had ever seen before, from the head of an eagle in midflight to a man jumping from space. More recently, drones equipped with HD cameras are giving people the chance to re-create shots that could only be produced from helicopters before.

Today, the highest-end phones and portable cameras can record in formats better than what most TVs can display, from 4K and HDR to immersive 360-degree video. If our creators were still filming videos on grainy webcams, I'm sure some of them would still be popular; but the ease with which we are all able to create high-quality footage is what has accelerated YouTube's evolution from a host of amateur videos to the domain of professional filmmakers.

The ubiquity of smartphones also led to the third dynamic that has fueled the rise of independent creators: not only do our cameras turn us all into potential creators, our screens give us all the potential to be viewers. "Big deal," you may say, "everyone who has a smartphone has access to a TV anyway." Though that's true, we are largely accustomed to sharing our TVs—with roommates, with spouses, with siblings, with family members. So choosing what to watch at home often means choosing to compromise.

But with the omnipresence of smartphones and tablets, you don't have to worry about compromising. And though it may sound a

little selfish, you don't have to share what you're watching with anyone at all (at least not in the physical world; you probably still want to share it on Facebook if it's good). You don't have to watch cartoons with your sibling or golf with your dad or whatever your grandmother finds acceptable during the holidays. You can watch whatever you want in any room you're in.

Free distribution, the chance for a steady paycheck, better cameras—all three of these factors have led to a new supply of creative talent. But the explosion of individual screens has unlocked a new source of demand. The mobile phone is successfully changing the way we watch video into the way we read books: you find one that interests you and consume it whenever and wherever you want. As a result of this explosion of choice and access, fewer of us will spend our time consuming the same videos and shows; that's why YouTubers can be the most popular celebrities in high schools today without other people ever having heard their names.

Today the competition that matters is no longer for the right to appear on shelves or in cable bundles; today what matters is the competition for your time. Every advertiser, every network, every news publisher, every Web outlet, every content creator, every app has now become the equivalent of a middle child, desperately seeking your attention. And once it has your attention, it can sell you a product or service or sell advertising that might convince you to buy a product or service. It is only with your attention that you can be "monetized."

Thus, if attention is the currency of the digital age, every company should be after the biggest source of people's attention: watching video. Watching video is the number one way human beings spend their free time. The average American spends more than five hours a day watching something on a screen. There are only two things we spend more time doing: working and sleeping.

Five hours of watching video may sound to you like an unbe-
lievable amount of time every day. But think about your average
weekday. You wake up and maybe turn on the *Today* show or
SportsCenter in the background while you get ready for work; that
can be anywhere from half an hour to an hour. Unless you're driv-
ing, you're probably spending your commute reading emails, but if
you have your headphones, you can fit in a couple of clips from the
late-night shows; another ten minutes there. You get to work, where
you break up some of your day with YouTube videos that coworkers
or friends are passing around, or maybe you check out a clip on
Upworthy or scroll through your Facebook feed; that can easily eat
up forty-five minutes to an hour of your day. You commute back
home in the evening—another ten minutes of video there—and
almost instinctively turn on the TV while you think about dinner,
maybe with the assistance of a few BuzzFeed Tasty videos (another
ten minutes). Perhaps there's a game you can leave on in the back-
ground, or maybe you prefer cable news; either way, that can easily
get you from 6 to 8 p.m. You finish dinner—maybe put the kids to
bed—and have plenty of time to binge through a couple of episodes
of whatever new AMC or FX or Netflix series you haven't finished.
You're about to turn the TV off, but maybe you'll catch Jimmy Fal-
lon's monologue before going to sleep.

Obviously your average day is different from that rough sketch,
but as with any caricature, I bet you can recognize some parts of
yourself in it. Before you know it, you've easily consumed five hours
of video, some of it hidden within the margins of your day but most
of it devoured in big chunks every night.

Video is king, and it's very difficult to see anything dethroning
it as the major sink of our free time. If anything, the explosion of
interest in virtual reality and the craze around augmented reality fol-
lowing the release of Pokémon GO suggest it's likely that we're going

to spend more time watching things on screens, not less. Our phones and tablets are complicit here, too—every year, they're getting bigger, brighter, sharper, and faster. And because brands are willing to pay much more for video advertising than they are for print ads, magazines and newspapers that currently invest the majority of their resources in journalistic writing are going to increasingly invest in documentary filmmaking and multimedia "explainers"—digestible videos that help people understand complex topics. And yes, one day, we'll be watching videos in our self-driving cars, too. The future is video, as far—and as close—as the eye can see.

I don't mean to conjure up images of *Wall-E* here, with all of us strapped to chairs in front of screens drinking Big Gulps, but hopefully this gives you a sense of why Red Bull and Pepsi have video production studios, why the *New Yorker* has a show on Amazon Prime, and why *Esquire* has a TV network.

The sheer amount of all these new shows and videos can feel overwhelming. But whenever we've witnessed an explosion of choice of a good that was formerly capped, a similar pattern has emerged: greater total consumption, but fewer people consuming the same thing.

During World War II the government began ordering massmarket paperbacks to entertain soldiers fighting overseas, since they were lighter to carry than hardcover books. The demand for titles ushered in a new era of reading, leading to the formation of new genres such as murder mysteries and science fiction, with fewer people reading the classics.

In the 1980s the microbrewing revolution broke open the oligopoly of Budweiser, Coors, and Miller, leading people to drink more total beer as well as more IPAs, ambers, and ales.*

And in music, consumption and genre fragmentation continue to

* I'm Czech, I had to include a beer reference.

grow in tandem. The vinyl record led to massive record sales and the creation of R&B and rock and roll. The move from AM to FM in the 1980s boosted tape and eventually CD sales, ushering in new wave and hip-hop. And today, streaming services such as SoundCloud and Spotify allow us to enjoy more music than ever, while giving rise to even more niches. As of this writing, Major Lazer's "Lean On" is Spotify's third-most streamed song ever. It's classified as moombahton, a fusion of house and reggaeton that was only invented in 2009.

Video is now diversifying in the same way, allowing an incredibly wide variety of voices and genres to thrive. That includes many of the streampunks with massive audiences I mentioned in the last chapter. But it also includes people such as Henry Reich, a film school dropout from Montana who also happens to be a physics buff. By making complex topics approachable on his channel *Minute Physics*, Henry is able to draw more than 5 million views for videos on academic concepts such as Schrödinger's cat. Every day, instead of being stuck watching "must-see" TV, people around the world can watch Henry's videos, binge a season of *Game of Thrones*, stream *Doctor Zhivago*, or watch *The Blacklist*. The choice is truly stunning.

Now, what digital video companies don't like to admit is that TV still commands far and away the dominant slice of those five hours of your video-based attention, at just over four hours. For all we hear about Netflix, YouTube, Hulu, and Amazon Prime, you might expect the digital slice to be larger. But I would say, be patient. According to Nielsen, TV viewing actually peaked back in 2009—prior to that it had grown every single year for fifty years. Meanwhile, digital video consumption continues to grow at a rate of 25 percent a year, and since there is literally a limit to how much video one person can consume in a day, its growth means it will start to take up a larger and larger share of the video pie.

So, if you're an aspiring streampunk, how can you get your slice?

Nerding Out

The Green Brothers and the Importance of
Online Community Building

"THERE IS NO part of me that wants to get up on that stage," Hank Green tells me. It's the day before the start of VidCon, the online video convention that he and his brother, John, founded in 2010. Though VidCon is just one of the many ventures he's started, and though he's spent more of his life on camera than most people, Hank can still get a little nervous. Perhaps his anxiety comes from the fact that 2016's VidCon will be uniquely important to his vision for the future of online video. On its final day, he will unveil his latest and most ambitious project yet, the Internet Creators Guild.

The Guild isn't Hank's first attempt at forming a community, but it may be his boldest. He wants Internet creators, many of whom are still young, to understand the true value of what they create so

they can better represent themselves and promote their interests. It reflects Hank's long-held belief that Internet creation—whether it's a blog, a vlog, a tweet, a post, a vine, a video, a gram, or a snap—is vital and that its evolution needs to be nurtured carefully.

Here in Hank's suite at the Anaheim Hilton, he explains that Vid-Con was born in the same spirit. "It seemed like there was going to be a convention for online video at some point," he says. "And I realized, it's going to suck! It's going to be fancy and it's going to be done by somebody in the convention industry and it's going to be a little bit exploitative of both fans and creators, and that line of thought kind of bummed me out."

By 2010, Hank had been to several conventions himself, both as a fan (attending Harry Potter and anime conventions) and as a professional environmental blogger (attending the North American International Auto Show). It occurred to him that the only way the online video community could have the type of convention he envisioned was to start it himself. He called a friend with some experience in the field to sound out his idea. She was so enthusiastic that by that afternoon, she had lined up three potential locations.

His brother, John, was a little less supportive at first. "Don't do it," he told him. "It's going to be a lot of work, and you'll never make any money." But Hank shrugged off his brother's advice, and just two weeks later, the first VidCon was held in the ballroom of the Hyatt Regency in Century City, featuring Hank, a reluctant John, and nine other popular YouTubers. Despite the short notice, 1,500 people showed up, and, thanks to a last-minute sponsorship, it was profitable.

Six years later, VidCon seems to have taken on a life of its own. Though the Anaheim convention center is quiet the day before the gathering begins, soon nearly thirty thousand people, most of them teenage fans, will fill its halls for a three-day, three-night

new-media pep rally. There will be panels and performances and concerts and speeches and brand "activations" and fan meet-ups and signings and selfies and stampedes and screaming, all of which can make Disneyland, just a mile away, seem serene by comparison.

While the Anaheim gathering continues to get bigger every single year (more than thirty thousand people attended in 2017), VidCon has begun hosting international gatherings, in Europe and Australia as well. And beyond its own growing global footprint, the convention has inspired others to host online video conventions in Germany, Canada, England, France, Russia, Mexico, Brazil, and nearly half a dozen countries in Asia, each drawing its own stadium-size crowd eager to meet their favorite online video stars.

But despite the convention's growing scale, for Hank, the industry that VidCon has both become and inspired was always based on more than money. At its heart, it was about bridging the distance between Internet creators and their fans, demonstrating the power of online communities up close. "A lot of YouTube creators saw the number of views they got, but they didn't understand the reality of it," Hank told me. "Getting that creator up on a stage in front of five thousand people is much more impactful than making a video viewed by fifty thousand. It helps you understand just how big a deal this is."

And how did Hank first discover the importance of face-to-face interaction with fans? By going on a book tour with his older brother.

———

From a young age, John Green knew he wanted to be an author. He wanted to write the kind of books he read and loved as a teenager, such as *Their Eyes Were Watching God* and *Catcher in the Rye*.

Streampunks

"It always seemed to me a tremendous privilege to have a seat at the table in the lives of young people when they're forming their values and having their initial experiences with love and grief and the big questions of being a person," John told me.

After graduating college, the path to becoming an author seemed daunting and opaque, so he took a job at a temp agency while he sorted out his life. Eventually, the agency placed him at *Booklist*, a magazine that reviews hundreds of books a week to help librarians determine what to stock. The job turned out to be a great fit, allowing John to read as much young-adult fiction as he wanted—"I was the closest thing *Booklist* had to a young adult," he said—while introducing him to authors and editors who would help him shape his own writing.

After four years at *Booklist*, he published his first book, a young-adult novel called *Looking for Alaska,* about a teenage boy who attends boarding school (loosely based on John's own adolescence) and becomes infatuated with an enigmatic student there named Alaska. The book won the Michael L. Printz Award, the top prize for young-adult fiction, but it couldn't crack the best-seller list. His next book, *An Abundance of Katherines*, was a finalist for the same prize, but its sales were even worse.

It was just after the release of his second book that John decided to start an experiment with Hank. The two brothers had grown distant since John had left for boarding school, sending emails and instant messages to each other often but speaking only once or twice a year. Out of a desire to bridge their distance, John proposed "Brotherhood 2.0," an experiment wherein they would cease all other forms of communication and exchange YouTube videos online every weekday for a year. John and Hank weren't the first vloggers, but they became the first "vlogbrothers."

At first, their videos were almost too personal and idiosyncratic,

quickly edited together and wide-ranging. John talked about his dental surgery on January 8 and then on January 10 calculated his carbon footprint. Hank taught John how to build a house of cards on January 17; on February 8, he offered a meditation on death. The experiment didn't take the world by storm.

"For the first seven months, all of our viewers were teenagers or librarians who liked my books," John said. But a few months in, something happened that showed them the power of their small but passionate community. While learning about effective programs in international development, John and Hank became interested in the concept of microfinance, the practice of extending small loans to poor people to help them escape poverty. They reached out to Kiva, a nonprofit that allows people to contribute directly to those in need of microfinance loans, and asked if they could visit some of the organization's beneficiaries. Together with Kiva representatives, John and Hank traveled to the Dominican Republic and, through their vlogs, explained the concept of microfinance and the work the nonprofit was doing. In the days after those vlogs were posted, fans overwhelmed Kiva with donations. The organization told the brothers that their effect was "bigger than Oprah."

Slowly, the brothers' community grew, until one day, one of Hank's videos (a song about Harry Potter) appeared on YouTube's front page, netting them 7,000 new subscribers. Best of all, because most of those subscribers were huge Harry Potter fans, they brought with them an understanding of what it meant to be part of a community and were unabashedly enthusiastic about the book they loved. In other words, they were unafraid to be nerds.

I use that word because it's one that John and Hank have sought to reclaim. To hear them explain it, nerds aren't the boring kids who lack social skills and live online because they can't deal with humans. In fact, they are the ones who are brave enough to declare

their love for something, even to complete strangers, and committed enough to build followings around their passions.

Rather than define themselves by what they oppose and use irony or sarcasm to shield their insecurity, nerds build their identity around what they love and want to celebrate. In 2009, John explained his embrace of the label in a vlogbrothers video that's become immortal on countless Facebook walls and Tumblr pages: "We don't have to be like . . . 'Yeah, I like that band's *early* stuff.' Nerds are allowed to love stuff! Like jump-up-and-down-in-the-chair-can't-control-yourself love-it! Hank, when people call people 'nerds,' mostly what they're saying is 'You like stuff,' which is not a good insult at all! Like, 'You are too enthusiastic about the miracle of human consciousness!'"

So it was just plain good luck when John was stuck at the Savannah airport one day while filming a vlogbrothers video and stumbled into an arcade to kill time. He spotted an old game whose title, *Aerofighters*, happened to be written in a particularly illegible font. "This game seems to be called *Nerd Fighters*," he says on the video. "That's my favorite kind of fighter!" Without any encouragement from the brothers, their community of fans embraced the name, calling themselves Nerdfighters because they defended the virtues of intellectualism and nuanced discussion.*

The idea of a community built around positivity and shared enthusiasm wasn't just a coincidence; It was based on a shrewd un-

* For John's thirty-sixth birthday Hank bought him that same arcade machine. It now sits prominently in John's office. John and two of his staff members hold world records for top scores. "It's kind of unfair since no one else has the game," he said.

derstanding of how grassroots movements are sustained, a lesson Hank learned personally during his first-ever foray into online stardom, well before the creation of the *vlogbrothers* channel.

While living in Orlando just after college, Hank, like anyone else who's ever been to Orlando, came to hate Interstate 4, the main thoroughfare that runs through the middle of the city. And he didn't just hate the traffic or the fact it had been designed for a much smaller city than Orlando had become; as a young environmental scientist, he hated the car-dependent lifestyle that infrastructure such as I-4 promoted. But instead of just getting angry while stewing in traffic, he decided to organize. He created a website, IHateI4 .com, and put up signs for it at notoriously bad choke points along the interstate. The stunt landed him on the local evening news and got him a write-up in the *Orlando Sentinel*.

Soon, IHateI4.com had a forum filled with commenters who all disliked the same thing he did, but for very different reasons. He had built a community of finger pointers. "Everybody was blaming everybody else," Hank said. "Instead of talking about transportation policy, it was talking about old people or young people or white people or Hispanics, or who the 'bad driver' was. And that's the thing: it's easier to create a community when you are in opposition to something, but those communities always seem to self-destruct."

It's an encouraging thought, especially at a time when so much of our cultural and political dialogue seems to center around opposition. Inequality dominates the economic discussion, immigration and the role of refugees have roiled the political systems of the United States and Europe, and discrimination, whether targeting a person's race, religion, culture, gender, or sexual orientation, seems like an insurmountable problem throughout the world. The idea that opposition movements are fated to flame out quickly is incredibly tempting to entertain.

But at least in the world of YouTube, Hank's observation tends to be true. Be they the Nerdfighters, proponents of gay rights, advocates of the natural-hair movement,* or the millions-strong fan followings that thousands of creators have built, successful communities on YouTube are mostly communities of celebration. By and large, fans come together to watch the things they like, rather than to fuel their cynicism or stoke their outrage. The half-life of anger seems to be shorter when people are forced to commit their negativity to video.

Make no mistake, YouTube has its share of problems with trolling and offensive comments. But if there's one thing that John and Hank have shown, whether through their content, through their community, or through VidCon, it's that YouTube is a place that can foster a deep sense of belonging.

At least in the Nerdfighter community, Hank and John have transformed that sense of belonging into a forum for thoughtfulness and understanding,† as well as one that supports worthy causes. Since their early days partnering with Kiva, Nerdfighters have raised more than $4 million for the microfinance organization, most of which has been supplied as credit to female entrepreneurs in the developing world.

And every year, Nerdfighters run "Project for Awesome," a forty-

* For years, black women who wore their hair naturally were considered unkempt and risked being fired from work, expelled from school, and even penalized by the United States. The natural-hair movement advocates that black women wear their hair naturally, resisting the pressure to straighten or chemically treat their hair. The movement has largely found its voice on YouTube, where style gurus such as "The Chic Natural" encourage women to embrace natural looks and offer styling tips. The movement's strength has led to a reversal of discriminatory policies in schools and workplaces while causing sales of hair relaxers to plummet.

† One of their most popular videos is a nearly eight-minute, thoroughly researched clip on why US health care costs are so high.

eight-hour YouTube version of a telethon, for which community members make videos about their favorite charities in order to raise money. In 2016, Project for Awesome raised more than $2.1 million from thousands of donors for several organizations, including Partners in Health and Save the Children.

Portraying Nerdfighters as fund-raisers doesn't do them justice, though. They are as much a part of the content John and Hank make as the brothers themselves. It is their comments that help lead to ideas for new videos or even new channels. It is their creativity in starting inside jokes and creating pieces of fan art that strengthens and sustains the community. And it is their financial support, often in the form of pledges or merchandise sales, that helps fuel the brothers' creative output.

"You all are probably familiar with this tired narrative that young people are only interested in distraction and have no interest in the world outside themselves," John told an audience of advertisers at a YouTube-sponsored event back in 2015. "But my experience has shown otherwise. While the world has talked about their insularity and solipsism, young people have created a fascinating and complex world of deep engagement online, a world in which they are not just *watching* content but becoming *part* of it by being community members whose comments and fanfic and artwork and passion have profound impacts on the broader culture."

This idea—that Millennials aren't passive slackers but engaged contributors—is part of why I joined YouTube in the first place. The more I learned about the platform, the more I realized that people were watching it in an entirely different way than I had realized. At first, I had thought YouTube was just a more distracting version of TV, with short, snackable clips of cats and dogs and #fails and dance crazes. And while it might be that to many people, YouTube was also a place where creators were making deep and broad connections

with their fans. Those fans weren't just searching for distraction, the way I might when I watch an episode of *Scandal*; they were searching for a place to belong.

In some ways, the number of views a video gets fails to capture exactly what is special about YouTube. Counting views suggests that what matters about the platform is what is seen once by the most people possible. But the true potency of online video isn't just what gets someone to watch, it's what gets them to watch a creator's other clips, click the "Like" button, write a thoughtful comment, subscribe to a channel so they don't miss the next video, maybe buy a shirt, maybe go to a fan meetup, and maybe start creating some videos of their own. "I don't care how many people watch or read something I make," John said. "I care how many people *love* what I make."

Understanding that engagement and realizing how powerful it could be for creators were huge turning points in my appreciation of YouTube. When I arrived at the company in 2011, one of the first things I wanted to do was help others understand that passion as well. I wanted to invest in creators such as Hank and John who had built strong followings on YouTube to help them expand and grow their presence, while also recruiting others who had passionate fan followings—Jay Z, Pharrell Williams, Tony Hawk, Madonna, Amy Poehler—to start their own channels. We called the effort "Original Channels," and it represented a massive $100 million bet that the platform could support a more professional kind of content than most people were used to seeing online.

Like many major efforts, it both succeeded and failed in unexpected ways. It got advertisers to take the platform more seriously, helping us bring in more revenue that we could reinvest in the platform. And it got viewers to see us differently, too, heightening the perception that YouTube was a place not just for viral videos but for organized channels with consistent content.

But many observers accurately pointed out that the celebrity-run channels failed to find their YouTube footholds. It was difficult to get fans of Jay Z or Madonna to follow their favorite stars online, despite their fame. Because the attention of those celebrities was naturally focused on other creative endeavors, their investment in YouTube felt more like a side project than something you had to visit every day or week. Running a successful YouTube channel takes sustained effort over time, with frequent updates and accessible creators. That's asking a lot of anyone, let alone some of the biggest celebrities in the world.

But what became clear from the Original Channels experiment is that the money we invested in creators and companies that had *already* built followings on YouTube was undeniably well spent. You may not have heard of online networks such as Maker Studios, Fremantle Media, and Studio Bagel, but after our initial investments in those companies, they went on to be acquired for hundreds of millions of dollars by major media conglomerates such as Disney and Canal+. Other targets of the Original Channels investments, AwesomenessTV, Tastemade, and Vice, have become major media properties in their own right, serving as leading voices in the world of family entertainment, food, and video journalism. And of course, the Original Channels initiative led to the creation of two massively popular educational channels hosted by John and Hank.

The idea for those channels arose after we approached the brothers with a simple question: "What would you make if you had more money?" The brothers had made some educational videos during their Brotherhood 2.0 experiment ("When you have to make a video every day for a year, you do everything that you can think of," Hank explained). Although those videos had been difficult to create because of the time and research involved, they had performed well on the *vlogbrothers* channel. Equipped with the resources to hire writers

and staff, the Green brothers agreed that new channels with educational content would be a natural extension of their nerd ethos.

They pitched two shows to us, one called *SciShow*, the other called *Crash Course*. *SciShow* was built around scientific inquiry, answering questions such as "Why do boomerangs come back?"* and "Why do we have freckles?"† *Crash Course* was the more ambitious of the two, designed to introduce an educational topic such as chemistry or world history to high school students at an advanced placement level, an entertaining video version of a textbook. We decided to fund both.

Today, *SciShow* produces videos every single day, hosted by Hank and two guest hosts, out of his production facility in Missoula, Montana. *Crash Course* is a joint collaboration between the brothers, with Hank teaching courses on the sciences (he has degrees in biochemistry and environmental science) and John teaching courses on the humanities.

John's videos are produced in his studio in Indianapolis, and visiting the set gives you a keen sense of just how lean the productions can be. Equipment-wise, they're able to film with nothing more than a camera that costs a few thousand dollars, a makeshift teleprompter run off an iPad, a couple of stand lights, and a semipermanent set. The crew consists of John, a videographer, a script supervisor, and a writer ("And even that sometimes feels crowded," John said).

There's no director calling "Action!" or cutting in between takes. Instead John reads the script rapid-fire as he controls the prompter with an iPhone he hides off screen. Though he is usually in a polo

* The two wings of a boomerang travel at different speeds as they rotate, generating torque that causes it to move along a curved path.

† An inactive MC1R gene in some people leads to the increased production of a pigment called pheomelanin, resulting in small areas of the skin with darker shades.

shirt and the setting is informal, he brings an intensity to the process, even if it's interspersed with levity. While filming a clip about soccer, I heard him restart a sentence eighteen times in twelve seconds before he finally got it right. It would be up to his videographer to select the worthy footage and cut away everything else. In the end, about forty-five minutes of filming yielded a clip of just under six minutes.

The two educational channels have grown larger than either they or YouTube could have hoped, with more than 10 million subscribers between them. *Crash Course* has been featured in the curriculums of high schools around the world, a godsend for many schools that can't afford up-to-date textbooks. *SciShow* has branched out with three new channels, one focused on space, another on psychology, and yet another version for young children (*Crash Course* also has a kids channel).

In 2013, the brothers began a channel for the magazine *Mental Floss*, providing listicles and quiz shows that John hosts and Hank produces. In 2014, John's wife, Sarah, got in on the fun, starting her own channel, *The Art Assignment*, which focuses on contemporary art and challenges viewers to re-create notable paintings and sculptures.

Every year, another venture or two seems to spin out of the Green machine, from a sex ed series (*Sexplanations*) to a fitness channel (*100 Days*) to a weekly podcast. All these channels are designed with community interaction in mind—*100 Days*, for instance, provided fans with lists of workouts and nutritional guidance so they could follow John along in his quest to have a healthy midlife crisis. And all of them are supported by the Nerdfighter community the brothers founded over ten years ago.

———

Through the years, several members of that community have become notable, none more so than Esther Earl. At a young age, Esther developed thyroid cancer, making her dependent on an oxygen tank. As a young girl suffering from a life-threatening illness, as well as dealing with a burdensome and evident symptom of it, she found solace among a Nerdfighter community that embraced bright, curious people who didn't fit easily into their surroundings.

As an active part of that community, Esther helped shape its attitudes about disabilities and illness, while benefiting from the warmth and support its members lent her. After striking up an online friendship, John met Esther for the first time at a conference in Boston in 2009 and later visited her and her parents. Their friendship became so prominent and meaningful to the Nerdfighter community that on August 3, 2010, Esther's sixteenth birthday, John declared the day "Esther Day," devoted to expressing love for family members and friends, rather than romantic interests. Sadly, Esther would succumb to her illness three weeks after that video was made, but the day is still recognized by the community every year.

John's friendship with Esther would serve as the foundation for the character Hazel in his fourth novel, *The Fault in Our Stars*, a love story about two teens living with cancer. The book came out in 2012, less than two years after Esther's death and only a year after the launch of *Crash Course* and *SciShow*. But even before it was released, it shot to the top of both Amazon and Barnes & Noble's bestseller lists shortly after John announced the title, in part because John read the first two chapters to his YouTube audience.* Upon its release, the book topped the *New York Times'* best-seller list for young adult fiction, where it remains to this day, along with all four

* He also committed to signing the first printing of 150,000 copies, a three-month full-time misadventure that left his writing hand debilitated and in need of physical therapy.

of his other novels. Within one week, it had sold more copies than John's three other novels combined.

The book has become, by any measure, a stratospheric success, selling more than 20 million copies worldwide, more than *Pride and Prejudice* or *The Grapes of Wrath*. In 2014, the book was adapted into a film starring Shailene Woodley and Ansel Elgort. Although it was released in a crowded field that summer, it debuted at the top of the US box office, beating out Tom Cruise's blockbuster *Edge of Tomorrow*. The film cleared more than $300 million during its box-office run, while also garnering stellar reviews, perhaps because it was a merciless tearjerker. When I watched it with my two daughters, we all cried. But I cried the loudest.

After the success of the film, John executive-produced an adaptation of his third novel, *Paper Towns*, an experience that could have easily led him to a career making films, rather than videos. But when I asked John about that possible future, he was quickly dismissive. "If anything, Hollywood has made me like YouTube more," he said. "The success of *Crash Course* makes me happier than the success of anything else in my professional life.

"Don't get me wrong, I love movies and I love the scope and scale of film and a lot of what movie studios do with the impossible. The movie adaptations of my books are very good, and I really like them and they were both commercially successful. But then I came home and went back to making *Crash Course* and *The Art Assignment* because that's what I want to do with my life. I want to write books and make YouTube videos. I don't want to be a movie producer when I grow up."

———

Three days after meeting Hank in his hotel room, I take a seat on the side of the main floor of the Anaheim Convention Center to

watch him and John host the annual in-person gathering of Nerd-fighters. They sit together onstage, running through a string of questions their fans have submitted ("What's your guilty YouTube pleasure?" "Would you rather wake up in a bed of mousetraps or wake up naked in a Starbucks?"). Hank is freshly shaven and clean cut, wearing a Hawaiian shirt, while John sports a couple of weeks' worth of stubble and an AFC Wimbledon T-shirt, the League One English soccer team that he sponsors.

If you ever hit the halls at VidCon, the first thing you'll notice is that it's incredibly loud, with shrieks echoing through the cavernous convention center as fans spot and then literally chase their favorite creators through the halls. But the Nerdfighter gathering, held on the convention floor, feels like an oasis by comparison, with hundreds of young people sitting mostly still in their seats just to hear from John and Hank. As I look around the gathering, I realize that it's not just an oasis for me but an oasis for them as well. I see girls wearing cat ears or dressed like tomboys and boys wearing eyeliner or furry hats in the shape of bear heads. A teenage girl sitting in my row squeezes a copy of *The Fault in Our Stars* in her hands, channeling the nervous excitement she must be feeling. While Hank talks about the time he visited the White House to interview President Obama, a boy in a blond wig and fairy wings walks by.

If you hear anything about teens and online culture, you likely hear about the dark side. You hear about harassment and cyber-bullying and phone hacks and doxxing and trolls. But there is also this side of it: gatherings, sometimes real but mostly virtual, that provide acceptance and understanding to people who are largely socialized to be ashamed of their differences.

Deep down, all of us have a desire to feel that we belong somewhere, that we live in a world where our opinions are shared and

our experiences are relevant and our feelings matter. The truth is, we do live in that world; it's just obscured by distance and conflict.

At its best, YouTube can reveal that world. It can show you the breadth of humanity that you may not see outside your window every day. It can connect you to others who look, think, or love like you, who've struggled through the same issues you have, or who are grappling with the same forces, even if you can't find those people in your own school or neighborhood. YouTube can help you understand that it's okay to unabashedly love something, that intellectualism is worth celebrating, that an illness doesn't have to be a defining characteristic, or that even someone who dies young can live a full life whose impact can stretch on endlessly.

As the questions wrap up, John and Hank stand to deliver a closing statement. "When I was a kid," Hank says, "I remember I spent a good deal of time making friends online. And it took me a while to realize that wasn't me being a loser. That was me making friends with people who shared my interests and values." He and John offer a heartfelt thanks to their fans, and as they wave good-bye to the audience, the crowd rises to its feet and begins to rush the stage. The oasis disappears.

———

After the gathering, I hitch a ride through the convention center on Hank's golf cart, which quickly ferries us to another giant stage, the one Hank confessed he wanted no part of stepping out on just a few days ago. In a few short minutes, he'll do it anyway, announcing to thousands of people the formation and official kickoff of the Internet Creators Guild. His shyness is gone now, and he seems at peace, hugging the creators he sees in the greenroom while casually

taking a chair and watching an onstage feed from a nearby monitor so he can hear all the presentations that precede his.

All of a sudden, his assistant comes up and whispers something into his ear. He turns to me to explain. "You'll love this," he says. "The site's down." Minutes before it's supposed to be unveiled, a bug in the code for the Guild's website is preventing it from loading.

Still, Hank is cool about it all. It occurs to me that perhaps he knows his idea is much bigger than today's launch. Back in the hotel room, he explained his vision for the Guild. "Right now, if you think about all these creators as part of one company, it'd be the fastest-growing company in Silicon Valley," he says. "But to be a big industry, that's like two to four hundred thousand people doing this professionally. And that's where I would like us to be." Hank doesn't want to start a union or an interest group; he wants to lay the groundwork for the entire future of the creative Internet.

Almost by definition, a creative partnership between brothers can invite comparison and suggest rivalry. There is no question that John is more successful and famous than his brother; he may be the most successful YouTuber, *period.* But in hearing the way John spoke to me about Hank—about looking up to him even though he is his younger brother, about how Hank continually saw the promise of things like VidCon even when John could not, about his relentless perseverance and his ability to found movements—I couldn't help but think that Hank's legacy of legitimizing Internet creation may end up being as rich and meaningful and lasting as his brother's.

Time passes quietly backstage, but mere seconds before he's due to speak, Hank's team fixes the bug and the Guild's website goes live, ready for him to announce and accept the first sign-ups. The timing feels almost *too* fortunate. It feels like the start of something.

4

True Blue Hair

Tyler Oakley, Authenticity, and the Changing
Nature of Celebrity

IT'S CLEAR TO me that the ability to build a passionate community might be *the* consummate skill of the new media age. Hank and John Green started with a group of people who felt misunderstood, gave them an ethos to believe in, and created a steady stream of entertaining content that spoke directly to them.

But none of that would have worked if the content hadn't felt authentic—both to the personalities of John and Hank and to the interests of their audience. *Authenticity* is a term that is thrown around a lot in new media, but in a world in which anyone can curate how they are seen on social media, the importance of appearing genuine and accessible has only grown. And few creators convey that better than Tyler Oakley.

Streampunks

"Does anyone in the room make videos?" asks Tyler, a YouTuber/activist and one of *Time* magazine's most influential people "on the Internet." It's an early-fall evening at Virginia Commonwealth University, and Tyler and his close friend and collaborator Korey Kuhl are answering questions submitted by an audience of three hundred students. They've gathered here tonight for "An Evening with Tyler Oakley," put on by VCU's Activities Programming Board, whose logo is being projected behind a small, unadorned stage where Tyler and Korey are sitting. Korey leans back in his chair, while Tyler is perched cross-legged in his. The pair are ostensibly here to promote Tyler's book, *Binge*, but the laid-back nature of the event and the fact that the book has already been a best seller for nearly a year suggest that they're more interested in interacting with the audience than selling to them.

About ten of the students raise their hands in response to Tyler's question about making YouTube videos. He scans the audience and then quickly follows up with another question: "Does anybody want to *start* making YouTube videos?" More hands go up this time, about thirty in all. "If you want to, it's easy!" he says. "All you have to do is make your first video—Bam! You're a YouTuber."

Having made his chosen career sound so simple, he offers a bit of a warning. "I will say, your first video will be the worst thing you ever see in your life. You will hate your voice and your face and everything you do. I look back at mine and think"—his voice drops into a self-deprecating tone—"*so that's the human I am.*"

The audience laughs at his honesty, and he continues dispensing advice for aspiring YouTube creators with a quick, stream-of-consciousness cadence. "As you make videos, you get better at it and you find your voice and you figure out how you talk and you figure out how you edit and you figure out how to set up a camera without a stack of books, which I *still* do sometimes."

But he finishes with the best part: "You don't have to get any fancier!" he says. "You just have to get better at being you."

———

For ten years and counting, Tyler Oakley has been getting better at being Tyler Oakley. He first became a YouTuber in 2007 with dispatches from his dorm room at Michigan State University. He may cringe at those videos now, shot on a low-quality webcam in his dorm room with his bunk bed visible behind him, but even his earliest videos reflect craftsmanship. They're edited, they're soundtracked, they combine monologue with voiceless reaction shots and facial expressions. He seems every bit the drama kid he was in high school, unafraid to act out and be seen by others.

A few weeks before the VCU event, I met Tyler at a coffee shop near his home in West Hollywood, where he explained the long journey between those early videos and the massive online presence he commands today. He told me he hadn't started his own channel looking to build a career. Instead, he'd been looking for a way to keep in touch with his high school friends. "I was talking directly to literally three people," he said. "I wanted to tell them specific things, show them around my dorm room, tell them about Welcome Week, things like that. Back then, it was just mind-boggling that anybody would subscribe that didn't know me."

You might mistake dorm-room Tyler, with close-cropped blond hair and generic metal-rimmed glasses, for fifty other college freshmen. But today Tyler is instantly recognizable, with thick black-framed glasses and a shock of usually blond (but occasionally blue) hair. At five feet, five inches, he seems shorter than he appears in his videos, but I've come to learn that, like movie stars, YouTube creators are almost never the height you expect them to be.

"Over the course of a few years," he said, "I kept making content, slowly becoming more conscious that an audience was watching, not necessarily treating it with a sense of responsibility. It never crossed my mind that it could become my full-time job." In fact, the videos landed him a job even back in college, making videos for the Career Services Network. The first time he was ever recognized was on campus, by students who had seen his videos about how to build a résumé and prepare for an interview.

At the same time as he was making his own videos, he was following other YouTubers, learning about the communities that were forming around their channels. He began collaborating with other creators, including Korey, who was his resident adviser at Michigan State. In time, the two began attending the early YouTube conventions and made friends with other rising creators.

After graduating into a weak economy in 2011, Tyler applied for a number of jobs (including one at Google that led to several rounds of interviews) but had little luck. Employers told him that his YouTube career was a liability. "They were just kind of, like, 'If you were working with partners, they might find you and this might misrepresent our brand," he said. "It was before companies could expect their employers would all have Twitter."

After struggling to find work in Michigan, he and Korey moved to San Francisco and Tyler began applying to every Craigslist job listing he could find. After landing an internship, he eventually got a full-time job managing social media for a few companies in the Bay Area. It would seem to have been a good fit, but he bristled at the job's constraints considering he knew how to successfully build a social media profile.

"I felt I was jumping through so many hoops to get tweets approved—like, I know what I'm doing," he told me. "And then I would come home and do that for myself and I was finding so much

success with something I was enjoying and in charge of." Eventually the frustration became too much and he decided to take the leap to become a full-time YouTuber. He remembers thinking, "Imagine if I took all the time that I'm dedicating to this full-time job and just dumped it into my YouTube career. I feel like it could take off."

His first year as a full-time creator was consuming, he said, feeling not just like a job but like a pursuit that occupied every hour of his time. I asked him if that meant he was spending more time editing footage or producing higher-quality videos or collaborating with other stars. "It's all of that," he said, "but it's also fostering the creative, because it's not just uploading the video and throwing it against the wall and hoping it sticks. It's replying to comments, it's promoting the video, it's making the thumbnails,* it's replying to tweets, it's interacting with the Tumblr community and the Facebook community and figuring out the language that exists in each of those different communities and what works where, and it's completely different, each platform."

The effort that Tyler describes is often lost in conversations about creators who have found success on YouTube. The explosive speed of viral videos and social phenomena can lead people to believe that YouTubers are merely overnight successes, undeserving people who have managed to capture lightning in a bottle. And although we certainly have seen stars rise rapidly, the vast majority of those who have built careers on YouTube have done so over years of sustained effort.

In fact, videos that catch fire can often be limiting for creators, the same way that catchy songs can turn hardworking bands into one-hit wonders. "I've never had a viral video in my life," Tyler told me. "And I thank God I've never had a viral video, because if people

* The image that precedes the video before someone plays it.

49

are subscribing, they're subscribing for that little bit of content. They weren't there for the journey. So when you do something different—which anybody would want to do—there's a disconnect. I would much rather gain ten subscribers every video than ten thousand subscribers in one video."

When I reflect on Tyler's success, it's this willingness to slowly build personal connections over time that I think underlies much of his story as a creator. He operates less like a celebrity who seeks to maximize exposure and more like a retail politician who wants to earn his following even if it requires more work. Even if it means understanding and mastering the dialects of Facebook, Twitter, Snapchat, and Tumblr. Even if it means flying across the country to meet three hundred undergrads on a Thursday night. Even if it means sharing deeply personal parts of himself with his fans.

"I've always made YouTube videos from the start as a diary that people have a key to," Tyler told me. "And I've learned this more and more, even up until this year: the more I'm honest, the more people are invested and feel a deeper connection."

———

Honesty in entertainment; there's an interesting tension in that idea. For decades, the prevailing forms of popular entertainment were all about suspending disbelief. Actors act, after all, in comedies and dramas, in the fantastic realms of *Game of Thrones* and the futuristic galaxies of *Star Wars*. The long-held belief was that what we sought from TV and film was escapism, not authenticity. To this day, the highest-grossing film of all time (after accounting for inflation) is *Gone With the Wind*, a fact historians attribute to its release during the Great Depression, when it provided a distraction to millions of Americans who had fallen on hard times. In turning their attention

to an even more tumultuous past, *Gone With the Wind* gave people a way to forget about the present.

Then, around the turn of the century, we began to see the beginnings of a new kind of entertainment. The dawn of TV shows such as *Big Brother* and *Survivor* seemed to suggest that people were hungry for something a bit more "real" that reminded them of their own lives. Audiences loved seeing everyday people thrust into situations ranging from fraught competitions to high-stakes talent shows. They even tuned in to fly-on-the-wall documentaries that depicted life in seemingly mundane jobs, such as the BBC series *Airport* and *The Hotel*.

Networks were quick to embrace the trend, realizing that they could generate fantastic ratings for much less money than they spent on sixty-minute dramas and thirty-minute sitcoms. As reality TV evolved to offer more compelling shows such as *American Idol* and *Deadliest Catch*, the genre became so popular that its techniques and aesthetic began to creep into scripted series such as *The Office* and *Modern Family*.

Yet the reality was quickly drained from reality television. Today it's become largely formulaic and overproduced, with perfectly timed cliff-hanger commercial breaks and music designed to ratchet up the tension of every rose ceremony and quickfire challenge. There are still moments of genuine surprise and humanity, as when an amateur such as Susan Boyle demonstrates that she has a truly hidden talent.* But for the most part, reality TV has succumbed to a network's desire for controlled, reproducible success, sacrificing its spontaneity in the process. This doesn't mean that reality TV will fade in popularity—above all things, it's cheap and can still be damn entertaining even if it feels

* No surprise, these are the clips that tend to go viral on YouTube.

manufactured—but I don't think it can be considered as honest or as refreshing as when it debuted.

What does remain real about reality TV is the desire that viewers have to see something a little less polished, starring people who feel a little more like themselves, dealing with issues that feel a little more relatable.

In fact, it was that exact desire that led Google to acquire YouTube in the first place.

Prior to Google's acquisition of YouTube, some might remember that the search company had its own video effort under way, called Google Video. The head of Google Video was Susan Wojcicki, YouTube's current CEO (and my boss), and initially her focus was on signing deals with Hollywood studios in order to offer films and TV shows online. At the time, this was relatively uncharted territory, several years before I would work on similar deals to launch Netflix's streaming service, and the negotiations proved difficult. So alongside the effort to get commercial content, Google Video allowed users to upload their own video content. A *New York Times* review of the service called it "Trash mixed with treasure."

But it turned out that the amateur "trash" was doing much better than the professional content Google had managed to license. The first video to hit 1 million views on Google Video featured two Chinese college students, both wearing Yao Ming Houston Rockets jerseys, enthusiastically lip-synching the Backstreet Boys' "I Want It That Way" from their dorm at the Guangzhou Academy of Fine Arts* while their roommate plays computer games in the background. That was what people wanted to watch online, not TV shows.

* The "Back Dorm Boys" would soon be signed to a five-year contract with the Beijing-based Taihe Rye Music talent management company and become spokespeople for Motorola.

Those early hits convinced Susan and the rest of the leadership team at Google that explosive growth in online video likely would come not from Hollywood but from content created by users. And despite Google Video's efforts, YouTube was growing at a much faster rate. In 2006, Google acquired YouTube for $1.65 billion in stock. At the time, it was the largest acquisition Google had ever made.

The insight that Susan had was that amateur content not only could stand up to professional content but in some cases could outperform it. Early viral hits such as "Charlie Bit My Finger" and "David After Dentist" confirmed this, showcasing recognizably human—if unexpected and hilarious—moments occurring in the lives of everyday people. Tyler Oakley and most other YouTube vloggers have taken this idea further, throwing their entire lives into full view, allowing them to have deeper and more meaningful conversations with their fans.

For Tyler, that meant the early unflattering videos in his dorm room. It meant discussing body image issues and later revealing his struggles with an eating disorder. It meant writing about drug use and an abusive relationship in his book, *Binge*. But most notably for him, it meant addressing his sexuality openly, in 2007, when it was still a rarity in American culture.

"As far as authenticity goes, a big part of my identity is my sexuality and being gay," he told me. "I have always been gay on YouTube. I've never made a coming-out video; I don't think I've ever had to. I think that's been a huge part of my success, not just being revealing about that but treating it as though there's nothing to hide."

Tyler came out officially while he was still in middle school, four years before he made his first YouTube video, "so I had a huge head start on accepting myself and being comfortable with myself," he told me. He was able to navigate high school with support from other openly gay students and teachers. That isn't to say that

coming out was easy for him; his biological father initially wasn't accepting of his identity and even suggested conversion therapy.* But by the time he started vlogging, being gay was such a normal part of his life that, he says, "It didn't feel like a descriptor of me."

But one thing Tyler does note about his early understanding of his identity was a lack of gay role models. "I sometimes get asked in interviews, 'What gay icons did you look up to?' or 'Who did you identify with?' I literally can't think of anyone. I remember Ellen or *Will & Grace*, but there wasn't anybody that I saw myself in. The It Gets Better Project didn't exist, and I was figuring out who I was and googling things and trying to relate to people."

He went on to talk about that lack of representation in mainstream media in an interview with *New York* magazine, detailing how social media was giving underrepresented groups more control over how they're depicted. "Traditional media hasn't really been a great place for disenfranchised voices to tell their own stories. . . . Even with how much that has changed from then to now, often those characters are still being written by people that aren't actually representative of those groups. But now marginalized people can speak for themselves on these platforms, and the audience is choosing the people instead of the people being presented to the audience."

According to Tyler, that change has resulted in a massive cultural difference in society. "Now you can go on YouTube and search for a coming-out story and find tens of thousands of results," he told me. "You can find people that voice how you feel. I think, thanks to

* A moving scene in Tyler's tour documentary, *Snervous*, shows him confronting his father about those early days, though they've now reconciled. He told *New York* magazine that it was important to include that scene to show that acceptance can grow with time. "If there are kids watching it and they're, like, 'My dad hates me or doesn't get who I am,' I don't want them to think that's the end of the sentence."

YouTube, the acceptance of being gay has been accelerated in ways that are unfathomable. The progress that's been made is getting quicker and quicker and quicker, and I truly one hundred percent believe that's because of YouTube and the Internet. I think it's because people are being real."

———

We talk about this idea often at YouTube—whether we're playing a role in broadening society's horizons and increasing the acceptance of the LGBTQ community by connecting people to diverse voices. Of course, it's difficult to attribute causation to social progress, and we've all witnessed how movements for tolerance can face setbacks as they strive forward. But it is a point of pride at our company that LGBTQ creators provide solace to those who feel that they must hide who they really are.

That said, the belief that your tech company is "changing the world" is an alluring cliché, so I asked Tyler whether he thought it was really true that YouTube has accelerated the acceptance of people with different lifestyles and values. He answered without reservation. "I've experienced it firsthand," he said. "I feel like I've grown, because of the Internet, more tolerant, more accepting, more knowledgeable of other cultures. I feel like I've learned about my own privileges because of the Internet. I feel like the world is a lot more accessible—the world is not intimidating—because I've seen it on YouTube."

That has led Tyler to use his own success to make the world less intimidating. He has become a public advocate for the Trevor Project, the leading national organization for crisis and suicide prevention for at-risk gay youth. Every year on his birthday, Tyler devotes his channel to raising awareness and funds for the nonprofit;

to date, he's helped it raise more than $1 million in donations from his fans. When I asked him how his involvement with the Trevor Project had begun, I assumed the answer was that he had wanted to use his fame to aid a worthy cause. In fact, the story was much more affecting.

"There was a moment on YouTube when I was back in college," he said, "where I got a message from a kid that said instead of killing himself, he watched my videos. And I was just like—How do I even respond to that? How do I even comprehend that? I still can't comprehend that.

"Before that, it never felt like I had a social responsibility; or maybe I just wasn't conscious of the impact that somebody can have on the Internet by being openly honest and unapologetic about who they are in a way that resists what mainstream society wants you to be. But when I got a message like that, I guess it just opened my eyes."

Tyler was inspired to find a specific nonprofit to support by, of all things, John and Hank Green's Project for Awesome, which asks fans to submit videos about the charity or nonprofit they believe deserves their support. He found the Trevor Project by googling "gay nonprofit" and researching the various results. "I just thought, okay, that kid was brave enough to tell me. There's got to be others that are thinking it but won't say anything, for whatever reason."

I heard him relay the origins of his advocacy at VCU. "For a long, long time I thought, I'm just doing this for fun," he told the audience. "I have no social obligation whatsoever. I never signed up to be a good influence or some kind of role model. I roll my eyes at the concept," he said as he flicked his hand in the air, batting back the idea.

"But I'm a part of a community that has an opportunity to represent something that maybe mainstream media doesn't represent and to give somebody an outlet to feel recognized or valid. There's a

unique opportunity on YouTube for you to connect with people that you would never have been able to connect with before. Recognizing all that and trying to do my best is a challenge. But it's a good challenge. And I'm thankful that I'd had that turning point and recognized that, because there are so many YouTubers that are ten times better than me and should have ten times more subscribers than me but don't for a lot of reasons that are systematic in our own society."

After making his first video supporting the Trevor Project, Tyler expected an appreciative but muted response. "But it did crazy well," he said. "I just remember realizing people connected with it. And I thought, Okay, well, maybe that got fifty thousand views; that's fifty thousand more people that know that resource is available. And maybe one percent of them will ever get to the point where they need to use that resource. But what's one percent of fifty thousand? That's game-changing. That's lifesaving. That's life-affirming."

———

Of course, Tyler isn't alone as either a gay YouTuber or one who advocates for the broader acceptance of the LGBTQ community. One of the first successful efforts to raise awareness about the high rates of teen suicide among LGBTQ youth was Dan Savage's It Gets Better Project, which encouraged people to film videos to provide hope to bullied teens. Celebrities such as Ellen DeGeneres and Neil Patrick Harris, as well as politicians such as President Barack Obama and former UK prime minister David Cameron, have posted videos to YouTube, all of which have millions of views.

Since then, the young Australian creator and singer Troye Sivan and the beauty guru Ingrid Nilsen are just two of many who have filmed powerful and touching coming-out videos and used their

fame to advance the understanding of gay rights. The fashion vlogger and model Gigi Gorgeous, one of the most popular YouTubers in Canada, documented her transition from male to female on her channel years before Caitlyn Jenner and Laverne Cox became household names.

Those creators join hundreds more who've used their channels to advocate for social causes. Bethany Mota, a massively popular beauty creator, started her channel at the age of thirteen as a distraction from the cyberbullying she experienced as a teen. She has since become a leading voice in the antibullying movement. While appearing as a contestant on the show *Dancing with the Stars*, she staged a performance that evoked her early struggles, dancing with her partner while words such as *nerd*, *freak*, and *loser* appeared on a screen behind her, eventually transforming into the words *brave*, *inspirational*, and *I love who I am*.

Nilam Farooq, one of the most popular creators in Germany, has lent her voice to numerous causes. She's been an advocate for gender equality and helped lead a mentoring effort to encourage more women and girls to find success as video creators. At a time when many people were demonizing Syrian refugees attempting to find asylum in Europe, she devoted several videos to the crisis in an effort to put a human face on the tragedy. Recently she helped launch the lifestyle video channel *Ellevant Media*, focused on issues ranging from the industrialization of food to political turmoil in Turkey, sort of a socially conscious version of Gwyneth Paltrow's Goop.

"Nobody is required to use their platform for a cause," Tyler told me. "But I think it's a missed opportunity if you don't recognize that you can change the world whether you have one subscriber or a million, by sharing what's important to you. You are not going to remember how many views you got on whatever Q and A you did.

But you will remember the messages you get [from at-risk teens] or the wells you helped build."

———

To me, Tyler is a pioneer of a new kind of fame, one where your personality, your preferences, your beliefs, your values, even your politics are on full display. Before the explosion of social media, being a celebrity meant being detached from mainstream society, floating above it in a sphere of unattainable fame. In Hollywood's earlier era, stars such as Greta Garbo and Marlon Brando were famous for being recluses, while later celebrities such as Michelle Pfeiffer, Sean Penn, and Johnny Depp have been notoriously camera-shy in a tabloid-obsessed era. Denying people access to your personal life or opinions was one of the principles of fame—it fuels gossip and keeps people intrigued.*

Today, even Kanye West has made peace with the paparazzi. A new social compact has emerged between celebrities and their fans, one where those seen as the most accessible, most open, and most authentic are elevated above those who try to keep their personal and professional lives separate. The priority for celebrities these days isn't to be worshipped, like Michael Jackson or Madonna, or even admired from afar, like Audrey Hepburn or James Dean; it's to seem like your down-to-earth (yet stunning) friend, like Jennifer Lawrence or Chris Pratt.

The power that publicists used to have over a celebrity's image is now rivaled by Instagram, Twitter, and Snapchat, which hold out the

* In the HBO series *The Young Pope*, the titular character explains his desire to remain hidden from the public, citing Stanley Kubrick, J. D. Salinger, and Daft Punk as inspirational figures who exert more influence through mystery than through exposure.

promise of a direct link to the stars. In some cases, these accounts are just another way for celebrities to earn money from their fame, using high-profile product placements to trade access for profit. But in most cases, these social media channels add a complex layer of responsibility to fame. It's not enough to actively tweet about your new project or some product you fell in love with; fans expect you to reflect on what's happening in the world as well.

Perhaps nowhere is this truer than in the world of sports. When I grew up in the Eastern Bloc during the Cold War, sports and politics seemed invariably linked, from Muhammad Ali's conscientious objection to the Vietnam War to the boycott of the Olympic Games in 1980 and 1984 by the United States and the USSR, respectively. But in the 1980s and '90s, there seemed to be a new paradigm emerging, characterized by a quote attributed to Michael Jordan: "Republicans buy sneakers, too." In other words, it was more profitable for athletes to avoid politics entirely.

That era seems to be over. Today, athletes from nearly every sport are using their voices to shine a spotlight on issues such as police brutality and mass incarceration. LeBron James, the most famous current basketball player, has campaigned actively for Democrats and stood onstage at the ESPY Awards, urging all professional athletes to use their influence to "renounce all violence." Colin Kaepernick's decision to kneel during the national anthem rattled NFL fans and aroused the passion of critics but also undoubtedly raised awareness of several incidents of police violence that occurred throughout 2016.*

* Jordan himself recently waded into the national conversation about race, criticizing both violence directed at African Americans by law enforcement officers and the targeted killings of police, donating $1 million each to the International Association of Chiefs of Police's Institute for Community-Police Relations and the NAACP Legal Defense Fund.

Past debates about whether athletes should serve as role models or whether celebrities should weigh in on politics are simply no longer relevant. Today the spotlight carries with it obligations and expectations that extend far beyond performance on the field or talent on the screen. And stars who are willing to share more of their opinions with their fans have an opportunity to build more authentic and enduring followings.

I'm not suggesting that celebrities should endorse a cause because it's good for their career. I am suggesting that no one should stay silent because he or she thinks it will be *bad* for his or her career. The number of people turned off by your beliefs will almost surely be outnumbered by those who respect your honesty and outweighed by the goodwill and trust you will earn among your fans.

I say that because I see it time and again on YouTube, a platform where success is often defined by appealing to as many people as possible. In that climate, you might think that exposing more of your personal beliefs would be a liability. But our most popular stars openly and honestly express their opinions, a behavior that's reflected by their fans. According to a survey we conducted, teen and Millennial subscribers are more willing to share posts about their politics or personal beliefs than they are about their personal relationships.

This embrace of openness by both fans and creators has led to a stronger link between them than the traditional teenage fan club. Sixty percent of those same subscribers tell us that the community they form with other fans of their favorite YouTubers is stronger than those they form around traditional celebrities from TV, music, or film. And earlier in the book I mentioned that the same percentage tell us that a YouTube creator has changed his or her life or view of the world. It's frankly a little difficult to imagine the same group saying the same thing about talented actors like Bradley Cooper or Brie

Larson (even though I'm a huge fan of both). The relationship they have with those stars is just fundamentally different.

When I asked Tyler about this, he explained that even the format of vlogging encourages connection. "YouTube is so intimate because it's a YouTuber talking directly into the eyes of the viewer," he said. "It's physically so close to the screen, it feels like you're with your friend."

But I believe that intimacy goes even deeper. When you first encounter actors, you're likely encountering them performing a role. Their success depends on your believing their portrayal of someone they are not. With YouTubers, it's the opposite: their success depends on your knowing and liking who they actually are. That doesn't just lead to a situation that's more intimate; it's the definition of how intimacy is built.

———

Back at VCU, Tyler's Q&A has turned into a bit of an advice-giving session, one he handles with a wisdom that defies his young age.

What advice do you have for someone graduating from college and entering the real world?

It's okay to not know what you're doing. Enjoy the time you have left here, you won't get it back.

What advice would you give to someone coming out of the closet, other than it gets better?

Take your time, there's no rush. It's important to recognize not everyone has the resources to be able to come out. Not everyone has

protection or security or the support system. Knowing when it's right for you is half the battle of being okay with doing it in the first place. There are plenty of people who are going to be happy and hug you when you're ready.

Then, finally, a question submitted by five different attendees:

What advice do you have for someone who wants to start a YouTube channel?

I would say, offer to YouTube what only you can offer. That's going to be the reason that people subscribe. If you're doing what someone else already does, you'll be a second-rate version of that.

5

No Passport Necessary

Lilly Singh, Mr. Bean, K-Pop, and the Global
Media Melting Pot

IT TURNS OUT that, yes, even ||Superwoman|| gets tired. It's around 3 p.m. on a bright Los Angeles afternoon, but Lilly Singh, the Indian Canadian Renaissance woman, has been awake only a few hours. With little time for vanity, she sits on a couch in her spare LA apartment in sweats. "I'm refreshed mentally," she says. "I just might not look it." She was up through the night until 8 a.m., working on the last few chapters of her book, a motivational guide with a Millennial edge called *How to Be a Bawse*.

She didn't want to pull all-nighters. She says she wanted to finish the book in one two-month stretch. "But then a White House opportunity came up" (filming a video with Michelle Obama in support of higher education) "and then Brazil came up" (to attend the Rio

Olympics as part of a brand deal with Coke) "and then Kenya came up" (as part of a campaign to expand access to education for girls living in poverty) "so it definitely got a bit chaotic towards the deadline. Where did the time go?"

Despite Lilly's current situation, time seems to be on her side. In what feels like the blink of an eye, she's gone from an emerging voice on YouTube to an ascendant one, with over 11.5 million subscribers. Our public relations team at YouTube told me that in less than a year they had gone from having to explain to magazine reporters and media bloggers who Lilly was to fielding dozens of interview requests for her every week. As her popularity has grown, she's cemented herself as an inspirational speaker, sketch comedian, singer, actress, activist,* and regular on *The Tonight Show*. Jimmy Fallon even filmed a sketch in which he meets her parents.

Well, not her actual parents, but that's kind of the point. Lilly's longest-running and most popular bit involves impersonating fictional, comedic versions of her parents. Lilly plays both roles herself, dressing up in colorful saris to portray her "mother," Paramjeet, and donning a wig and fake stubble and chest hair to portray Manjeet, her "father." Both characters have their own Twitter accounts, each with more than 150,000 followers. They are just one of the many, many characters and roles Lilly has taken on since founding her channel, with author being only the newest.

Although she was still drafting it when I met with her, Lilly's book already had a website up and running. At the top sits a striking image of Lilly, her long, dark, satiny hair blown to the side, her eyebrows arched above kohl-rimmed eyes, both her lips and her blazer a striking shade of YouTube red. But just below the photo

* She recently filmed a video with Bill Gates to promote his foundation's Global Health work.

is something even more telling. As on most book websites, there's a link to an Amazon.com preorder page. But there are also links to Amazon.ca, Amazon.in, and Amazon.au. There are links for the Australian e-commerce site Booktopia, the New Zealand book outlet Mighty Ape, and the Indian e-commerce site Flipkart. If there's one thing Lilly Singh knows, it's her audience. And that audience is global.

———

Like many established creators, Lilly first turned to making videos as a way to distract herself from emotional turmoil. But in her case, it wasn't bullying or anxiety that ailed her, but depression. She was finishing her last year of study at York University in Toronto, where she was pursuing a degree in psychology, just as her older sister had done. "Solely, that was the reason," she said. "I didn't really have a great interest in psych; I was going through the motions." As graduation neared, she became depressed at the thought of living out someone else's path. "I used to be so creative as a kid," she thought at the time. "Why am I getting a degree just because my sister did and doing what my parents want me to do and being unhappy as a result?"

During a particularly rough stretch, she came upon a YouTube video by JennaMarbles, a comedian and for years the most popular female creator on the platform. "I was just so baffled by the fact someone was creating something in their room," Lilly said, "and that random people they didn't know were watching." It was one thing to connect with friends and family on social media, but in 2010, the idea of creating content online for complete strangers still felt odd.

Then one day, while sitting in her parents' basement, she decided to upload a video about her thoughts on religion. The video

has since been taken down,* but she recalls the process of making it as uniquely uplifting. "After so long, I felt like, 'Wow, I'm doing something that's really exciting and challenging,' and I was not sad for that period of a few hours," she said. After that, she made a second video and then a third, as a way of distracting herself and "self-medicating."

As her videos slowly began to find an audience, she came to a crossroads in her life. "I was applying for my master's because my parents wanted me to," she said. "I remember filling out the application and just stopping halfway because I thought, I do not want to do this for the next few years. I want to try and do this You-Tube thing. At that point, some people knew me, but nowhere near enough to make the decision not to go to school."

She gathered up the courage to tell her parents that she was unhappy and wanted to be an entertainer instead. "Growing up, I wanted to be a rapper and I wanted to be an actor, and then I went to school and convinced myself none of that could happen," she said. "For me, YouTube was that reigniting spark." Her parents made a deal with her: she could have a year to pursue an online career, but if things didn't take off, she'd have to go to grad school.

For the next year, she put everything she had into her burgeoning YouTube career, studying the success of other creators, meeting with them, and creating as much content as she could. She studied editing and invested in a better camera. And as she built her channel, slowly her depression began to lift. When I asked her what about the creative process she enjoyed, she initially mentioned the process of setting goals for viewership and subscribers and meeting them. But she also found comfort in the comments from people

* "Not because it's bad," she told me. "It's *very* bad; but because it just doesn't reflect who I am anymore."

telling her they could relate to her videos. "Complete strangers were listening to stories about my life and saying 'Oh, my God, my parents are just like this' or 'I'm going through the exact same thing.' Anyone that's been through depression knows that you just feel really alone. And so, for me, to not feel like I was alone because people I didn't even know were relating to my content—it was just really comforting."

Usually creators might say they've found success once they hit a milestone, such as a million subscribers. "I hit a million—I might have even hit two million—but still I thought it was totally a fluke," Lilly said. Instead, it was her first trip to India after starting her YouTube career that changed her understanding of her influence. On that trip, for which she had proactively planned a few meetups and tour stops, she was flooded with media requests. "They wanted me to do countless interviews and TV appearances, and this is early in my career. That was validating not only for me but for my parents. To see their home country receive me so well—it was, like, 'Oh, our daughter's doing something pretty cool. We understand this now.'"

Beyond the media attention, though, was something even more unexpected: two of her favorite Bollywood idols reached out to her. Madhuri Dixit, a Bollywood icon and star of *Devdas*, one of *Time* magazine's 10 Greatest Movies of the Millennium,* filmed a video with her titled "What Bollywood Has Taught Me." The video has been viewed more than 5 million times, with more views coming from India than the United States.

And Shah Rukh Khan, the "King of Bollywood," invited Lilly to his house to meet his daughter, who was a huge fan of hers. If you've never heard of Shah Rukh Khan (or SRK), try googling "biggest star in the world." SRK is often compared to Tom Cruise, and

* Yes, this millennium.

69

he routinely appears on *Forbes'* annual list of highest-paid actors. But a more accurate description is that he is quite possibly the most famous actor ever, having sold billions of movie tickets in India. When he approached Lilly to tell her he was a fan of her videos, she was floored. "What?" she asked him. "I idolize you. Here you are telling me that you've been casually watching my videos on the other side of the world without me knowing."

At one of Lilly's events in Mumbai, he made a surprise appearance. "I thought, Oh, my God, people are going to lose their mind when they see Shah Rukh is here," she said. Instead, as he joined her onstage, the chants of her name rang out louder than his. "It was the most overwhelming experience ever. I got offstage and felt sick. I wanted to puke, literally." After she recovered, her fans began to approach the stage, reciting some of her skits word for word. "I know the World Wide Web is worldwide," she said, "but you don't realize that until you have someone in India tell you, 'Hey, when you said this in your video, it related to me.'" She told me this even happens with fans who can't speak English, who can mimic the sounds she makes in her videos but don't understand what she's saying.

———

Earlier in the book I talked about how TV networks operated in an era of limited shelf space. By controlling a scarce resource—airtime—they could auction off programming and advertising slots to the highest bidder. But there's another way that scarcity comes into play in the media industry, and that's in restricting the distribution of content within borders. Anyone who's ever tried to play a DVD from another country knows just how confusing international rights arrangements can be.

HBO, for instance, where I used to work on international distri-

bution, employs a number of different ways to air its content around the world. In several countries (mainly throughout Asia), it owns and operates a network, offering a foreign version of its US channel. In other regions, such as Eastern Europe and the Nordics, HBO has joint ventures with local media firms to air its shows. Still in others, such as Canada, Australia, and most of western Europe, HBO licenses its content to local media companies for distribution.

This complex web of arrangements exists so that HBO can maximize the value of its content based on whichever arrangement makes the most sense for the company. That's great for HBO; it has already paid to produce the content to air it in the United States, so licensing it for international airings generates huge margins. But the consequence is that its shows premiere on different dates in different markets and some may never make it abroad at all.

Because shelf space on the Internet is infinite, digital business models tend to be built around abundance, not scarcity. Rather than auctioning off content in different markets in an effort to draw the highest price, Internet platforms race to accumulate users and loyalty by ensuring that content is available across borders and worry about making money later. When YouTube first started, the fact that a video could be seen by as many people as possible was essential, whether that person was in London, England; London, Ohio; or London, Nigeria. By ensuring that any user, anywhere, could both upload videos to the site and watch videos on it, YouTube grew exponentially while establishing itself as an inherently global media site.

Today, YouTube is available in nearly every country in the world (with the notable exception of China) and pays out revenue to creators in ninety countries. Localized versions of YouTube are available in seventy-six languages, including Lao, Telugu, and Kyrgyz, covering 95 percent of the Internet population.

When Conan O'Brien visited YouTube for a Q&A with our staff,

he talked about how the global distribution of clips from his shows had helped change his career. "We have had stunning success with YouTube, to the point where there are a lot of countries where I'm not on, my show doesn't air there, but I have huge fan support." As a result of submissions or requests he received from these fans, he began to film remote segments in foreign countries, including South Korea, Germany, and Armenia. "I go to the Seoul airport, and there are, I don't know, fifteen to eighteen hundred screaming seventeen-, eighteen- and nineteen-year-old girls crying, shouting, shrieking, flashbulbs, media, pushing, shoving, absolute craziness. I cannot tell you how insane it was. That's YouTube. YouTube did that. My show isn't on in Korea."

Most creators, including Lilly, will tell you that the majority of their traffic comes from outside the United States (on average, more than 60 percent of a YouTube creator's views comes from outside his or her home country).

"I think, compared to a lot of other creators, my demographics are really interesting," she said. "One of my biggest fan bases is in Trinidad. Their population is only 1.3 million people," a figure she rattles off the top of her head. "But a lot of people there subscribe to me." In fact, more people watch her in Trinidad than in Bangladesh, a country of 150 million people. When I asked her why, she explained that she makes a lot of references in her videos to soca music, an offshoot of calypso that's popular in Trinidad and that she grew up listening to in Toronto.

"I make a lot of jokes that people from Jamaica will understand because I grew up with Jamaican people," she said. "I can almost have conversations in Tamil, even though I'm not Sri Lankan, I'm not South Indian." All of these cultural nods make appearances in her videos, cascading around the world and revealing themselves in her global stats.

Lilly's global appeal has made her less willing to produce content that won't make it overseas, something we ran into when we wanted to acquire the rights to her tour documentary. "Other creators might not emphasize that point as much as I do," she told me. "But I know that my number six [market] is Dubai, my number four is India. I know that, and I know those demographics aren't always considered when it comes to a lot of business endeavors."

Though it's easy to understand Lilly's appeal in Canada and South Asia, the anecdotes about the Caribbean surprised me. I never appreciated the way subtle references could manifest themselves in subscription tallies and view counts in smaller markets.

Another creator who was actually born in Trinidad, Adande Thorne (better known as "sWooZie"), explained it to me in even more detail. "Anytime I talk about being from Trinidad, the views in Trinidad go crazy," he said. "Just at the mention of the word. And anytime I see my numbers in Australia or Canada going up, I will throw a shout-out to them. I'll maybe say, 'Hey, the prime minister of Australia said X' and then everybody loves it in Australia. Even a quick little shout-out in some of these videos can get people to latch on to it."

———

For decades, language has been a barrier to the exportation of content (it certainly was in Soviet-era Prague, where a single person seemingly did all the dubbing on bootlegged films).* As a result, some of the earliest videos to find true international appeal on YouTube were clips from *Mr. Bean*. The show succeeded on YouTube for

* If you're curious, the research network Media Across Borders has produced fascinating accounts of how content is localized, edited, subtitled, and dubbed as it makes its way across borders.

the same reason it's been sold in 245 territories around the world: yes, it's funny, but also, the character never speaks. No dialogue means there's no need for translation. Similarly, when we looked at the success of Warner Bros. content on YouTube, we learned that the most popular videos didn't feature Batman or Harry Potter but the silent pair, Tom and Jerry.

Despite the fact that English is only the third most popular language in the world, the exportation of content traditionally occurred in one direction: from the West outward. As a result, generations of global audiences grew up on BBC costume dramas and American cartoons, occasionally localized to reflect cultural differences. For instance, you may know *The Simpsons*, but throughout the Middle East, they know *The Shamshoons* (a show in which the patriarch, Omar Shamshoon, drinks Duff juice, not Duff beer). Similarly, the documentary *Exporting Raymond* is a hilarious depiction of producer Phil Rosenthal's attempts to adapt his show *Everybody Loves Raymond* for a Russian audience.

But that dynamic has begun to change. Thanks to the Internet, culture is traveling new routes, in new directions, globalizing in ways it never has before, from East and South to West. Most people know that *The Office* originated in the United Kingdom. Fewer people know that *Ugly Betty* was based on a Colombian show, that *Shark Tank* is the American version of the Japanese competition called *Dragon's Den*, or that *Homeland* is an adaptation of an Israeli drama.

And no one has better demonstrated how global hits can come from unexpected places than the Korean singer Park Jae-sang, better known as Psy. His mammoth K-pop hit "Gangnam Style" became the first video ever to hit 1 billion views, doing so in just over five months. It is also the first video to hit 2 billion views, and during its inevitable march toward 3 billion views, our engineers had to reprogram YouTube's counter so it could display such large numbers.

The song's spread on YouTube helped "Gangnam Style" top the charts in dozens of countries, including Belgium, Honduras, and Slovenia. It became the fastest-ever single to sell a million copies in Australia and eventually sold 5 million copies in the United States. The song's popularity around the world even led UN Secretary General Ban Ki-moon to call it a "force for world peace."

That may feel like an exaggeration, but even if "Gangnam Style" didn't solve political crises, it certainly had meaningful cultural consequences. Prior to the song's release, more than half of our K-pop viewership came from Asia, Australia, and New Zealand. A year later, the ratio flipped, with the majority of views occurring outside the Asia-Pacific region and more than 90 percent coming from outside South Korea. The interest in Korean culture didn't stop at YouTube videos; in the year after "Gangnam Style" was released, tourism to South Korea grew by over 15 percent, a boost that the Korea Tourism Organization attributed to the song.

"Gangnam Style" represented just the latest crest in the Korean Wave, or Hallyu, a phrase that originated in the Chinese press to describe the growing popularity of Korean culture abroad. Concerned about the growth of Japanese music, manga, and games in South Korea's black market in the 1990s, the South Korean Ministry of Culture began to invest heavily in domestic content production. When the late-'90s financial crisis struck the region, the South Korean economy began to reorient toward media, leading to the production of slick soap operas and infectious pop songs that quickly found audiences abroad.*

* South Korean soap operas have done particularly well in the Middle East. The fact that South Korean period dramas feature women in modest dress helps limit the need for censorship in more conservative countries in the region, with some shows doing better there than in South Korea. The soap opera *Dae Jang Geum* reached a staggering 90 percent of television audiences in Iran, and several South Korean actors have become massive celebrities in the country.

Streampunks

Today, no country is as focused on or devoted to the exportation of its culture as South Korea, where the creation of K-pop groups resembles the formation of Olympic teams. South Korean pop stars are recruited in open auditions and train for years to sing, dance, and act, often while learning foreign languages. Only after making it through this rigorous process are they assembled into supergroups with rotating casts.

Lee Soo-man, the founder and producer of SM Entertainment, Korea's leading entertainment group, explained the creative process of his company at a YouTube corporate summit. "There is a producing committee that analyzes the current market and consumer trends and an A-and-R team that selects and produces the right songs for each artist," he told us. "The producing committee is in charge of visual performances. They create music videos and direct stage performances, even strategize new fashion styles. The A-and-R team collects and monitors thousands of songs every day from composers and writers worldwide before selecting the best match for each artist."

SM Entertainment has assembled a network of composers, writers, choreographers, and video directors from around the world and hosts regular writing camps in South Korea to bring global songwriting talent together in one place. "Writers from Europe and Hollywood who've never met each other are invited to spend weeks and months with our composers and producers and work with our talented singers on the spot," Lee said. In this meeting of East and West, songs are crafted to maximize their global appeal. "To create a new song that runs only four minutes," Lee said, "may take more than a year."

SM's K-pop bands such as TVXQ and Girls' Generation also release songs on YouTube in multiple languages, including Mandarin and English. On global tours, different singers take the lead onstage

based on their language skills, with some bands even creating sub-bands made up of their Mandarin- or Japanese-speaking members. EXO, currently the most popular boy band in the world, debuted in South Korea and China simultaneously with two different "units," EXO-K (who sing in Korean) and EXO-M (who sing in Mandarin). They release the same songs simultaneously, just in two different languages. SM's acts also have their own games, social network, and a karaoke app called everysing.

"If we look back on world history," Lee said, "it was always the economy first and culture next. The global strength of European and American economies resulted in cultural penetration. I strived to take the opposite approach: culture first, the economy next."

This approach has been incredibly successful. K-pop is increasing its popularity throughout the world despite the fact that Korean is spoken by about 80 million people (25 million of them in North Korea, the country with the lowest Internet penetration on earth.) With machine-learning algorithms rapidly improving translation accuracy, language could soon cease to be a barrier to the transmission of culture. Even as companies such as Netflix race to make series such as *Narcos* and *Marco Polo* to draw both American and international audiences, the next generation of consumers may not grow up looking to the West for their entertainment, as I did. Instead they may look east or south; or in any other direction, as long as it reveals something good.

Show Me Something
I Haven't Seen Before

Satire, Representation, and Bias
in Online Video

WHEN I THINK about why YouTube was successful in its earliest years, I attribute much of it to the fact that it didn't look anything like what was on television. If YouTube had been full of original thirty-minute scripted comedies, sixty-minute dramas, or ninety-minute films, it never could have successfully competed with TV. Without large budgets or the efforts of seasoned professionals, amateurs trying their hands at those formats would have mostly created programming that felt like a lesser version of television.

Instead, YouTube clips offered a radical departure from your average prime-time show—part *America's Funniest Videos*, part

outsider art, part real-world confessionals, part something entirely new. By creating content that felt completely different from television, YouTube creators were able to establish their own niche.

That has been even truer in foreign markets, where people have fewer entertainment options than we enjoy in the West. If all there ever is on TV is soccer and soap operas, you might become desperate to watch something else. And if you look at the markets with the highest amount of YouTube consumption per capita, you see this clearly. The average viewer in Saudi Arabia consumes nearly thirty more hours each year than the average Canadian viewer, making the Kingdom YouTube's most active market per capita. And in Saudi Arabia, "not looking like who is on TV" can simply mean being an independent female.

Hayla Ghazal is a young Syrian YouTuber whose elastic expressions, warmth, humor, and advocacy for female empowerment have made her one of the most popular creators not just in the Kingdom but across the Middle East and North Africa.

At a young age, she wanted to be a presenter, but she knew her options to do so would be severely limited. "For so long, I had to abide by what society expected of me," she told me. "I had to put aside my dream of being on camera because I was a woman." But YouTube gave her a chance to realize her dream, building a following of millions even though the idea of women appearing on camera is still considered taboo by some in the region. By 2016, her uplifting messages led to an opportunity to become a Change Ambassador for Gender Equality at the United Nations and to an audience with Pope Francis to promote understanding and empathy online.

Prior to the Arab Spring, there were just a handful of female YouTube creators in the Middle East. But the embrace of smartphones, social media, and a youth culture that suddenly felt empowered by local political movements has enabled thousands of female-driven

channels such as Hayla's to spring up. Those social stirrings have also encouraged the growth of another form of entertainment that is rare for the region: satire.

———

In March 2011, just a month after protests in Tahrir Square drove Egyptian president Hosni Mubarak from power, a cardiac surgeon named Bassem Youssef set up a desk and a camera in the laundry room of his Cairo apartment. His aim was to create his own version of an American program he deeply loved, *The Daily Show*. The result was the *B+ Bassem Youssef Show*, named after Bassem's blood type. The earliest episodes of Bassem's show were scrappy but dutiful in their tribute to *The Daily Show*. They featured Bassem in a suit in front of a mural of Tahrir Square, commenting on videos and over-the-shoulder photos of local politicians, while aided by clever editing, sound effects, and the occasional guest correspondent. But unlike Jon Stewart, Bassem can't help but crack himself up, and his wide grin, round blue eyes, and dark, arched eyebrows are much better suited to eliciting big laughs than wry chuckles.

When Bassem's show debuted on YouTube, it became the first independent Egyptian program in production. In a country where the Internet reached less than 20 percent of the population, a video with fifty thousand views was considered a viral hit. Bassem's channel drew 5 million views in his first two months. His early success led to a TV deal and the creation of his next daily news satire show, *Al-Bernameg* (The Program). After its first season, *Al-Bernameg* became one of the most watched programs on Egyptian television and the first channel from the Middle East to draw a million YouTube subscribers. Media outlets around the world were quick to hail Bassem as "the Jon Stewart of Egypt."

After being invited by the actual Jon Stewart to appear on *The Daily Show*, Bassem returned to Cairo, inspired to film *Al-Bernameg* in front of a live audience. To accommodate the filming, he rebuilt the Radio Theatre in downtown Cairo, a replica of Radio City Music Hall that is just a ten-minute walk from Tahrir Square. In its second season, *Al-Bernameg* became the first show ever to film in front of a live audience in Egypt.

The electricity of Bassem's humor played perfectly in front of the live audience and their resulting enthusiasm helped turn the show into a powerhouse. *Al-Bernameg* became one of the most popular shows in the world, reaching an estimated 30 million viewers in Egypt alone in 2012. As a point of comparison, the highest-rated show in the United States that same year, *NCIS*, reached 15 million people—half the audience, despite airing in a country with a population more than three times the size of Egypt's. In 2013, Bassem became one of *Time* magazine's 100 Most Influential People in the World and one of *Foreign Policy*'s Leading Global Thinkers.

As his show turned its fire on the newly formed government of Mohamed Morsi and the Muslim Brotherhood, Bassem was threatened with lawsuits and arrest warrants. In early 2013, he was briefly detained for questioning before he was released on bail. Then, on June 30, 2013, Morsi was overthrown by the Egyptian military. As Jon Stewart explained while introducing Bassem at an awards ceremony hosted by the Committee to Protect Journalists,* the fate of *Al-Bernameg* was unclear.

"Bassem had a choice," Stewart said. "Bassem could stop doing that show at that moment and leave a hero. He was beloved, had his name chanted in the streets. . . . Or he could stand for a higher

* Where Bassem was receiving an International Press Freedom Award.

principle, which was not that his satire was purposeful for regime change but that his satire was purposeful for expression."

Bassem continued his show under the new military regime. It lasted one episode before it was pulled off the air and eventually banned. "It turns out, the new regime in Egypt has less of a sense of humor than the Muslim Brotherhood," Stewart quipped. After being taken off the air, Bassem left Egypt for the United States, where he now has a series called *Democracy Handbook** on Fusion, Univision's English-language channel. He also released *Tickling Giants*, a documentary chronicling his experience, and wrote a book called *Revolution for Dummies.*

Despite *Al-Bernameg's* untimely cancellation, satire is still alive and well in the Middle East and beyond. After becoming the first local stand-up comedian to appear onstage in Saudi Arabia, Fahad Albutairi started a YouTube show called *La Yekthar.†* He used his show to criticize corruption and unemployment in the Kingdom through sarcastic skits, drawing millions of views for his material and earning the nickname "the Seinfeld of Saudi Arabia." Albutairi later scored a global viral hit when he coproduced a Saudi-specific cover of Bob Marley called "No Woman, No Drive."‡

In India, the comedic troupe AIB made a series of acidly comic videos that criticized the treatment and perceptions of women in their home country. After a horrific sexual assault on a private bus in south Delhi eventually led to a young girl's death in 2012, protests

* In a recent episode examining the Second Amendment, he visits a combination jewelry store/gun shop. A clerk shows him her favorite combo: a pump-action shotgun along with a five-stone diamond anniversary band. Bassem jokes: "So I can give her that, and if she doesn't like it, I can take her out . . . to dinner."

† Loosely translated, it means "Keep a Lid on It."

‡ Sample lyric: "Hey, little sister, don't touch that wheel."

erupted throughout India. Yet, despite the outrage, there remained a pervasive view in the country that women bore responsibility for provoking their attackers. In response, the comedy collective made a sarcastic PSA called "Rape: It's Your Fault," starring a smiling young actress espousing made-up claims such as "Scientific studies suggest that women who wear skirts are the leading cause of rape." The video went viral on every social media platform and established AIB as a leading satirical voice in the country.

And in Brazil, YouTube's second largest market in terms of viewership, one of the earliest channels to find success belonged to the sketch comedy group Porta dos Fundos.* Its members came from traditional media backgrounds, as directors, screenwriters, actors, and comedians. Had they wanted to create a comedy show on television, they would have had the resources and the connections. But the group had a specific vision for a series that challenged viewers and broke boundaries, one that told jokes that weren't being told on Brazilian television.

Ian Fernandes, one of the founding members of the group, explained Porta's vision at a media conference in Rio de Janeiro in 2014, translated here from Portuguese: "To be a successful comedian, to really entertain people and make them laugh, you have to challenge them," he said. "You have to wake them up, get them to think, to see the absurdity of daily life, of human interaction. You have to break boundaries. So we wanted to tell the jokes that other people were not telling on TV. And we wanted to address topics—religion, bureaucracy, corruption—that weren't being addressed satirically."

That desire led them to YouTube, where they could express themselves without fear of censorship. At first their sketches drew a

* The phrase translates literally as "back door," though it has a slightly indecent connotation.

decent response. But five months after their debut, over the Christmas holiday, their popularity skyrocketed. It turned out that college students who had become fans of the series returned home and began to share their clips with their families, resulting in millions of views over the break. One of the clips that did particularly well that Christmas was a sketch showing Jesus getting fired from a carpenter's workshop for being too uptight and refusing to swear like the rest of the blue-collar workers. Within two years, Porta dos Fundos owned the most popular channel in Brazil and became the first to reach 10 million subscribers in the country.

———

In 2015, I traveled to Brazil to meet with some of our partners, including some members of Porta dos Fundos. While there, we hosted an event for local marketers and ad agency executives to meet some popular YouTube creators to help them understand the popularity our creators were finding on the platform. I expected the event to go the way many of these events do, with representatives from brands expressing modest surprise at the reach digital platforms offer, at a cost far lower than they're accustomed to paying on TV. But quickly I saw that this event was going differently.

In Brazil, there are five official categories used by the census to designate a person's race. There's *amarelo* ("yellow," or East Asian), *indio* (referring to indigenous peoples), *pardo* ("brown," or multiracial), *preto* ("black"), and *branco* ("white"). If you walk along Copacabana, you will see every one of those categories represented. In one of the most ethnically diverse countries in the world, it is nearly impossible to tell who is a local and who is a tourist. I love that melting pot; it's what makes Brazil one of my favorite countries in the world.

But flip on the television, and unless you're watching soccer, chances are you will see only *brancos*. Spike Lee, who filmed a documentary in Brazil for the 2014 World Cup, told a local news outlet that if you watch Brazilian TV, you "will think that all Brazilians are blond with blue eyes."

At the advertiser event, there were creators from every state and of every shade. There were black beauty gurus and dark-skinned samba dancers, LGBTQ vloggers with shocking pink hair and hipster sketch comedians with tattoos and beards. There were brown-skinned music video directors and green-eyed gamers, and, yes, there were blonds, too. There were Afro-Brazilians and Asian Brazilians and Euro-Brazilians, all of whom had found audiences on YouTube.

"Who are these kids?" one executive asked me.

"This is the real Brazil, I guess," I said with a big smile on my face.

———

Talking or joking about issues that aren't typically addressed on TV may be one path to building a YouTube audience, but could simply *looking* different aid a creator's popularity? As I mentioned in the previous chapter, Internet communities can serve as an important arena in which to discover people with similar viewpoints. But perhaps they can just as easily be a place for people to seek out underrepresented voices and hear from people whose stories aren't often told on-screen. Representation matters, and the absence of on-screen portrayals can leave viewers with a strong desire for meaningful depictions of people with different ethnic backgrounds.

Asian Americans, for example, the fastest-growing demographic in the United States, are significantly underrepresented in film and

television.* According to USC's Annenberg School for Communications and Journalism, only 1.4 percent of lead characters in Hollywood films are Asian, despite Asians' making up over 6 percent of the American population.

But on YouTube, Asian creators became some of the platform's earliest stars and continue to make up an outsize proportion of our top creators. Michelle Phan was one of YouTube's earliest beauty gurus and one of the first creators I met when I joined the company. While still in high school, she had been turned down for a job at Lancôme's makeup counter at her local mall. Disappointed but undeterred, she channeled her love of makeup into a beauty channel of her own. Rather than help customers at her local mall, she would help millions of YouTube viewers find their beauty.

Within a few short years, based on the popularity of that channel, she became Lancôme's first official video makeup artist. Soon, she founded her own production company to help support the growth of other beauty vloggers before founding a makeup subscription company in 2012 called Ipsy, which is now valued at over half a billion dollars.

Michelle's success was preceded by the comedian Ryan Higa, who began posting videos the year YouTube was founded and has amassed nearly 20 million subscribers to date. Freddie Wong began posting videos in 2007, before starting one of the most successful web series ever, *Video Game High School*. And Wong Fu, the filmmaking trio of Wesley Chan, Ted Fu, and Philip Wang, began uploading music videos and short films at about the same time

* Alan Yang, when accepting the Emmy for Writing in a Comedy Series for *Master of None* in 2016, eloquently summed up the current media depiction of Asians: "There's seventeen million Asian Americans in this country, and there's seventeen million Italian Americans. They have *The Godfather*, *Goodfellas*, *Rocky*, *The Sopranos*. We got Long Duk Dong, so we've got a long way to go."

as Freddie and soon began touring colleges and landing appearances on the international short-film circuit. Wong Fu has since blossomed into a thriving new-media company, alongside Ryan's Higa TV Productions and Freddie's studio, RocketJump, all three focused on putting Asians both behind and in front of the camera.

But while YouTube has a higher proportion of women, Asian, and Latino* stars among our top channels than do the top TV shows and films, when it comes to the popularity of black creators, our numbers are no better than Hollywood's. In fact, unless you count musicians, only one of YouTube's one hundred most popular channels as of this writing featured a creator of African descent, the British gamer and comedian KSI.

In 2016, we hosted a private event dedicated to our black creators, in the hope of strengthening the community's presence on our platform. We invited a number of speakers, from the comedian Wanda Sykes to the activist DeRay Mckesson to Def Jam mogul Russell Simmons, all of whom talked about the struggle African Americans face in getting their stories told.

There, we acknowledged that our numbers of black creators were no better than Hollywood's and that some of the factors that hold back black talent in traditional media have crept into our platform as well. Algorithms that recommend content or program our front page are designed to be impartial, but statistics show that they're still subject to the same biases—unconscious, explicit, or systemic—that exist in society. Having an open platform where anyone can contribute content is not enough to guarantee equal representation.

I asked Adande Thorne, who is our most popular black Ameri-

* Latino creators fare far better on the platform, though nearly all of them reside outside the United States and create videos in Spanish.

can creator, with nearly 5 million subscribers, why he thought there weren't more popular black creators on the platform. He ascribed part of the problem to a supply issue. To build a successful YouTube channel, "you've got to have a nice camera, you've got to have the editing equipment, you've got to have a good computer," he said. "A lot of my black friends aren't into that stuff. They don't have the funds; they don't have the time; that's not their interest. But I've noticed on Vine, on Instagram, on the shorter-form stuff where you just need a phone, a lot of my black male friends are crushing it."

But he went on to highlight an issue that was more unsettling: "I've noticed whenever there's a thumbnail of my face, it always gets a worse reaction than a thumbnail of an animated image that I've drawn. And it doesn't even matter if my animated character is black, it'll still get more views than a video with my face because I think a lot of people, when it comes to discovery, they'll look at an image like that and they already have a preconceived notion of what to expect: 'Okay, this guy's going to be cursing a lot. He's going to be using the N-word. He's going to be doing this, he's going to be doing that.'" In other words, viewers were less likely to tap to watch a video knowing that the creator was a black male, even relative to a cartoon featuring a black character.

Anecdotal evidence suggests that women of color face an even greater bias. Black female creators tell us that darker skin and tighter curls lead to lower subscription counts and views. That seems to hold true even for creators whose channels are devoted to supporting the natural-hair movement.

Because YouTube is largely on demand, viewers are frequently deciding what to watch next. And those decisions aren't made in isolation; viewers are choosing whether to tap on one thumbnail over another. As Adande explained, in that competition, a recommended video featuring a black creator might be tapped on less

often than that of a white creator. Over time, that preference becomes weighted in recommendation algorithms that are focused on providing viewers with videos they are most likely to watch.

"If you have two thumbnails side by side," Adande explained, "a black young man versus a gorgeous white girl, me and probably the majority of people are going to click the white girl, you know? And maybe we might make it back around to the black guy. I think it's just because of what we've been conditioned to see."

After speaking with Adande, I went back to look at his channel. Of his thirty most popular videos—over a nearly decadelong career—none show his face in the thumbnails. I then looked at KSI's channel; several of his top videos do show his face in the thumbnail, but all were made after he had become popular. When I looked at his first videos, the ones that helped establish him, only one out of his first hundred shows his face in the thumbnail.

My wife is Dominican. My two daughters are young women of color. The thought that if they start a YouTube channel, people will be less likely to seek out their videos because of their race is deeply troubling. The fact that they—or any black creators—have a more difficult time establishing themselves on YouTube shows that even open, impartial systems can be corrupted by hidden biases.

YouTube is hardly alone in this challenge. Amazon faced criticism when reporters from Bloomberg discovered that its Prime same-day delivery service was not available in predominantly black neighborhoods. The viral augmented-reality game Pokémon GO was faulted when it was discovered that Pokémon were easier to find in predominantly white neighborhoods with more parks and public spaces than in black ones; a decades-long legacy of segregated housing policy in the real world rearing its head in the virtual world.

While it's easy to shrug off the lack of Pokémon in your neighborhood, there are far more pernicious examples of algorithmic

bias. Investigators for ProPublica discovered that software used by courts to assess a defendant's risk of future criminal behavior was almost twice as likely to incorrectly predict recidivism among black defendants as for white defendants. And a group of Harvard researchers discovered that online ads for obtaining criminal records were more likely to appear alongside searches for names associated with people of African American descent than for other names.

Part of this reflects Silicon Valley's own struggle with diversity and inclusion. African Americans comprise only around 2 percent of tech firm workforces on average, despite their earning over 4 percent of degrees awarded in computer science, according to the Computing Research Association. If algorithms aren't built with input from diverse perspectives, they risk mirroring existing biases in our society.

Missing out on YouTube views may not have the same consequences as having your bail request denied, but it's still regrettable for several reasons. It runs contrary to the ideals of the open and democratic platform YouTube strives to be, one in which anyone can find equal opportunity to share his or her voice. But perhaps worse, it fumbles an opportunity to change the way the media industry currently operates. If you believe that streaming video represents a once-in-a-generation chance to change how Hollywood works—and if you're reading this, I'm guessing you're open to the idea—then what rule deserves more revision than who can appear on-screen or whose stories can be told? With a much younger audience than television's, YouTube has a chance to create a new status quo in entertainment while simultaneously inspiring a new generation of diverse creators.

I'm heartened by the stories of creators such as Franchesca Ramsey, who struggled to find meaningful roles in Hollywood at first but whose popularity on YouTube helped open doors to stints

at Comedy Central and MTV. And I've been inspired by Issa Rae, Donald Glover, Justin Simien, and Quinta Brunson, black filmmakers who went on to create original series for HBO, FX, Netflix, and YouTube Red after getting their start in the open environment of online video.

But despite those successes, we clearly have work to do when it comes to elevating underrepresented voices on our platform, from analyzing our recommendation algorithms to increasing our staff's diversity to providing more resources and opportunities to black creators. YouTube's mission is to give everyone a voice and show them the world. Unless black creators have the same opportunity as everyone else, we are not doing right by that mission.

Stick to Your Quilting

The Deep Appeal of Narrow Niches

THE SMALL TOWN of Hamilton, Missouri, is located an hour north-east of Kansas City, and on the day I visited construction detoured me off the interstate and down a long, flat dirt road bordered on both sides by farmland. As I got closer to the town, the farms gave way to more intimate scenes of rural life: auto repair shops with as many broken tractors as cars, a Baptist church, and a bright white water tower displaying the town's name in bold blue capital letters. It was a hot, rainy day in August, and I had made the drive for the same reason nearly everyone visits Hamilton: to meet Jenny Doan.

In the last few chapters, I've tried to point out some of the com-monalities among a few of our more popular creators: their ability to create and cultivate fan bases, their accessibility and genuine nature, and their tendency to bring new, diverse perspectives to the

fore. But for those willing to look beyond the top YouTube names, there are still important lessons to be learned.

Jenny Doan isn't like a lot of the names you'll encounter in this book. She's not a Millennial with millions of followers or a new-media mogul. She is the unlikeliest of streampunks, a baby boomer with seven children and twenty-two grandchildren whose charm, warmth, and sense of humor help power the economy of an entire midwestern town. Jenny is the personality and talent behind the Missouri Star Quilt Company and easily the most famous quilter in the world.

The story of Missouri Star actually began in 1996 in Greenfield, California, when the Doan family discovered that their son Josh had a tumor in his lymph gland. Its treatment saved his life but bankrupted the Doans, forcing Jenny and her husband, Ron, to find a cheaper place to raise their large family. They packed all their belongings into a rental truck and headed east to a small town in Missouri right in the middle of the United States. Their only connection to the town was that Jenny's parents had visited it once before.

Hamilton proved to be a good fit for the family, and they were able to raise their children on Ron's salary as a machinist at the local newspaper. But by 2008, the financial crisis had wiped away their retirement savings and Ron's job seemed in jeopardy; his machine shop had cut its staff from twenty-five employees to five. It was during that hardship that their children Al and Sarah decided to set up their parents with a retirement plan of sorts. They took out a $36,000 loan and bought their mom a long-arm quilt machine so she could embrace her favorite hobby and make quilts for the local community. They then borrowed another $24,000 to buy an old auto showroom that was big enough to house it, which became Missouri Star Quilt Company.

At the start, business was slow. It was three weeks after Jenny

opened her quilting shop that she had her first sale, to her niece. When Jenny eventually hit seven sales, the family had a dance party and Sarah wrapped the orders up like presents.

After a few months, Al suggested that his mom do a little marketing to drum up business. He asked if she'd be interested in filming quilting tutorials and uploading them to YouTube. "Sure," said Jenny. "What's a tutorial?" At that point, she had never even visited YouTube.

After some explanation from Al, she began her online video career. Her first few videos were straightforward tutorials, a single camera pointing at Jenny as she explains matter-of-factly how to assemble basic quilts. The camera work is shaky, and you can hear her grandchildren playing in the background. But even in those early videos you can see glimpses of Jenny's warmth and knowledge that might predict future success. Jenny starts each video with a wide smile, her voice clear and confident as she explains the different cuts and stitches she makes. And she consistently talks about how easy an otherwise intimidating hobby can be.

Only later would Al tell me how those first few videos were made, recorded on his miniature Canon PowerShot ELPH digital camera. When Jenny wanted an overhead shot to show people what she was doing with the fabric, Al, who is six feet seven, would literally hover over her table, bent over at the waist to capture the footage. It was his sister Sarah's children who were running around in the background because the quilt shop also served as their day care. Al, who was a tech consultant by day, would work long hours, then stay up late into the night editing the videos with Windows Movie Maker.

As the tutorials progress through the months, you can see more of Jenny's personality shine through. She tells stories about her family and laughs self-deprecatingly when she makes a mistake. In one video, she asks her husband, Ron, to hold a quilt she wants

to display. "It's good to have a tall husband when you need these kind of things," she says. His face never appears on camera, hidden behind the quilt, but an annotation on the video says, "I swear Ron's behind here, but he's just too beautiful to share with the world!"

One day, someone called and asked to order the material Jenny was using in one of her tutorials. "Oh, we're not selling that fabric," she told the caller. "This stuff has been in a bin under my bed for seventeen years. I'm just showing you how to quilt!" But the call caused her to rethink that strategy, and soon the shop began to stock the featured fabrics while sales began to grow. She made enough money the first year to pay back the loan on the quilting machine, though no one in the family took home a paycheck.

Even during those early lean years, curious things began to happen. People began showing up at the door of the quilt shop from out of town, having seen Jenny's videos on YouTube. One woman came from New York, then another, from Mexico City. "We were just so surprised that people were watching," Jenny told me.

The spontaneous visits began to get more frequent. When the Doans first filmed their tutorials, they didn't bother closing their shop because they never had any foot traffic. But with time, curious quilters from far-flung locations began popping in more often, interrupting their shooting.

Fan mail began to trickle in, too. Jenny began to receive letters from people who were disabled, who were learning to quilt from her videos. People who were confined to wheelchairs were finding an empowering new hobby online. "Their lives were changing because they had this opportunity and a creative outlet that they'd never had before," she told me.

By 2011, the channel had crossed the 25,000-subscriber mark and suddenly Missouri Star experienced an explosion in both attention and sales. People visited from even farther afield, from England

and Israel, South Africa and Australia. Asian tourists who didn't speak English were visiting from China and Japan. A woman from Mexico began to visit every year with her husband to celebrate their wedding anniversary.

Jenny's videos hadn't become a viral sensation, exactly, but they had connected with an incredibly passionate audience, scattered across countries and generations. They would watch her tutorials on YouTube, order fabric from the online store, and in many cases make a pilgrimage to Hamilton. By the end of the third year, Missouri Star Quilt Company had grossed more than $1 million in revenue.

That milestone led Al to quit his consulting job in order to steer the company's growth full-time. High among the family's priorities was expanding out of Jenny's one-room quilt shop to provide a more compelling experience for visitors. They had options. The Great Recession had devastated Hamilton, leaving most of the buildings on its main street boarded up or abandoned. By 2011, the town was left with just two antiques stores, a supermarket, a Subway, and a couple of gas stations.*

The family bought its first new building, refurbished it themselves, and dedicated it to selling only Civil War and mercantile quilt fabric, the material they had the most of in stock. Soon they had more fabric than their two buildings could hold, so they opened another store, this time for seasonal fabrics. They soon opened another for floral fabrics, another for modern fabrics, and yet another to sell sewing machines and equipment.

By the time I visited in 2016, the Missouri Star Quilt Company was operating *seventeen* storefronts in Hamilton along North Davis Street, the main road that forms the town's heart. They included

* "And the Subway was in the gas station!" Jenny told me.

a burger joint, a bakery, a farm-to-table restaurant,* and a sewing center that hosts fifty weeklong quilting retreats a year. Perhaps the most clever store is "Man's Land," a large building full of leather recliners, dark wood floors, and TVs tuned to ESPN so husbands have a place to pass the time while their wives shop.† During my visit, cars lined the streets, with license plates from Iowa, Texas, Illinois, and even one from Florida. The street looked bucolic; there were roses planted along the sidewalk and large murals of quilts painted on the sides of some of the company's stores.

After my visit, I decided to look at the town through the time-machine effect of Google Street View. The contrast was shocking. In 2009, Hamilton looked like a ghost town and North Davis Street was filled with battered buildings. Several of them were abandoned, and weeds climbed high out of the cracks in the pavement. The one sign of life was a farmer selling vegetables out of the back of his truck, but otherwise few cars could be seen.

Flash-forward to 2016, and you'll see construction workers lining both sides of the street, busy building new, elevated sidewalks. In one view, you can see an entire block of two-story buildings, six in all. In 2009, all the windows of their second stories were boarded up. In 2016, each of those windows has a letter spelling out "MISSOURI*STAR*QUILT*CO" and each of the buildings was open for business. Even in photos, the town has the look of something alive.

In a town of 1,800 people, Missouri Star now employs over 400, including five full-time construction workers who are busy renovating even more buildings in Hamilton. That makes it the largest employer in the county and the largest seller of quilting fabric in

* The restaurant is called Blue Sage. I recommend the lamb burger, though Al swears by the pastrami sandwich.
† "Normal quilt shops have a bench outside and a skeleton sitting in it with a sign that says 'I'm just waiting for my wife,'" Jenny told me.

the world, fulfilling five thousand orders a day—nearly 2 million a year. Visitors still turn up at random, but now most come in coordinated packs, with busloads of quilting enthusiasts disembarking in Hamilton nearly every day. In 2015, more than 100,000 people visited the town, a shockingly high proportion of the company's nearly 400,000 YouTube subscribers.

And there is room to grow.

———

When I entered the main store of the Missouri Star Quilt Company, the first thing I saw was Jenny Doan's wide smile. Inside, Jenny's tutorials were playing on flat-screen TVs amid stands of quilting fabric illuminated by midcentury industrial pendant lamps. Again and again I saw that juxtaposition of old and new, as a long-established hobby was marketed and sold with a tech-savvy edge. Deeper in the store, several iPads were set up for customers to browse the company's inventory. Later that day, when I bought some souvenirs to take back with me, a friendly young woman asked me for my email address.

As I waited in the store for Al to arrive, a sharply dressed woman with red hair and a turquoise dress approached me with a hint of uncertainty. "Hi there, are you looking for something in particular?" I could understand her confusion. I was the only man in the store and aside from the clerks, the only person under fifty; I must have seemed desperately out of place. When I explained why I was there, the woman took me around the store, showing me the various displays. In the middle of the store was the newest addition: apparel with the company's logo and shirts that read "I Love Jenny."

"I can't keep it in the store," the clerk said.

A few minutes later, Al arrived in a garrulous mood, excited to

talk about what his family was building in Hamilton. He wore a blue T-shirt and an auburn beard a few shades lighter than his hair and had a solid bearing that matched his tall stature. As CEOs go, he looked much more like a tech executive than a retail executive, though one who was good at sports and cared as much about ATVs as drones. He clearly had the welcoming nature of a midwesterner, but you could sense his early California upbringing from his laid-back demeanor and his passion for Internet marketing.

When I asked him about the mailing list I had just signed up for in the store, he told me that Missouri Star had a 70 percent open rate on its daily emails, "which is insane!"* He explained that that engagement was a reflection of the care the family takes with each opportunity they have to interact with their customers. "Instead of 'Thank you for your order,' it's just having fun with it," he told me. If you're a Missouri Star customer, you might get an email with a funny little story about how a marching band picked up your order at the warehouse and is now parading its way to your door.

Al walked me through the various storefronts, showing me just how specific the world of quilting fabric can get. "This is our novelty store, with your Angry Birds and your *Star Wars* fabric," he said as he toured me around. "If your kid loves bicycles, we're going to carry that in here."

We walked through Man's Land, too, where an older man was playing solitaire on his iPad while watching highlights from an Alabama-Clemson game. From there, we took an elevator up to the Kids and Baby store, along with two ladies from Salt Lake City who recognized Al from the brief appearances he had made in Jenny's earliest videos.

* That *is* insane! The average open rate for email marketing is only 22.17 percent, according to emfluence, an email marketing consultancy.

"You're the son!" one of the ladies said, delighted.

"Yeah, I'm the nerdy kid on the computer," Al demurred as he typed on an imaginary keyboard.

"We're so excited; we're going to meet your mother tonight!" they told him.

"Oh, yeah, you're in town for mom's stand-up routine tonight?" he asked. Jenny was hosting a tutorial that night in town.

"Yes, we're here for three days and we're just getting warmed up!" The elevator doors opened, and the ladies thanked him.

Less than a minute later, we were stopped by another woman, middle-aged with long brown hair. She seemed nervous to approach Al and asked if he was Jenny's son. Al repeated his line about being a computer nerd. I started to guess just how often these encounters occurred. But the woman didn't laugh at his joke. Instead, she explained that her trip to Hamilton was a birthday present for her and a friend from her husband. The two had driven out to Hamilton all the way from Virginia. She wasn't enthusiastic to meet Al, as the other customers were; she was genuinely moved.

"I just want to thank you," she said. "This is just so phenomenal, what you have here." Her voice broke off, and it seemed as though tears would soon gather in her eyes. She looked at Al but didn't quite know what to say, unable to express how much this—Jenny's videos, being in Hamilton that day, meeting Al—all meant to her.

"Well, thank you, it's great to meet you," Al said as he smiled and shook her hand. It wasn't clear to me that he knew what to say, either.

———

We finished up our tour of the buildings, including some new construction projects the company was undertaking, and made our

way across the street and down the road to a small cottage that was the site of the original quilt store. It was there I met Jenny in person, sitting behind a large, high sewing table covered with various scraps of fabric. "I'm a messy creator," she told me as she apologized for the clutter. She was wearing a black scoop-neck sweater, and her short blond hair was parted at the side, as it is in nearly all her videos. Behind her hung a large, dark patchwork quilt made in 1894 that a local woman had given to her. "She brought it in and said, 'I have no use for this, are you interested?' And of course I just died," she told me.

Jenny began our conversation by telling me about her own quilting experience growing up. She seemed set on sewing even before she knew how, cutting up pieces of her mom's clothing and stapling them together—"That only happened twice," she said—before her family enrolled her in 4-H to learn formally. Later she hosted musical theater productions, making the costumes for the various roles. It was only later in life that she began looking for more ambitious projects and discovered a love of quilting.

She described how long it had taken for the company's channel to catch on. Her children would start fake debates in quilting forums in order to drive traffic to her channel. "The seventy-year-olds were not hanging out on YouTube," she said. "They wanted DVDs of everything! But Al said, 'Mom, anytime Walmart puts something in a bin in front of the store for five dollars, you know it's going away.' So we had to go with streaming."

I asked her why she thought she'd been able to resonate so successfully with the quilting community. "I've made it easy for them," she said. "There's a whole elitist part of quilting where everything has to be perfect. My whole mantra is, 'Finished is better than perfect.' You don't have to be as good as anybody else, and if you sew an hour today, it's all just practice. Tomorrow you're an hour better

than you were. I don't quilt because I'm perfect, I quilt because I want to give things to the people I love."

In other words, Jenny believed she made the craft approachable, a Julia Child of quilting. She was creating tutorials for a community of mostly mothers and grandmothers who didn't have a dedicated place to turn. But she was also broadening that community, bringing in others who might have been intimidated by the hobby. That included a younger generation of quilters—"your pierced, your tattooed"—but it also included men, who could follow along online even if they were too embarrassed to walk into a quilt store. She also mentioned her early letters from people who were disabled, whose wheelchairs couldn't fit through the aisles of craft stores, but who could learn the craft on YouTube and order supplies online.

Jenny explained that in addition to filming tutorials every week, she is on the road throughout the year to perform live tutorials at quilting trunk shows. The shows, which can run as long as two and a half hours, draw hundreds of paying guests, most of whom wait in line to meet her afterward. She then told me a story about a woman who'd waited to speak to her after one of those shows. "I never dreamed I could do anything like this," she told Jenny, "but you said, 'You can do this,' and I believed you." The woman reached into her purse to pull out a small quilt that she had made. It was then that Jenny realized that she had prosthetics on both arms because she had lost both of her hands.

Jenny told me another story—one I will never forget—about an older man who had seemed out of place at one of her trunk shows. After the show, he waited in line for more than an hour to speak to her. When he finally reached her table, he began to tell her about his wife, who was a big fan of Jenny's but was suffering from Alzheimer's disease. When he found out that Missouri Star was selling a custom deck of playing cards with Jenny's quilts on them,

he bought one for his wife, who passed most of her day shuffling cards.

After giving his wife the deck, she began shuffling the cards with her usual quick rhythm. But as the quilts caught her attention, she began to slow down, recognizing the designs from different tutorials she had watched. When she reached the joker card, which had Jenny's face on it, she stopped. She looked up at her husband and said: "It's Jenny." They were the first words the woman had spoken in four years.

The man was now sobbing, thanking Jenny for what she'd done. "To know for just one moment that she's still there—" he said before his voice broke off.

Jenny began to tear up as she finished telling me the story. "I mean, who's prepared for those kind of things?" she asked. "Who thinks that because you show somebody how to put four blocks together, that you can make someone that happy?"

She paused for a second and said, "But you know, when you create, it heals you. And then you can go on to bless other people's lives. You can fill up your own house and your kids' and your grandkids'. You can start making pillowcases for hospitals or quilts for foster kids and Wounded Warriors and NICU units. I mean, it's just so amazing what's happening in the quilting world."

———

Amazing things are happening in other worlds, too. Jenny's story is a remarkable one because it demonstrates how one person's passion has the potential to impact so many. But it also illustrates one of the most compelling possibilities of online video: the opportunity to create content that can satisfy any interest.

When YouTube first began, it had a brilliant tagline: "Broadcast yourself." That tagline helped inspire millions of people to turn their

cameras on themselves and film their own perspectives and their own worlds. As a result, early YouTube was a diverse, whimsical place. You never knew what might show up on the home page, and the opportunity for serendipity was enormous.

But in that free-for-all, every YouTube video competed for your attention. And just as in any ecosystem, the resulting competition exerted a subtle pressure on the inhabitants to occupy more specific niches.

The appeal of some of YouTube's categories, such as sports, music, or film, is incredibly broad and obvious. But many more of our content categories are incredibly narrow, such as channels devoted to the technique of soap carving,* views from the cockpits of airplanes, or the pleasant sounds of a roaring fireplace. Entire PhD theses could be written about these random branches of YouTube's family tree and what compels millions of people to view, for instance, something new crushed in a hydraulic press every week.†

To me, these highly specific niches represent the esoteric and arcane beauty of human nature. Our interests are as diverse as our imaginations, with no rhyme or reason as to what piques our curiosity. The economics of online video—the cheaper cost of creation and distribution—allows nearly anyone the opportunity to create content based on his or her singular passion. And with the potential to reach 1.5 billion people, content with what you would assume is limited appeal can actually find quite a large audience.

As YouTube evolves, we're shifting from an era of "Broadcast yourself" to one of "Channel yourself." Anyone can find content on

* Check out the unbelievable designs on the Japanese YouTube channel *mizutama.soap*.
† There are even rumors—which I will neither confirm nor deny—of a spreadsheet floating around YouTube with a list of obscure fetishes that are banned on the site, such as videos of people licking statues or getting pied in the face.

the platform that relates to his or her specific inclinations. As our algorithms get better at understanding your watch history and divining your interests, we have the ability to create individually tailored recommendations, making everyone's YouTube home screen look completely different and completely personal.

As fascinating as the more esoteric YouTube niches can be, though, the most successful YouTube categories tend to be organized around interests that are relatively mainstream but that viewers struggle to satisfy through other media.

Perhaps the prime example of this is video gaming. Video games, boosted by the growth of mobile gaming, have become a nearly $100 billion industry. To take one example, in the month of its debut *Grand Theft Auto V* outsold every record released by the global music industry *combined* in all of 2013. The game's sales from its first *day* of release doubled the total gross of that year's biggest film, *Iron Man 3*.

By any measure, gaming is a spectacularly popular genre of entertainment. Yet it failed to find a footing on television. The last TV network dedicated to gaming was G4, which NBCUniversal shut down in 2012 after years of weak ratings. eSports competitions have begun to show up on ESPN (which counterprogrammed Super Bowl LI with a FIFA 17 competition) and TBS, but their exposure is nowhere near what you see online.

On YouTube, gaming is massive. It is one of our largest categories of content, accounting for billions of hours of viewership every single month. Several of our top creators, such as elrubius in Spain, Fernanfloo in El Salvador, and EeOneGuy in Russia, got their start filming themselves playing multiplayer games with their friends.*

* Though hosting channels under your own name on YouTube is most common, gamers are almost exclusively identified by the usernames they use to play multiplayer games.

The question I always get about gaming is why anyone would spend time watching someone else play a video game. Part of the viewing is instructional: people wanting to know how to beat a certain boss or unlock a frustrating puzzle can watch an online walkthrough. Part of it is curiosity: video games are still expensive, often more than $50 each, and both prospective buyers and those who can't afford new games want to take a peek. Part of it is akin to athletics, with fans wanting to watch some of the best players in the world compete at a certain game; eSports attracts nearly a quarter-billion fans a year and is the fastest-growing spectator sport in the world.

But by and large, the reason gaming is such a phenomenon on YouTube is that the personalities of our creators shine through the gameplay, turning something that seems passive into active and engaging entertainment. And those creators have also expanded their channels to include comedy sketches, vlogging, and live streaming, further personalizing their channels.

There are also a whole host of creators who've managed to tap into their love of gaming to create complementary content. Rosanna Pansino started a channel called *Nerdy Nummies* to combine her love of baking and video games; her Angry Birds cupcake video has more than 20 million views. The series *Video Game High School* from RocketJump is a serialized drama about competitive gamers that raised almost $900,000 in funding on Indiegogo. And Matthew Patrick (aka "MatPat") has drawn 7 million subscribers to *The Game Theorists* channel, which explains how video games would work if they were subject to the physics of the real world in videos such as "The Science of *Sonic the Hedgehog.*"

In fact, educational content of all kinds—gaming-related or not—is a booming category of online video. While journalists write snarky articles calling YouTube "the home of cat videos," educational

and how-to videos generate five times as much screen time as videos featuring animals.*

Those educational videos include deeply detailed explanations about the discovery of the Higgs boson, as well as instructions for how to replace a carburetor in a Soviet Lada Riva, the first car I ever drove. When I ask older generations how they use YouTube, they often tell me it's to learn how to fix something in their house or see the way an appliance is installed. In its own way, YouTube serves as a Wikipedia for practical matters, showing people how to assemble Ikea furniture or plant their own indoor herb gardens. And it's not just people solving immediate needs; in addition to the millions of people who've learned to play the guitar or build their own furniture by watching instructional clips, the silver medal–winning javelinist at the 2016 Rio Olympics, Julius Yego, taught himself how to throw by watching YouTube videos.

When I asked Hank Green why he thought educational content had never been very successful on TV but thrives on YouTube, he pointed out that online video is "allowed to look cheaper but not feel cheaper.

"If you put *SciShow* on TV, you'd ask, 'Where's the set? Where are the jokes?'" he said. "Online you can do it for less and not have people complain about it."

He also brought up video length. On YouTube, an educational video can be any length, as people might be more open to sitting through three minutes on fractions than thirty. "And what are you going to do with a two-minute-long video on physics on TV? Sneak it in between commercials?"

The on-demand and searchable nature of the content is also crit-

* Though "How to Draw Grumpy Cat" probably gets double-counted.

ical. "If someone is studying the respiratory system right now, they need a video on the respiratory system right now. They have a test tomorrow. They're not going to wait for it to come on TV."

That gives online video a massive advantage over educational and instructional cable channels. The Food Network, HGTV, and the History Channel can be enormously entertaining and great sources of inspiration. But most of the time when we're cooking, remodeling, or helping our kids with their history lesson, we need information instantly. When you're on the hook for cupcakes at your daughter's bake sale, chances are that Rosanna Pansino is going to be of greater help to you than Guy Fieri.*

The ability to instantly gratify someone's informational needs suggests to me that instructional content has a far healthier future online than on TV. And the interactive relationship between creators and fans means that even if you don't see a video catering to your specific interest, you can always request one in the comments (good luck trying that on TV).

The more you look at successful, tailored categories of content on YouTube such as gaming or cooking or home improvement, the more you see something that resembles a well-stocked magazine stand. Publications from *Architectural Digest* to *Modern Farmer* to *Field and Stream* all have online video analogues. If you want to start the next great YouTube channel, it might be worth your time to see which interests can sustain themselves in print but haven't yet struck gold online.

The magazine comparison is especially apt when it comes to beauty and fashion. Before YouTube, if you wanted to learn how to create the perfect smoky eye or learn about the latest fall fashions,

* In fact, that's probably true in most circumstances.

you were pretty much left with your subscription to *Seventeen* or *Vogue*, which only featured pictures and text.*

Today, you can get that information through the rich fidelity of video, relayed to you by someone of your own race or ethnicity, with a similar body type and hairstyle, in your own language. You can hear from someone who hasn't been airbrushed and can admit his or her imperfections, whose personality makes things far less intimidating than the magazine page does.

And just as gamers are popular around the globe, each country seems to have its own reigning beauty blogger, from Yuya in Mexico (YouTube's most popular female creator) to Bianca Heinicke in Germany to Da Sol Lee in South Korea.

When I spoke with Hank about the appeal of niche content on YouTube, he pointed out something else that tied beauty and gaming together. "They are both things that we glorify, but we're also a little ashamed of as a broader society," he said. "We don't want young women to be thinking too much about the way that they look, except that's the only feedback they ever get from society. You probably shouldn't play video games all the time, but also—" and here he sat back and exclaimed, "GUNS AND VIOLENCE AND EXPLOSIONS!"

In this way, he suggested, YouTube is like a psychic release valve for the dissonant signals that society sends us. As a woman, you face pressure to look polished and made up, even if it's superficial to care about such things. As a man, you have to make a show of your masculinity, but really, can you please turn off that violent video game?

––––

* My daughters helped me with this sentence.

After I finished speaking with Jenny, I asked Al for a tour of Missouri Star's warehouse, where those five thousand orders a day are fulfilled. We drove the mile or so south from the company's stores to a wide tract of land behind a Conoco station. On the plot was a 42,000-square-foot warehouse constructed of white corrugated aluminum, about the size of a supermarket. Behind that was an even larger construction site. The first warehouse, which had been supposed to last the family "until we died," Al said, had lasted just a year. It was impossible to predict how long the new 104,000-square-foot warehouse they were building would last.

We walked into the warehouse, and the high ceilings, huge surface area, and dim lighting made it feel like a Home Depot. Al said hi to several of the workers, addressing most of them by their first names. They were all happy to see him, though seemingly a little surprised as well, as though he hadn't been around for a few weeks. I took that as a sign that things were running smoothly.

He showed me how orders came in, how fabric to fill them was found and cut and bundled, how they were grouped into bins and shuttled through the facility to be packed and eventually shipped. The most popular fabrics were arranged closer to the cutters for speed and efficiency. I asked him whether he'd hired supply-chain consultants or efficiency experts to design the warehouse. I should have been prepared for his answer, but I wasn't.

"No, I actually learned how to build this warehouse from watching Amazon videos on YouTube." He watched footage of the company's fulfillment centers, pausing to take notes about how things were arranged. He seemed a little embarrassed. "I don't mean to sound ego-stroking, but, like, legit, I just watched videos on it." A business built on instructional videos using instructional videos to build its business; it was almost too perfect.

Streampunks

—

Before Missouri Star opened in Hamilton, the town's main claim to fame was that it was the birthplace of James Cash Penney Jr., the founder of the nationwide department-store chain that bears his name. To commemorate his birthplace, he opened the five hundredth JCPenney location on North Davis Road in downtown Hamilton in 1924. The location closed long before Jenny started Missouri Star, but when the family bought the building to create a shop for their solid fabrics, they named it Penney's Quilt Shop, in a show of respect. A plaque recognizing him hangs on one of the brick walls of the store.

After speaking with Al and hearing about his ideas for further expansion of the business, I started to think about that historic coincidence. He told me about how the company is planning to eventually break into other areas such as knitting and crafting, using the same combination of customer service, technological foresight, and social marketing that has served its quilting business so well.

"Quilting was just this forgotten industry that we got to come into and treat really, really well," he said. "By being focused in a very niche area, it has let us build this identity and connect with people. . . . We're willing to go superdeep and earn that authenticity with our audience. That's the thing that most companies can't do."

On the drive back to Kansas City from Hamilton, I couldn't help thinking what it must have been like to visit Bentonville, Arkansas, the home of Walmart, in the early 1960s. Is Missouri Star a modern-day Walton five-and-dime, a family-owned business led by passionate and ambitious personalities growing at an astounding rate? I don't meant to say that Missouri Star will be the next Walmart or

even the next JCPenney.* But the Doans are demonstrating an entirely new way of doing business, attracting hundreds of thousands of global fans and resuscitating an entire town in the process.

"It's funny," Al said, "but I would have given up on this a long time ago if we didn't have that marketing ability to push it out. Because literally, I couldn't have seen the opportunity here. Nobody could see the opportunity without YouTube."

* Coincidentally, Sam Walton's first job was as a management trainee at JCPenney.

8

The Struggle Is Real

Why Today's Stars Have to Give 110 Percent in a 24/7 World

THE STORIES OF Jenny, Lilly, Tyler, Hank, and John illustrate, to me, the fundamental traits of successful YouTube creators. They are experts at forming and nurturing communities. They are fundamentally true to themselves, offering revealing and authentic depictions of their lives. They understand how to connect to global audiences, making videos whose appeal crosses borders. They embrace their diversity and the perspectives that make them unique. And they understand the appeal of niches, realizing that it's better to draw a passionate few than an indifferent crowd.

In all these ways, our creators are rewriting the Hollywood rule book. They are highly accessible, responding directly to their fans rather than keeping them at a distance. They reject the highly

polished image management and poll tests that have long defined mainstream media stars. They believe in maximizing the reach of their content around the world, thinking beyond their local audiences. And they understand that often what is most personal and unique is most universal and appealing.

Yet even as rules are being rewritten in the media industry, one thing unites nearly all YouTube creators and Hollywood stars: hard work. I mentioned before that people misinterpret the phenomenon of viral videos for overnight success. If something or someone becomes popular quickly, the assumption is that success occurred on the first try. But the reality for the vast majority of YouTubers who reach a million subscribers is that success is a long, fraught journey through largely uncharted terrain. Those who succeed do so because they're persistent and devoted, willing to submit themselves to constant public evaluation across many years. Even Psy, the ultimate YouTube phenomenon, was uploading music videos to his YouTube channel for two years before "Gangnam Style"; he released his first album almost ten years before that.

In fact, the more you dig into the biographies of successful YouTube creators, the more you realize just how long their journeys have often been. Hank, John, and Tyler all joined the platform in 2007 and have few massive video hits (Tyler has three videos on his channel with 10 million views; Hank and John have one). Michelle Phan, YouTube's first beauty sensation, joined YouTube a year earlier, in 2006. One of YouTube's most popular channels, belonging to the comedy duo Smosh, started before YouTube was even founded. The pair uploaded videos and flash animations to their own site before transitioning to YouTube in 2005. And they weren't alone; the founders of several successful online content shops, from Buzz-Feed to CollegeHumor to Vice, were making online video content

pre-YouTube, before eventually using the platform to reach a mass audience.

The first time I ever heard of Adande (aka sWooZie)* was in 2016, when he was asked by the White House to interview President Obama following the State of the Union address. During the interview, Adande asked the president thoughtful, pointed questions about police violence and racial profiling, the sensationalized coverage of school shootings, and the challenge of online radicalization, before asking lighter-hearted questions such as whether Obama preferred Drake or Kendrick Lamar.† Since I hadn't heard of Adande's channel, I assumed he'd risen up on the platform recently. But when I looked at his channel, I saw that his earliest videos dated back to February 2006, just a few months after YouTube was created.

I spoke to Adande to try to understand what his decadelong journey was like. He explained that his YouTube career had actually begun because he was going to be on TV. While working as a lifeguard at the Hard Rock Hotel in Orlando, he had gained some notoriety as a competitive gamer, eventually leading to an offer from DirecTV to compete in an eSports competition called the Championship Gaming Series. The interest among his coworkers in his new TV gig led him to document the experience online. "I was a broken record going back to work at Hard Rock and explaining to everybody what it's like to be on a TV show," he said. "So then I figured, 'You know what? Let me just make a YouTube video about this so everybody will shut up, everybody will leave me alone, and I can get back from break on time.'"

* In school, Adande's love of Nike led to kids calling him "swoosh," which eventually morphed into "sWooZie."
† "Gotta go with Kendrick."

He began vlogging about his experiences, in a time well before actors regularly took people behind the scenes of their TV shows. Because what he was doing was so new, he was granted remarkable access with little oversight and the glimpse he provided of TV life helped him generate a small following, but it never became a full-time pursuit.* For the next four years, that was Adande's pattern: he worked as a lifeguard, he competed as a professional gamer with stints on TV, and he uploaded occasional videos to YouTube. Sometimes the videos would showcase his talent for animation, a passion he had cultivated for years, but his videos and his channel largely stayed under the radar. Then, in 2010, he had a chance encounter that began to change his trajectory.

It turned out that one of his friends was a classmate of Michelle Phan and told her about Adande's early success on YouTube. At that point Michelle was one of YouTube's biggest stars, and she sensed that Adande had an opportunity to also break through. She reached out to him and encouraged him to focus on building up his YouTube channel. After telling him she was making $300 a day from her videos, he was shocked. "I'm, like, 'What? You're making *what* a day, from just doing makeup in your bedroom?'" In a further effort to convince him, she offered to let him shadow her on a brand-sponsored weekend trip she was taking to New York.

He enjoyed it. "I felt like freaking Usher," he told me. "We would go to restaurants, sit down, eat, get up, and leave without even paying. Everything was comped. Everything was taken care of. It was just unbelievable. Her hotel room? Nuts. Raid the minifridge, order steak for breakfast, lunch, and dinner. It was insane. When my fam-

* Early YouTube employees actually caught wind of Adande's channel in 2007 and offered him a deal to earn ad revenue as one of the first members of the YouTube Partner Program, but he turned it down over concerns that he'd have to delete some of his videos and start from scratch.

ily went to hotels, it was, like, 'Do not even look at the minifridge.' But Michelle was telling me 'Raid the minifridge. We are losing money if you don't.' So at that point I was, like, 'Okay, if I can raid the minifridge anytime I go to a hotel, then I need to take YouTube seriously.'"

Amid the whirlwind tour, Michelle also instilled in Adande the importance of plotting out his growth. "You can blow up one of two ways," she told him. "You can blow up off of luck or you can blow up with a strategy, and I'm going to suggest a strategy." After looking over his channel, she offered some tips that would inform the rest of his YouTube career. "I noticed your animation videos do best," she told him, "so maybe sprinkle in some more animation into your stuff." She also told him to keep things short because his ten-minute behind-the-scenes videos limited his exposure. She told him to focus on writing catchier titles and improving his thumbnails while he furiously tried to write down all her advice.

Adande left the weekend inspired and spent the next few days plotting out his next video. He noticed that confessions—videos of people confessing about their jobs or relationships—were a big trend on YouTube at the time. The revealing nature of confessions naturally inspires curiosity among viewers, who think they'll be hearing someone's closely held secrets. So he thought back on his own life, to a brief stint he'd had working at Disney World, and began mapping out a confessional about his time there. He realized that the brand was well liked and that his video would have a built-in audience just among current employees. "I googled and saw Disney had sixty thousand employees worldwide, so I figured, All right, maybe that's a good starting point"—a target of 60,000 views. He stayed up all night editing the video and uploaded "Confessions of a Disney Employee" at 6 a.m. Then he went to bed.

By the time he woke up at noon, the video already had 100,000

views. "Up until that point, I knew most of my subscribers by name. Like, I would say, 'Oh, that's Doug. Oh, here's Sarah.' And then I checked my Twitter and it looked like I got hacked because I was getting tweets from everybody. I got a tweet from a DJ in Afghanistan, and I was, like, '*What is happening right now?*'"

———

At the start of the book, I talked about how the opportunity to be a video star has never been greater. The fact that anyone with a smartphone and an Internet connection has the potential to reach over 1.5 billion people represents a democratization of visual media that's unprecedented. Jeffrey Katzenberg, a forty-year veteran of the media industry, put it to me this way: "There's never been more opportunity and there's never been more distribution platforms and there's never been a greater appetite and there's never been more content being consumed by people than there is today. It's extraordinary."

But there's a flip side to this expansion of opportunity. "At the same time," Jeffrey continued, "there's actually more content being made than ever before." In other words, the democratization of content creation has led to the fierce explosion of competition. YouTube alone had one thousand creators cross the 1,000-subscriber threshold every single day in 2016. Breaking through the noise to capture a viewer's precious attention has never been harder, even if opportunity exists for nearly anyone to do so.

Some observers argue that this new dynamic makes it harder for aspiring creators or musicians to succeed. I just don't see how that's possible. The media industry may never become a pure meritocracy, but a system that is open to everyone and shares revenue with anyone is far more meritocratic than the gatekeeper-dominated

model that used to prevail. If the old model of media success was assigned seating, now it's musical chairs. In a stadium. It may be tough to get a seat, but at least everyone can try.

Casey Neistat, a filmmaker who won an Independent Spirit Award and had an HBO series years before he started a YouTube channel, explained the new-media meritocracy to me this way: "If people care about what I have to say, people watch the content. Not based on how well I know Carolyn Strauss, the [former] head of programming at HBO. . . . In the history of communication, the opportunity right now is greater than it's ever been. And it's in a place that is democratic, that is egalitarian, that is accessible by all, and that has the same entry point, whether you're a dirt-poor kid with a fucked-up little Android phone that lives in the Midwest and has to go to the library to get free Wi-Fi, or whether you're Steven Spielberg. The viewers don't give a shit. If the kid in the Midwest makes something that's better, that's what people want to see. You will succeed if you have a message people want to hear."

I asked Casey, based on that view, what advice he would give to that midwestern kid just starting out. He told me that the only real answer is to figure it out. "If you try to base your path to success on YouTube on what anyone else has done, you've already failed. Because there are no two trajectories that are alike. . . . And on YouTube you truly have to pave your own path if you want to succeed. If you're swimming in a swimming pool with over twenty million people, you can't just grab onto somebody's ankles and say, 'This is going to work for me, too.' It requires a kind of ingenuity that goes way beyond the content that you're making to find success."

I asked several other creators a similar question. Tyler's advice mirrored Casey's and echoed what he told the crowd at VCU. "Give to YouTube what only you can give," he said, adding, "And you will

not have a million views on your first video, and that's so okay. It took me five years to go full-time."

Hank stressed the importance of collaboration. "Find people you love working with and make stuff with them, because I think we may be out of the era in which it's easy if you're one person. It's very much, in my head, the model of the rock band, where, yeah, maybe you got a lead singer, but five people are necessary to make this work and you have to have a really good relationship and you have to have a great time doing it. Don't do it yourself."

But Adande gave me the most brilliant, specific answer to this question I could have imagined. "You've got to keep the videos short," he told me. "When you're first starting out, your fan base is going to be your friends and your family. Those are the people who are going to watch your videos. So respect their time. Two minutes at first is going to be the max, I would suggest. After that, talk about stuff that will have your friends and family share it. And the best way to go about figuring out what that is is to watch their feed; watch their Twitter feed, watch their Facebook feed. Whatever kind of videos they're posting, break down the DNA and see, okay, they're sharing funny stuff. Oh, they're sharing cat stuff. Oh, they're sharing Buzz-Feed. Figure out, how can I implement my version of this stuff?"

I could almost hear him channeling Michelle and the first conversation they had about YouTube strategy back in New York. The more questions I asked him, the more nuggets of wisdom he shared. "If you'll notice, one of my little secret tricks is to either say something pretty funny or ask a question within the first fifteen seconds [of a video]," he explained. "We're all kids of the Internet now; we all have ADD. So I have fifteen seconds before you click off of this video. And I've got a five-second ad that runs before my video. Well, that's five seconds out of that fifteen. Now I've got ten seconds to grab you."

When I told him I was surprised how focused those tactics are,

he traced them back to his roots in professional gaming. "You get to a point where you're competing with the best in the world," he explained, and so you're left to look for an edge. "Every video game is based on animation. No game can escape that fundamental rule. So if I as a player learn all the frame data for each character, I know that if you pick Ken in *Street Fighter* he has a nine-frame punch. So if I block that punch, you have four frames of recoil animation. I have four frames where I can do whatever I want to you. That's how to break down any fighting game. And I applied that same kind of strategy to YouTube, and it worked." It was clear: Adande's strategy was to gamify YouTube.

"In the fighting-game community we call it *yomi*. It's a Japanese term, and it's knowing the mind of your opponent. So when I know what you want to share before you even get to share it, that's the best place to be. And that's honestly how I started out. It was just making sure that if I can get my friend to share, his friend might share it and their friend might share it, and boom! The word *viral* is thrown around so much. I think it loses meaning because people just figure, 'Oh, viral. It means a lot of views.' No, viral is like a cold. I catch it, and it stays alive because I touched this door handle and then someone else touches that door handle and then he shares it and he shares it and he shares it. It's something that's *awesomely* shared. So I want to make my videos like the flu; you have to share this, and it's going to go everywhere."

———

Of course, success has its own challenges. Although, as I argued in a previous chapter, fame may be a more fluid concept today than in the past, the drawbacks of fame are largely static. Adande told me about the media training he received before filming his reality TV

show. "One of the things that they told us on day one was, 'You are now in a glass house. When you step outside, [your fans] own you. If you don't like how that sounds to your ears, this is not the industry for you. If you don't like the idea of people going through your trash when you put it at the end of your driveway, this is not the industry for you. They're going to want to know your business. They're going to want to know your love life. They're going to want to know everything about you. So if you're not comfortable with that, this is not the industry for you.'"

As he pondered that trade-off, Adande thought about some of the experiences he'd had with celebrities while working at the Hard Rock Hotel. While serving as head lifeguard, he'd often see big names. Some, such as Jay Z, signed every autograph and posed for every picture. Other celebrities "hated their fans," he told me, and didn't want to interact with them.

"A fan would recognize one of these rock stars, run up to them, and the rock star would not even look at them in the face," Adande said. "And I'm, like, 'Are you joking? This kid is the reason you're here. And you're not even going to acknowledge their existence?' I would tell myself, 'If I'm ever in that position, please believe I'm not doing it how you're doing it.'" When he started accumulating fans, he made sure to reply to all his emails, direct messages, and comments, never forgetting that "your fans are your boss."

For some creators, especially those who chronicle their relationships on their YouTube channels, life in a glass house can be difficult. Charles Trippy, who continues to film the longest-running daily vlog in history (eight years and counting), devastated his fans when he revealed that he and his costar wife, Alli Speed, were filing for divorce. Similarly, Jesse Wellens and Jeana Smith ran the massively successful *PrankvsPrank* channel before branching into daily vlogging. Four years into that experiment, the couple announced

their split, citing the stress of the day-to-day chronicling of their lives as a factor in their breakup.

In Tyler's tour documentary, there are a couple of revealing scenes where he appears flustered, first when fans follow him back to his hotel after a show and later when some organizers at VidCon fail to provide him with a graceful escape from a swarm of fans at a meet-and-greet. He was nervous about including the scenes, he told me, because they didn't show him in the best light. "On YouTube, it's so easy to just present three minutes of flattering," he told me. "But with the documentary it was like I'm fully fledged, I'm a fucking human. Not everything's great. Not everything has the perfect lighting, emotionally or literally."

I asked Tyler whether this was different from what celebrities traditionally have to face. "I think there's a difference between this form of entertainment and a lot of others where—maybe a movie star, yes, it's a difficult job, but the timing—you maybe work on one project a year," he said. "It's okay for you to take a step back; your audience expects that.

"A YouTube creator, it's every week. There is no off-season. It's constant, and it's been constant for a lot of us for almost a decade. And having gone into those other [Hollywood] realms, there's so much more support. As a YouTuber, it's so solitary. Oftentimes you're writing, producing, editing, distributing all on your own. When it comes to making a video, it's not just throwing it up against the wall and seeing what sticks. It's the promotion, it's the interactions, it's every little bit of it. If somebody asked me how many hours a week I work, I would ask, 'How many hours am I awake?'"

But all this effort doesn't necessarily impart credibility. "I would say the hardest-working people I know are my peers in this industry and it's because it's an uphill battle to even get it recognized as a job," Tyler told me. "Nobody will call a YouTuber a celebrity, but

they still have to have all of the burdens and the responsibilities and the great things that come with it. Fame is just being known by a large audience. If your latest video gets more views than a season finale of an HBO show, I'm pretty sure you're a celebrity. . . . At the end of the day, how do you navigate fame when your fame is questioned to begin with?"

Tyler's question is one of the fundamental things I wanted to address in this book. Why is a movement that reaches so many people, that's changed so much of how the media industry operates, so easily written off? Many cultural critics are quick to look at popular "Internet celebrities," criticize them as vapid, and suggest that their success is unearned.

Certainly, YouTube's most popular creator as of this writing— Felix Kjellberg, aka PewDiePie—did Team Internet no favors in its fight for credibility when he posted several videos containing anti-Semitic content in early 2017 in an attempt at what he considered humor. Felix's actions were clearly offensive, as he eventually admitted, and in my opinion he underestimated the responsibility he had as the platform's most popular ambassador, even if he himself is not a hateful person.

Many were quick to compare Felix to Hollywood figures such as Mel Gibson and Charlie Sheen, who also made disgraceful comments. To me, a more appropriate analogy might be to Ted Danson.

In 1993, Danson was TV's biggest star, having just concluded a phenomenal eleven-year run as the bartender Sam Malone on *Cheers*. The show's series finale was watched by more than 90 million people, becoming the third-highest-rated episode in TV history. But just five months later, he appeared at a Friars Roast of his then girlfriend Whoopi Goldberg wearing blackface and made several racially insensitive jokes. I don't believe that either Danson or Felix

was attempting to be hateful, but both used deeply offensive language and imagery in distasteful attempts at humor.

What I hope other creators take away from Felix's fiasco is that their fame, even though it is solely a result of their own work, does not come without obligations: to be thoughtful, to understand the reach of one's influence, to weigh the demands of providing entertainment against the offense one's actions may cause.

Obviously YouTube believes in the importance of free speech and free expression—I more than most, having grown up in a repressive regime of state-controlled media—but the right of a creator to say something offensive is not the same thing as his or her need to say something offensive. Under the blinding glare of today's 24/7-Internet-enhanced news cycle, the risks of missteps are only heightened. I'm not so sure that Ted Danson would have gotten a second chance if a video of his epic blunder were up on YouTube.

All that said, those who argue that Felix's popularity (or that of other Internet celebrities) is unearned are underestimating the sheer amount of work that goes into an online career. Luck is a crucial part of anyone's success, no matter what industry he or she is in. But luck is less important in media now than it has ever been, because new stars aren't created, they're chosen. If you want to criticize that system, your quarrel is with the public's taste, not the work ethic of the talent.

"You don't got to love it, the phenomenon of YouTube," Tyler told me. "You don't got to tune in, you don't got to watch. But you can't deny that it's happening. There are shows that I will never watch; there are movies I'll never see. But I would never act like they're not entertainment for somebody."

Now, sure, the Internet might catapult some people to the top for seemingly unknown reasons,* but it takes perseverance and dedication to stay there. Just the thought of peaking in popularity is enough to give a creator nightmares. "The Internet can be a very unforgiving place," Adande said. "I've seen other YouTubers who are way bigger than me fall even harder, and they haven't been able to pick themselves back up." Dealing with fickle audiences is nothing new in media, but on a platform where popularity is measured by the number of a channel's subscribers, a creator's struggles happen in plain sight. Adande described a creator's success as "the invisible cool." He told me that "once the invisible cool leaves your channel, it's almost impossible to start that train back up."

Having studied channels and creators whose audience numbers have peaked, Adande traced their downslide back to one thing: predictability. "If your audience ever gets ahead of you, that's when your problems start," he told me. He mentioned that a couple of his favorite YouTubers had become too formulaic, from the type of content they produced to the type of filming techniques they used. At a certain point, Adande knew what their videos would be like before he even clicked on them. The priority has to be to keep innovating, he told me, to keep trying new things, in the hope that you're not moving too fast for your audience. Again, he told me, "The fans are your boss."

Matthew Patrick, better known as "MatPat," spent years advising creators and brands on YouTube strategy before launching his own successful channel. When I asked him about the struggles of keeping up with his audience, he compared being a successful creator with running on an endless treadmill. "You're constantly having to one-up yourself," he told me. "You're constantly having to

* "Damn, Daniel."

deliver videos. So YouTube takes no mercy if you're feeling down or creatively burned out or whatever. There's so much content, there are so many other talented creators, and the Internet has such a short attention span. If you take a couple of weeks off, there's a good likelihood that you're going to lose a big portion of that fan base to something else."*

Then there are the comments.

Managing your community actively means reading your digital fan mail, as painful as it can sometimes be. According to Matthew, that makes being a creator "simultaneously the hardest, most rewarding, most emotionally battering, but also most uplifting, job you could ever ask for. Nothing beats the joy of getting to see a room full of fans or hearing stories from people where they're, like, 'Hey, I was going through a tough time and you brought me through it' or 'Watching your videos made me feel better' or 'Watching this episode helped me pass a test.'

"But for the thousands of positive comments, there's always going to be the people who just, like, bash you for no reason or didn't understand the video and are just, like, belittling you and attacking you personally. And that's hard to stomach a lot of times, because those are always the ones that stick with you."

It reminded me of something Lilly had told me about a comment someone had left on one of her videos. It was a single, offhand mean-spirited comment about how YouTubers would "have to go back to school and learn how to function as normal people" once people stopped watching their channels. She said it had terrified her.

Amid all this stress and hard work, I asked Matthew if he ever

* His manager told me that anyone who wanted to be as successful as Matthew should watch a video of him signing autographs for three hours to understand the energy and patience it takes.

doubted it was all worth it. "It's totally worth it," he said. "At the end of the day, the thing I always remind people is, like, the number of positive fan engagements that you have, the number of positive engagements that you're having in someone's life, are so much more valuable than the one person who decided to leave a hate comment because they don't like the sound of your voice or whatever. And you just have to remember that, in any part of life, whether you're a YouTuber or not, you're never going to please everyone. There's no one solution where everyone is happy. And as long as you are happy with the content that you're creating and the effect that you're having, that makes it all worth it."

One of the biggest efforts we made at YouTube to boost the credibility and staying power of our creators was an attempt to bridge something we internally referred to as "the *Mad Men* gap." By 2013, several of our most popular stars were drawing audiences larger—in some cases much larger—than their counterparts on cable. Bethany Mota, an eighteen-year-old fashionista vlogging about clothes from her bedroom, had more people tuning in to her channel every week than *Project Runway* did. More people were watching Rosanna Pansino, who baked cupcakes in the shapes of her favorite video game characters, than *Iron Chef.* And Vice, whose raw global news and documentary footage was targeted at Millennials, was pulling in larger audiences than *Anderson Cooper 360°.* All told, more people in the United States were watching YouTube than any cable network.

Yet despite those numbers, most Americans had never heard of Bethany, Rosanna, or Vice, but nearly all had heard of *Project Runway, Iron Chef,* and *Anderson Cooper 360°,* even if they never watched

those shows. Our creators struggled to get coverage in the press and Hollywood trade publications and were overlooked even by sites covering new media. Attempts by our PR staff to pitch stories to magazines or daytime TV were often met with long silences, blank stares, or flat-out rejections.

And it didn't stop at press coverage. Brands were reluctant to advertise on YouTube stars' channels despite their massive viewership, claiming that their content didn't provide "premium" inventory. "Premium," in this case, implied two things. First, that the quality of the content YouTubers were creating couldn't measure up to what you might find on TV. Positioning your brand alongside a multimillion-dollar show starring Heidi Klum is one thing; positioning it alongside a teenage vlogger broadcasting for free from her bedroom is quite another. But the word *premium* also implied that YouTube's viewership was less sophisticated and therefore less valuable to brands in terms of both disposable income and cultural cachet.

Beyond the trouble they had earning ad dollars, creators struggled to sign endorsement deals, get representation by the major talent agencies, or branch out from YouTube. Their "ratings" may have been huge, with tens of millions of people tuning in to their content every week, but that popularity hadn't translated into mainstream cultural relevance. Our top creators were more like obscure bands you'd never heard of, except that in 2013, more people watched any one of their videos than bought Justin Timberlake's album.*

Around that same time, on TV, the show *Mad Men* had become a bona fide cultural phenomenon. It seemed as though everyone in the country had heard of Don Draper and the crew at Sterling

* *The 20/20 Experience* was the best-selling album of 2013, with 2.43 million copies sold.

Cooper. In addition to his starring role in the show, Jon Hamm became the voice of both Mercedes-Benz and American Airlines in nationwide ad campaigns. Multiple press outlets, podcasts, and entertainment magazines dissected nearly every aspect of the show, from its fashion to its historical accuracy to its soundtrack. Overnight, it seemed as though every bartender in America was wearing a skinny tie and knew how to mix a decent old-fashioned. But even the most watched episode of *Mad Men* drew only 3.5 million viewers nationwide. Over four million *Californians* watched Michelle Phan's most popular video.*

So what explained our *Mad Men* gap? Why did we lack such influence even though we drew such large audiences?

Part of our problem was that our audiences were dispersed globally instead of concentrated in the United States, so general awareness was harder to build in specific markets. Another factor was that our audience was much younger on average than the cable or broadcast TV audience. The average cable TV viewer is in his or her fifties, and the average broadcast TV viewer is in his or her sixties. Our average viewer is in his or her twenties. Although you'd think these differences would be assets to publications wanting to attract Millennial readership or to brands wanting to expand their global presence, they were perceived as liabilities.

Our larger problem, though, was all about marketing. Although YouTube gave its creators a powerful and free way to distribute their content, we didn't provide them an equally powerful way to market their content to new audiences. Our algorithms recommended shows to new viewers—and those recommendations actually account for the majority of the time people spend watching YouTube—but they still largely had the effect of preaching to the

* It was a makeup tutorial on how to look like Barbie, but still.

converted, those who were already eagerly consuming content on the platform. And our creators, many of whom had started their careers in their bedrooms with little to no money, didn't have the budgets for print ads or commercials. Nearly every single person who knew about a creator was already watching him or her—as opposed to the tens of millions of people who had heard of *Mad Men* but never got around to watching a single episode.

In this way, our creators are more like entrepreneurs than celebrities. They start out by drawing support from friends and family. As they grow and develop, they expand that circle, relying mostly on word of mouth and social networking. Eventually they reach a size where they're able to generate revenue (mainly through YouTube's Partner Program) that they can reinvest in their nascent business to grow their audience. But as with a start-up, that reinvestment is primarily in their product—their videos—rather than in marketing or PR. Even if they're able to reach audiences in the millions, creators are essentially still operating in "stealth mode," finding new audiences through word of mouth.

TV and film studios, on the other hand, have massive marketing budgets, usually equal to the cost of producing a film or show. They use those budgets to flood us with information about the newest films and shows through ad campaigns and press tours. Although that marketing expenditure isn't incredibly efficient in terms of bringing in audiences (very few people who see an ad or read an article about a film or show end up seeing it), it does a tremendous job raising the awareness of a premiere, ensuring press coverage, and attracting advertising dollars.

Faced with the *Mad Men* gap, we realized that if we were going to elevate our stars and draw more advertising dollars to their channels, we would have to take a page out of Hollywood's playbook and prime the pump. We would have to invest in the kind of broad-

based traditional marketing campaigns that studios do so well in order to shine a light on a few creators we felt were emblematic of YouTube.

Starting in 2013, we spent tens of millions of dollars advertising popular YouTube creators and channels in TV commercials, on billboards, and across websites and apps. In the key advertising markets of LA, New York, and Chicago, we wrapped ads around subway cars, painted murals, and advertised on taxicabs. We did fan meetups on Madison Avenue. We bought print placements in *Allure*, *Seventeen*, and *Entertainment Weekly*. In a move that felt wholly appropriate, we even ran a TV commercial before the season six premiere of *Mad Men*.

Before we launched our campaign, we hoped we'd be able to raise advertisers' favorable perception of YouTube by about 20 percent within a year. We hit that goal in less than three months. Ninety percent of advertisers who recalled seeing an ad said that it had improved their opinion of YouTube's quality. Seventy-seven percent said the ads had increased the likelihood they'd advertise on our platform.

In the press, we saw an immediate spike in both receptivity and interest from top publications and talk shows. Before the campaign, we couldn't get *People* magazine to answer our emails or return our calls. Afterward, it profiled all three of our first wave of featured creators (Bethany Mota, Rosanna Pansino, and Michelle Phan). Something similar happened on TV. Within weeks, Rosanna was baking cupcakes with Al Roker and Savannah Guthrie called Bethany a "mogul in the making," while Michelle discussed her career with Barbara Walters and the cast of *The View*.

Critically, that coverage began to move the needle among the public as well. We more than doubled the awareness of Michelle, Bethany, and Rosanna in key markets, and all three saw their You-

Tube subscribers and views jump. Perhaps most important, their success led to a halo effect on all of YouTube and its creators, boosting our ability to both sell ads and earn press. The success of our US ad campaign led us to feature creators, around the world in campaigns in the United Kingdom, Brazil, Japan, India, and Australia.

There's a saying in Silicon Valley: "Marketing is the price you pay for a bad product." That attitude derives from a belief that well-made software can thrive on word of mouth alone. In fact, before she was CEO of YouTube, Susan Wojcicki was Google's first marketing director; her initial budget was $0.

What we've learned at YouTube is that creators and content are not software; they're not products. Word of mouth and a zeroed-out marketing budget can take you pretty far in the age of streaming video, but there are limits. If you want to go beyond those limits, you need to seek out the Mad men.

9

Revenue Streams

Funding Creativity in the Digital Age

IF YOU WERE walking quickly down 9th Street in the SoMa neighborhood of San Francisco, you'd probably miss the offices of the crowdfunding start-up Patreon. The company's three-story building is painted dark gray and the windows facing the street are frosted, only letting in light, betraying no hint of the creativity inside. But inside the lobby is filled with an unmistakable energy. Young software engineers in hoodies and leather jackets sit on stools and flit between Slack channels, Javascript code, and YouTube videos. The building is full of the usual tech company conveniences: bikes are hung on the wall, and just off the lobby there's a kitchen with the requisite espresso machine, a fridge full of free drinks, and a massive jar of protein powder atop a shelf of snacks, a common sight in typically male-dominated tech start-ups. A less common sight

are the guitars hung up across from the bikes, just a few feet from a drum kit, a grand piano, and a keyboard. If there are brogrammers who work here, they can probably read sheet music.

Patreon was founded in 2013 by the musician Jack Conte, who is by turns earnest and energetic when describing the company's founding. Jack, who is tall and slim with a shaved head and a bushy brown beard, wore a hoodie when we met. But despite dressing like a founder, he said he had never had any intention of starting a tech company. He graduated from Stanford in 2006 with a degree in music and subsequently moved in with his father to follow his dream of becoming a musician. While his friends applied to medical school or found high-paying tech and finance jobs, he played local music venues in San Francisco for "pizza and beer" and had to beg friends to come see him play. He had a semiregular gig at a laundry called BrainWash just a few blocks from Patreon's headquarters.

"That was a really dark, dark time for me," he said, "just because it's scary to not know—to choose to be a musician and to not have a 401(k) and all that." He talked about the early tours he went on, each story worse than the last. In one instance he was touring with a band who were all under twenty-one. The bouncer of the bar where they were scheduled to perform confiscated their fake IDs on the way in, leaving Jack to play the show alone. "I got in, and there was the bartender and me, the two of us. And about ten minutes into the show, the bartender left. I was playing this show with nobody in the room. That was the low point for me." He ended up losing money on the tour.

Still he kept following his dream. He did two more tours and played both solo and together with his longtime girlfriend Nataly Dawn as the band Pomplamoose. Early in 2007, Jack stumbled on a YouTube video of a kid playing an acoustic guitar and singing a song. The quality was poor, but it had 300,000 views. "Meanwhile,

I had just finished an album that took me six months, four tracks, polished, clean," he said. "I mean, it was my first major release, so it wasn't amazing. But it was better than this, definitely better than this webcam video, and I was getting three plays a day on MySpace." He thought, I'm uploading my art to the wrong website.

Soon he shifted his energy to a YouTube channel and began pioneering a way to make music by layering video clips the way musicians loop audio clips, allowing one person to play every sound or instrument in a song.* Pomplamoose began to draw larger and larger audiences, eventually earning enough money through touring, brand partnerships, and iTunes sales to buy a farm in northern California, allowing Jack to move out of his father's house.

But the band's newfound success proved paralyzing. For three years he and Nataly tried to write their next big hit but never ended up releasing a single song. Nothing they came up with felt good enough. Eventually they put the band on hiatus. Nataly began raising money on Kickstarter to produce a solo album, while Jack became obsessed with electronic music. He spent two years working in his studio, reading music manuals and learning how to program synthesizers. Nataly embarked on a European tour, leaving Jack alone to tinker on his own music. Eventually he wrote a dubstep track called "Pedals" that he wanted to release and set about recording a video for it.

For three months, Jack worked fanatically on his vision of the video: robots would ascend into the deck of a Millennium Falcon–like spaceship via rotating elevators, while Jack shredded his guitar in between them. He single-handedly built the spaceship set, assembling old auto parts he found at junkyards and fusing

* "Video songs" are now a mainstay on YouTube. Jacob Collier, a multi-instrumentalist jazz virtuoso, won two 2017 Grammys for his EP *In My Room* after finding fame on YouTube for his expert take on the style.

washers and lights to the walls, badly scraping his hands in the process. He tinkered with machine parts to construct the rotating elevators, using winches, ropes, and pulleys to achieve his desired effect. He found some roboticists online who could build him an animatronic head that could sing the song's lyrics, as well as a 3D-printed spiderlike robot that he could program to dance along to the music.

When everything was ready, he shot and edited the video over three days. And then, just before he was ready to upload it, he had a thought: What the hell am I doing?

"I just spent three months, and I drained my savings account," he told me. "I spent over ten thousand bucks on this video! And I'm going to post it on YouTube and I'm going to make a hundred fifty bucks from ad revenue." His previous videos had reached around a million views and drawn a very strong reaction from fans in the comments. That kind of enthusiasm should be worth more, he thought. "No delusions of grandeur here; I know I'm not Lady Gaga. I know I'm not Psy. But a million views on a video with hundreds of thousands of comments and a community—that's *something*. It just felt like the value wasn't being translated to dollars."

Frustrated, he came up with an idea. "What if I ask my fans for a buck every time I release a music video?" he said. "Not 'Hey, you have to pay a dollar to see the music video' but 'Hey, I'm making music videos anyway. You know this because you've been following me on YouTube for eight years. Year-round, you know what I do. How about being a patron of me? Let's make art the way art has been made for thousands of years, which is, some wealthy dude gives an artist a bag of coins and says, 'I like that. Go make more of that.'"

Jack's idea was an old concept, retooled for a digital age where contributions could be diffused across many people rather than

come from one wealthy patron. He imagined building a crowdfunding platform that would pay its bills by collecting a 5 percent cut of contributions, a standard share in the industry.

At that point, Kickstarter and Indiegogo had been around for years, but Jack saw a crucial difference. Those platforms had been designed to fund one event or project in advance, resulting in one payout from one campaign. His idea was to help artists get paid on a regular basis, changing the crowdfunding model from onetime donations to recurring monthly ones.

Unlike in the music industry, where an artist might release an album with multiple tracks and then disappear for a year or two, the YouTube cycle favors a model where output is consistently spread out over time. "As a YouTuber, I don't need money for one big project and then I'm done. I need a salary to keep being a creator every month of my life."

In Jack's mind, crowdfunding could become a subscription, not a one-off transaction. The model sort of resembled community-supported agriculture, where people pay farmers in advance for a weekly share of vegetables during the growing season. Instead of a box of greens or a carton of eggs, patrons could help support the steady production of creative work, food for the soul.

Jack sketched out plans for the company on fourteen pieces of paper and sent them to his freshman-year roommate from Stanford, Sam Yam, a computer science major. Sam began coding the new platform that night. Three months later, in May 2013, they launched Patreon. Jack appended an announcement about the formation of the company to the end of his robot music video and finally uploaded it.

Two weeks later, he was earning $5,000 a video from his patrons.

———

The model of Patreon shares philosophical roots with an idea Jack told me about that was first proposed in a blog post by the founding editor of *Wired* magazine, Kevin Kelly. His essay, called "1,000 True Fans," written in 2008 before the emergence of crowdfunding platforms such as Kickstarter and Indiegogo, proposed a new financial model for sustaining a creative career. "The gist of 1,000 True Fans can be stated simply," he wrote. "A creator, such as an artist, musician, photographer, craftsperson, performer, animator, designer, videomaker, or author—in other words, anyone producing works of art—needs to acquire only 1,000 True Fans to make a living. . . .

"A True Fan is defined as someone who will purchase anything and everything you produce. They will drive 200 miles to see you sing. They will buy the super deluxe re-issued hi-res box set of your stuff even though they have the low-res version. They have a Google Alert set for your name. They bookmark the eBay page where your out-of-print editions show up. They come to your openings. They have you sign their copies. They buy the t-shirt, and the mug, and the hat. They can't wait till you issue your next work."

In Kelly's model, a True Fan is also one who is willing to spend around $100 per year to support an artist he or she loves. One thousand fans multiplied by $100 provides an artist with an annual income of $100,000 a year. He argued that in the Internet age, finding one thousand true fans is a reasonable challenge for most artists. "If you added one fan a day, it would take only three years," he wrote.

But the "key challenge" of the model is that artists have to actively communicate with their fan bases. "Many musicians just want to play music, or photographers just want to shoot, or painters paint," but today's aspiring creators don't have that luxury; they have to be there for their fans.

When I asked Jack what type of creator tends to do best on Patreon, he made a similar point. "The most important attribute is

being a great community manager," he said. "Those are the folks who really crush it on Patreon. They're the people who absolutely love their fans and whose fans absolutely love them." When he was building Patreon, some investors pushed him to create a crowd-funding platform for big-name musicians, but he resisted. "I wasn't thinking, 'Let's go after Radiohead.' I was thinking, 'Let's help the people who love their fans to death and whose fans love them to death. Let's help them make money."

Since its founding in 2013, Patreon has collected more than 2.2 million pledges in just four years, and pays out more than $9 million to creators every month. Patrons can choose to contribute either on a monthly basis or "per creation," every time a creator uploads a new work. It's up to creators to indicate whether they've created something new worth unlocking a set of pledges from their patrons, and patrons can choose to withdraw their pledges at any time if they feel that a creator is abusing the system. Creators can also offer tiered rewards for patrons to encourage contributions, such as exclusive access to original content or custom works. When I asked Jack how much the average patron contributes, he said he had initially been surprised by the figure. He had expected that it would be a dollar a month, but it ended up at around $11—or just over Kelly's $100-a-year True Fan threshold.*

Contained within Kelly's essay is the idea of a new type of creative economy. Companies such as YouTube and Patreon are creating a space between superstardom and obscurity that allows creative people to thrive, even if they don't find stratospheric success. "Instead of trying to reach the narrow and unlikely peaks of platinum hits, bestseller blockbusters, and celebrity status," Kelly

* This average total contribution is usually spread out over more than one creator.

wrote, "[creators] can aim for direct connection with 1,000 True Fans. It's a much saner destination to hope for. You make a living instead of a fortune. You are surrounded not by fad and fashionable infatuation, but by True Fans. And you are much more likely to actually arrive there."

"For the first time in history," Jack told me, "YouTube and—no, I'm not going to say other companies—YouTube has enabled people to run small-business content companies. Before YouTube, you were a Lady Gaga or you were playing at a bar for beer and pizza. Before YouTube, you were Fox or you were making an indie film that nobody saw ever and it cost you three million dollars. And then you filed for bankruptcy. And post-YouTube, you can make things and people will watch them. And that's amazing. That's amazing. And that didn't exist ten years ago. . . . What's happening now is the fragmentation of big-business media companies and the emergence of small-business media companies all over the place: podcasting, music, video. And YouTube is fueling that whole thing."

In Jack's vision, Patreon serves as an accelerant of the fuel YouTube provides for creators. He wants to help artists who have found their True Fans scale their channels into small media businesses. "Those media companies that are popping up—and they are popping up left and right, from RocketJump* to Mythical Entertainment†—they're not big companies," Jack told me. "They're small-business media companies, fourteen employees, thirty employees. And they're making six million bucks a year. And they need all of the infrastructure that small businesses need to thrive,

* A production company that makes video game–themed shows and films, founded by YouTuber Freddie Wong.
† A production company that produces YouTube's most watched online daily show, *Good Mythical Morning*, founded by YouTubers Rhett McLaughlin and Charles "Link" Neal.

except they're small-business *content* companies. So it's like a new category of small business that didn't exist ten years ago. Somebody's got to build the tools and the frameworks and the analytics for them to thrive and be successful."

Ultimately, Jack's goal is similar to Hank's: to democratize the job of artist and turn it from a long-shot fantasy into a viable middle-class career, giving people everywhere a job prospect that is potentially more gratifying. "My dream," Jack told me, "is to have kids finishing high school saying, 'Okay, I could be a doctor; I could be a podcaster; I could be a lawyer; I could be a video maker.' I want kids growing up to know that those are options for them, if they want. And, yeah, you've got to work your butt off and you've got to promote and you've got to market. But no matter what you do, you're going to be working hard. So it'd be nice if it was, 'Oh, if I work hard, then I can be a musician.'

He pulled back from the table we were sitting at in one of Patreon's meeting rooms. "God, that would be an amazing world. We're not there right now. We're almost there."

———

Throughout this book, I've made the case that YouTube has been an incredible way for people to find fame. The question this chapter seeks to answer is whether it can provide fortune. It's the same question Jack faced as he was building Patreon: Can a following of millions translate into a career worth millions?

The answer is unequivocally yes. There are thousands of creators earning over six figures a year solely from ad revenue they earn from YouTube, and that number has been growing at a steady clip for years (by more than 50 percent in 2016). And as the only company that offers any creator the opportunity to earn a share of the advertising

revenue he or she generates, we certainly pay better than peers such as Facebook,* Instagram, Twitter, and Snapchat. When YouTube's channel revenue is combined with the eye-popping payouts popular creators can earn from brand partnerships, merchandise sales, book deals, touring, and media opportunities, there's no question that YouTube has been and continues to be a pathway to riches for thousands of creators, several of whom outearn their peers on TV or in film.

In fact, as an industry, creative disciplines are growing in both size and income at a rate faster than the rest of the US economy. In a well-researched piece in the *New York Times Magazine*, the journalist Steven Johnson studied data from the US Bureau of Labor Statistics and US Census to evaluate the financial success of artists in the Internet era. Though artists on both ends of the financial spectrum have been vocal about the Internet being a disaster for artistic livelihoods, Johnson found that the creative class had largely outperformed the economy between 1999 and 2014. Not only did their annual income grow 2 percent faster than the national average, the creative sector† actually grew to represent a larger share of the US economy, from 1.2 percent to 1.3 percent.

When I looked at the data for 2015, the most recent numbers available, the creative sector had grown to an even larger share, nearly 1.4 percent of all American jobs. And that's before you consider self-employed creatives; their numbers grew by over 50 percent between 1997 and 2012,‡ while the total labor force grew by only about 10 percent during that period.

* As of this writing, Facebook has struck deals with large media companies and celebrities to use Facebook Live and is exploring payment options for video posts, though no plans have yet been announced.
† As defined by the major group code 27-0000 in the Bureau of Labor Statistics' Occupational Employment Statistics.
‡ Economic census statistics are updated only every five years, so more recent statistics were not available.

I don't mean to suggest that everyone can become rich on You-Tube or that those who don't simply aren't trying hard enough. I understand and empathize with many people who find themselves in the same situation Jack once did, feeling as though their view counts and their bank accounts should line up more closely. In fact, financially struggling Internet creators often have to face an uncomfortable situation that many traditional media personalities did not: public fame without fortune.

Today, many social media stars live in a limbo where they are famous enough to be recognized in public but not so successful that they can rely on their Internet careers alone for income. In 2015, YouTuber Gaby Dunn wrote an article titled "Get Rich or Die Vlogging," in which she openly discussed this dynamic, citing the embarrassment the actress Brittany Ashley felt when she had to serve drinks at a BuzzFeed Golden Globes party after starring in multiple viral videos for the company.* "Many famous social media stars are too visible to have 'real' jobs but too broke not to," Dunn noted.†

In Jack's view, people are so used to the dichotomy of the superstar and the starving artist that they haven't realized that it's out of date. "Fame used to be binary," he told me, "and now it's spectral." On that spectrum is a range where popularity doesn't correspond with financial success. This is the range Jack and Pomplamoose occupied for years and one he thinks Patreon can help serve.

But that isn't to say YouTube is standing still. Of course, we're

* In the YouTube Red documentary about creators, *Vlogumentary*, Gaby herself is recognized while serving as a courier for Postmates.

† If you've lived in Los Angeles long enough, chances are you've had a waiter you've recognized from an old TV show or an Uber driver who's written some hit screenplays in his or her time. But more often than not, those encounters occur much later in entertainers' careers, after their fame has declined along with their fortune.

working to grow our core source of revenue, video advertising. As we successfully compete for more of the nearly $200 billion global advertising market, the amount we pay our creators will rise, as will the total number of creators we're able to support. Since I joined YouTube, partner revenue growth has averaged more than 50 percent a year. Still, with millions of creators earning money on YouTube, we'd essentially need to become the world's first trillion-dollar company to pay them all a six-figure salary.* Some argue that YouTube should pay out a larger share of revenue than the majority we already provide, but this daunting trillion-dollar math would still hold even if we ran the company as a charity. There just isn't enough money spent on advertising in the world to sustain the number of creators who live on our platform.

That means exploring additional options.

For creators who find themselves outside the top ranks of YouTube, it is essential that they look to diversify their income with merchandise sales, touring, podcasts, direct sponsorship deals, and other complementary moneymaking opportunities, if possible. This approach isn't that different from that of TV, where unless you're Judge Judy (whose contract was worth a whopping $47 million in 2016), endorsements represent a significant source of your income.

When John Green spoke to a gathering of our largest advertisers, he told them that he and his brother earn more money from their channel's merchandise sales than from ads. In fact, he said, advertising makes up only 20 percent of their total revenue and that share has been declining over time. As I mentioned in the last chapter, there's no set path to success on YouTube, but nearly all creators have found it by earning money in multiple ways.

For YouTube, it means exploring a new business model, one that

* Not that we aren't trying!

represents how the majority of money is made in media today: subscriptions.

———

Historically, the media industry has primarily relied on three sources of revenue: advertising, transactions, and subscriptions. Newspapers and magazines run print ads, sell issues at newsstands, and deliver print issues directly to consumers. TV networks earn revenue from commercials, DVD sales, and affiliate fees from cable and satellite companies (derived from cable and satellite subscribers).* And music, which was once primarily a business of selling records and CDs, now earns more money from digital transactions, advertising, and subscriptions.

As streaming has made the ownership of physical copies of music and video less desirable, revenue from transactions is decreasing in relevance,† while digital advertising and subscription revenue streams have grown.

YouTube was built on video advertising, and that will always remain core to our business; it's what allows us to offer our content for free to a growing number of people around the world. But as good as the free YouTube experience is, the efforts of companies such as Netflix and Spotify have demonstrated that people like premium features and are willing to pay for them.

Whether or not people would be willing to open their wallets for music, movies, or TV shows was somewhat of an open question.

* The highest affiliate fee goes to ESPN, which earns an estimated $6.61 from every cable subscriber, whether he or she watches ESPN or not.
† A notable exception is the book-publishing business, where neither advertising nor subscription models have successfully taken hold. Even e-book sales have declined of late, while traditional hardcover and paperback transactional sales have grown.

Many people questioned whether Millennials, who came of age during the height of Napster, file-sharing services, and social media, could be convinced to open their wallets to pay for entertainment. But it turns out that enticing people to pay for things they enjoy is a rather durable business model. And enticing them to pay a flat, predictable fee for a subscription provides a more reliable source of income than a highly variable amount made through occasional transactions.

The growth of subscription services has been spurred along by the smartphone. According to research by Activate, a media consultancy, subscriptions are becoming the dominant business model in the mobile economy. In 2011, only 17 percent of the revenue earned by the top one hundred nongaming apps came from subscriptions; the rest came from a onetime download transaction fee or a "freemium" model, where people can pay to unlock more features within a free app.*

But by 2016, that ratio had flipped; revenue from transactions and freemium features all but disappeared outside of gaming, as revenue from subscriptions shot up to 86 percent of total app revenue. The majority of the top-earning subscription apps were streaming video and music services such as HBO NOW and Pandora, but they also included the *New York Times* and the *Washington Post*. In fact, after the *New York Times* launched a digital subscription in 2011, revenue from subscribers outpaced revenue from advertisers for the first time in the paper's history.

Subscriptions aren't just exploding in media, either. Nearly every experience, from dating (Tinder) to meditation (Headspace) to grooming (Dollar Shave Club) is turning into a subscription. To-

* Gaming apps earn revenue almost entirely through the freemium model, which is why they were excluded in this analysis.

day, you can subscribe to solar energy (Sunrun), expensive watches (Eleven James), or dinner (Blue Apron). With smartphone owners now well acquainted with the idea of paying a significant amount of money every month for their voice and data plans, tacking on a few moderately priced subscriptions doesn't seem so daunting, especially when they're easy to set up with just a few taps on your screen. That level of consumer comfort has made subscriptions as important to the mobile economy as digital advertising is to the Internet economy.

Subscription services have their downsides, of course. They can struggle to gain traction without a "funnel," or a base of free users who may be persuaded to pay. This is why many companies offer a free, advertising-supported service first, before evolving into subscription services. Subscription business models also result in higher "churn," the proportion of users who suddenly stop using the service, than do free services. And subscription business models require a whole host of direct-to-consumer relationship skills, from payment collection to dedicated customer service, that many companies lack.

But if consumers don't churn in the first few months, subscriptions tend to become a comfortable, recurring part of their budget. For media companies that depend on advertising, that stability can be especially important during economic downturns, when corporate advertising budgets are often the first to be slashed. Though you might expect budget-conscious consumers to cut entertainment expenses during difficult times, the cable and mobile phone industries proved remarkably resilient during the Great Recession, as did Netflix and Amazon Prime.

So with a global funnel of 1.5 billion people—and the desire of many of our viewers for an ad-free experience—we set out to build a premium, subscription-based version of the platform that we eventually called YouTube Red.

YouTube Red went through a few iterations before it was re-leased. It was originally envisioned as a music subscription, designed to compete with Spotify and Pandora but offering ad-free music videos, rather than just audio. In addition to the official album and single tracks you can find on any music-streaming service, our version would also offer the millions of covers, remixes, and samples you can find on YouTube. To do this, our teams went through the enormous task of cataloging all the music tracks on YouTube and cleaning up their associated metadata. We eventually released a beta version of the product, called YouTube Music Key, in 2014, providing users the ability to watch music videos without ads and offline them to their phones.

What we quickly learned is that beta users were frustrated by the boundary we had set up between music videos and the rest of YouTube. As hard as we tried to categorize our videos into music or non-music buckets, our viewers still ran into edge cases. What if the song they really liked was an original composition that played in the background of a skateboarding video or an animated clip? Why couldn't they watch those videos without ads? Why couldn't they offline those tracks to their phone?

We realized that the best experience for viewers wasn't to create a firewall between music and everything else but to create a premium offering that covered all of YouTube. So in 2015, we began the lengthy and arduous process of signing new contracts with all our partners, millions in total, in order to offer their content as part of a new subscription service. YouTube Red was born.

For $10 a month, a Red membership would let viewers watch YouTube ad-free, take videos offline, and listen to videos on their phones in the background while they used other apps. That monthly subscription fee would be split among creators based on how much time people spent watching their videos. And the cost of a subscrip-

tion would ensure that partners would earn more revenue from a YouTube Red member who watched their video than from one who watched it for free with ads.

From the outset, we envisioned YouTube Red as a subscription designed to appeal to mobile viewers. Though you can watch video subscription services such as Netflix and HBO NOW on your phone, it's likely the majority of their consumption occurs on televisions or tablets, reflecting the fact that long-form content such as movies or scripted series is best watched on a bigger screen, where you can sit back and enjoy.

YouTube Red's proposition is different; it is more attuned to the needs of a mobile viewer than someone who's sitting in front of a TV. YouTube videos are shorter than your average show or movie, so they're better enjoyed on the go, in the parts of your day where you have some time to kill but don't necessarily have half an hour. Mobility is also important if you're watching a how-to video, where being able to take it with you under your sink or into your garage is key. And YouTube Red's premium features such as taking videos offline and listening to content in the background are primarily mobile-first features.

To increase the appeal of a YouTube Red membership, we began investing in the production of original programming: shows, movies, and documentaries that featured some of our biggest creators. Here again we diverted from the path Netflix, HBO, and even Amazon have taken. Though they have focused mostly on funding splashy, big-budget titles, we first chose to focus on building titles around stars and genres that are already popular on our platform. It's a model based on catering to fans of YouTube, giving them something that builds on what we know they already appreciate.

———

YouTube Red's early results have been promising, pulling in sub-
scriber numbers at a rate ahead of our goals. And the move into
subscriptions has been applauded by people such as Hank and John
Green, who openly question whether advertising is the right busi-
ness model for online video.

Part of their argument has to do with the current rate adver-
tising provides creators versus TV networks. When he visited our
headquarters, Hank told an anecdote while talking about the pros-
pects of advertising on YouTube. "Weirdly enough," he said, "in
my tiny town,* there are two production companies. There is my
YouTube production company, and there's a production company
that makes reality TV shows. We get probably ten times more
views than they get; they make probably ten times more money
than we do."†

But beyond money, Hank and John have argued that there's a
broader flaw in the advertising model: that because advertising is
most effective when seen by as many people as possible, it favors
content with mass appeal, which runs counter to YouTube's niche-
embracing ethos.

"The architecture of the social Internet always favors more,"
John told me. More clicks, more views, more likes, more shares.
Rather than rewarding content that offers an interesting perspec-
tive or enlightens us, John argued, advertising rewards content
that plays to our basest emotions, such as shock, schadenfreude,
arousal, and our love of cuteness. In other words, pranks and fails,
butts and boobs, kids and kittens.

* Missoula, Montana.
† He added, "At the same time, we get to own all our content. We get to
make what we want, how we want. And we get to decide what we do with it
once it's made. And if it keeps making money forever, we keep making money
forever."

"When you look at BuzzFeed, people's options for responding to an article are LOL, WTF, CUTE, FAIL, OMG," John said. "There's never a nuance button. There's never a 'Thank you for introducing me to the complexity of this' button."

The competition between what we at YouTube call "delicious" and "nutritious" content has been a long-running one. When the site was created, one of the first decisions the founders made was to ban pornography, fearing it would become a weed that would quickly overtake the site. Years later, when algorithms were built to recommend videos with the most views, several clips with misleading titles or thumbnails rose to the top. People would click on a video, thinking it would show them a new movie trailer, a specific sports highlight, or a popular news clip, only to see a user discussing that content or even something entirely unrelated. We worked to eliminate spam and particularly egregious clickbait (an ongoing effort), but it was clear that a bigger step was necessary.

After much internal debate, we decided to shift our algorithms in favor of the amount of time people spent watching a video (watch time), rather than the number of times they watched it (views). The amount of time a viewer was willing to spend watching something seemed to be the best signal of how much he or she valued that content, whereas views could be racked up by videos people simply clicked on but didn't like.

The day we made the switch to our algorithms to favor watch time, we saw a scary, nearly 20 percent, drop in total views. It's not an exaggeration to say that many people at the company were freaked out. But behind that drop, we saw that the same number of people were still coming to YouTube and in fact were watching more. The switch had its intended effect: overall watch time increased, signaling that more people were enjoying YouTube videos for longer periods of time. The focus on watch time helped us

eventually cross a major milestone in 2016, with viewers watching a billion hours of YouTube every single day.*

Still, even with better measurement and incentives, John's concerns about advertising running at odds with artistic or intellectual merit persist. It's hard to hear his point of view and not think of Facebook's decision to favor posts by friends and family in its news feed over articles from established journalistic outlets. As platforms compete for your attention, isn't it in their best interest to serve up only what's delicious rather than what's nutritious?

Luckily, in online video as in life, a diet of dessert won't satisfy everyone. What we've learned from our viewers is that although some may satisfy themselves with clickbait, the vast majority have diverse tastes, with multiple subscriptions across a range of content categories. As far as recommendations go, often the type of video you're most likely to watch next isn't some other version of what you've just seen but something completely different, so it's in our interest to serve you some broccoli in between your cupcakes. And although there are some advertisers who care only about maximizing eyeballs, others want their sophisticated brands to only be associated with sophisticated content (and they pay better, too).

In the end, I believe that YouTube has a responsibility to uphold our community guidelines that prevent the posting of spam, scams, harmful or dangerous content, pornographic and sexually explicit videos, graphic violence, hateful content, and threats. And of course, I believe we have a responsibility to uphold and respect copyright law. But outside those constraints, I don't believe we have a right to question what becomes popular on our platform, whether

* A great account of how we arrived at this goal is detailed in the forthcoming book *Measure What Matters* by John Doerr and Kris Duggan.

it's a nuanced discussion of the refugee crisis, the trailer for the latest Marvel movie, or a two-hour *Minecraft* tutorial.

The pairing of consumerism and art has always been an unsteady one. Every now and then, they seem to align perfectly—Nirvana becomes the most popular band in America, Pixar movies run wild at the box office, *The Sopranos* sets ratings records for HBO. But in general it's the delicious thing, not the nutritious thing, that becomes most popular. And that's fine. We try our best at YouTube to provide the most meritocratic system we can. Then we wait to see what rises to the top, just like everybody else.

10

"This Just Uploaded . . ."

Vice, Storyful, and the New Business of the News Business

IN 2012, I attended the first-ever Abu Dhabi Media Summit, established by the emirate to bring together executives in media, tech, and finance. The summit was held at the opulent Emirates Palace hotel, just weeks after a short anti-Islamic film called "The Innocence of Muslims" was taken off YouTube, translated into Arabic, and broadcast on Egyptian media. Protests had spread throughout the region in response to the video, and though I wasn't concerned about my own safety, I remember it as a time of utter confusion, when politics, media, and news collided in a way that clouded what was truly happening.

Streampunks

After finishing my appearance on a panel, I wandered through the massive Palace in search of something to eat. As I walked into the Hakkasan restaurant, I heard a deep voice come from the direction of the bar. "Mis-terrrrr Kyyyynnn-cylllll," a man called out, in a tone suggesting that he was happy he had finally recognized somebody. I turned around and saw a bear of a man alongside what I soon learned was a very expensive bottle of wine. It was Shane Smith, the CEO and cofounder of Vice Media.

I had known Shane for a couple of years by then, having signed a deal with him to launch a Millennial-oriented YouTube channel based on some of the provocative videos Vice had made for its early online video site, VBS.tv. Vice started as a brand known mostly for glorifying a lifestyle of sex, drugs, and rock and roll, but by the time I met Shane in Abu Dhabi, he had begun to engineer the brand's shift toward a more serious orientation.

We talked about the reporting we had seen on the recent protests and how, despite the global coverage of what was happening, no one seemed to know what the hell was going on. Shane also told me about the HBO newsmagazine series that he had begun working on and how much extra footage they'd had on hand after editing the show. At the same time, Vice had built up offices in more than thirty countries, with thousands of freelancers working to help feed its growing audience with content. "We've got all these kids around the world who could be reporting on things," he told me. "So I have this idea," he said, leaning forward. "News on YouTube."

He talked about how there was a misguided assumption that young people don't care about news, that they especially don't care about international news, and that they won't watch anything longer than a few minutes. It immediately resonated with me because I knew firsthand how wrong that conventional wisdom was from looking at YouTube's data. Though Millennials might not have

160

been watching cable news networks, they were definitely consuming news. They were watching firsthand footage from the civil war breaking out in Syria, a live feed from NASA's Jet Propulsion Laboratory after scientists there successfully landed the *Curiosity* rover on the planet Mars, and the leaked footage of Mitt Romney's assertion that 47 percent of people would never vote for him because they were dependent on the government. Shane told me that his own data showed that the average time people spent enjoying Vice's content was more than seventeen minutes, a lifetime compared to other websites.

The conversation progressed, and after a few glasses of wine, we agreed to launch a new channel. We were going to do news for Millennials. Vice News was born. The next day, Shane would announce the idea during an onstage interview at the summit.

We settled the bill, and the combination of jet lag and red wine left me ready to head back to my own hotel to get some rest. "Oh, damn," I remembered. "I don't have a car service."

"That's okay, you can use mine," Shane said. He was staying at the Palace.

I thanked him and eventually made my way to the hotel's front entrance, stepping out of the air-conditioned lobby into the warm desert night. I walked up to the valet stand and asked an attendant to bring Shane Smith's car around. I expected it to take a few minutes, but he told me the driver would be right up because he was parked near the entrance. When his chauffeur pulled up, I realized why; Shane's car was a white Rolls-Royce Phantom.

———

Considering the origins of Vice, the luxurious touches illustrate just how far Shane and the founders of Vice have come. Before it was a

media company, Vice was a welfare scam. It was founded as a free magazine called *Voice of Montreal* in 1994 by Suroosh Alvi, Gavin McInnes, and Shane to take advantage of a Canadian welfare-to-work program. *Voice of Montreal* was intended by the government to be something like a cultural newsletter for the city, but the three were much more interested in the counterculture of Montreal, writing about the city's punk and hip-hop music scenes and the hard-partying lifestyle of drugs and prostitution that surrounded them.

Voice eventually became *Vice*, as the magazine's first-person perspective and brash, edgy editorial viewpoint attracted more readers. From the start, Shane showed his knack for deal making, helping the magazine secure ad buys from major record labels and youth-oriented brands. But to expand even further, the company would need capital. In an interview with a Canadian newspaper, Shane said that a local tech millionaire, Richard Szalwinski, was in talks to buy the magazine. It was a lie, but it attracted the actual attention of Szalwinski and led to his purchasing a stake in the magazine and bankrolling its move to New York.

Vice's initial strategy was to move into retail, opening boutiques in New York, LA, and Toronto that used the magazine's gritty brand to sell apparel. But the dot-com bust led Szalwinski to pull out of *Vice* and sell his stake back to the founders, eventually leading them to shutter their stores and relocate from Manhattan to Williamsburg, Brooklyn.

Although the company found itself in debt, the move was clarifying and helped its owners refocus on producing content, both in print and online, while also starting a music label. Their ironic editorial voice, fashion sensibilities (plaid shirts, tattoos, facial hair), good taste in music (Bloc Party, The Streets, and Justice), and rebellious attitude helped define hipster culture, beamed out from Brooklyn to the rest of the world through the magazine's website,

Viceland.com. Though it had taken the magazine ten years to reach a circulation of 1 million, it reached that number online within its first year.

As the company became profitable again and paid off its debt, it quickly expanded internationally, cultivating a global crew of reporters, photographers, and videographers to feed the growing online *Vice* profile. Spike Jonze, an award-winning filmmaker, helped steer the company's transition from print and photography to video, first by helping the company develop in-house production skills and then by introducing the founders to Tom Freston.

Tom is a legend in media, having cofounded MTV before becoming its first head of marketing. He worked to launch the most successful ad campaign in cable TV history; rock stars such as Mick Jagger and Billy Idol would tell kids to call their cable operators and yell, "I want my MTV!" Nearly overnight, MTV went from a network on life support because it was distributed in so few markets to one that spread nationwide. Tom was soon elevated to president and CEO of MTV Networks and during an incredible seventeen-year run, he launched VH1, Comedy Central, and TV Land, among other networks, and introduced the world to *The Real World*, *Sponge-Bob SquarePants*, *Beavis and Butt-head*, *The Daily Show*, and *Jackass*.

It was Spike who had first brought Johnny Knoxville and the *Jackass* crew to the attention of Tom. Spike had met the gang in the southern California skateboard scene after they, too, had started a magazine. After MTV bought *Jackass*, Spike became an executive producer. Years later, he would do the same with Shane and *Vice*.

"I must admit, I wasn't aware of [*Vice*] at that point in time because it was just kind of given away in boutiques," Tom told me. "But they explained to me their vision, which was, 'Hey, YouTube just started and nobody is making quality Internet video with a point of view and an attitude and a certain style.'"

At that point, Vice had made only one video, a DVD compilation of several short, first-person trip documentaries called *The Vice Guide to Travel*, edited by Spike. In the first episode, Suroosh Alvi travels the Khyber Pass to reach one of the largest illegal gun markets in the world, in Peshawar, Pakistan. In another episode, a *Vice* correspondent walks around the *favelas* of Rio de Janeiro in a double-breasted suit, avoiding a shootout before dancing at an outdoor party thrown by local drug gangs. One of the most notable episodes shows a young-looking Shane sporting long hair and an earring, getting drunk on a train ride to Chernobyl. Once there, he wanders around abandoned buildings and a desolate amusement park, commenting on the absurdity of the nuclear age while a Geiger counter ticks frightening readings in the background. The episode ends with him and a female correspondent firing machine guns off camera at what Shane says are mutant boars.

"I really liked it," Tom said. "I thought these guys were original. I didn't think that I had anybody in the company that was going to be able to do what they were doing. They had a certain authenticity about them. And Shane's an impressive guy. He's quite a deal maker and a mover. He's very knowledgeable, very studied, a great student of history. And he's got good creative instincts."

Shane's pitch to Tom was that Vice wanted to morph from a print publication into a big youth brand and that he wanted to harness the power of YouTube and the Internet to hone the company's video production skills. Spike convinced Tom of the group's storytelling talents, leading Viacom to fund a joint venture with Vice Media called VBS.tv.

VBS.tv became Vice Media's great laboratory of online video. Its members produced documentaries that premiered at film festivals and even began making feature films. However, Tom was soon let

go from Viacom,* and the company's new leadership "didn't really want to deal with these tattooed guys," he told me. It turned out to be a stroke of luck. It allowed Shane to eventually buy back the 50 percent stake in VBS.tv owned by Viacom and start posting their videos to YouTube. Tom soon joined Vice Media as an investor and adviser, helping the young company raise money and realize its vision of building a premium video brand for the Internet.

———

In 2009, Vice Media began a partnership with CNN to start producing videos for the news company's website, including a new episode of *The Vice Guide to Travel*. This time, Shane and a skeleton crew of two others flew to Liberia, a country still reeling from its second civil war in as many decades. The wars were notorious for their involvement of child soldiers who were forcibly addicted to drugs as a means of controlling them. Although the war was over by the time Shane arrived and the country's former president, Charles Taylor, was standing trial in The Hague for war crimes, there were questions of whether another civil war would break out once UN peacekeepers departed the following year. Shane wanted to see the state of affairs for himself.

The page on CNN's website linking to the video began with an editor's note: "The staff at CNN.com has recently been intrigued by the journalism of VICE, an independent media company and Web

* Tom's departure was a stunning development. It was widely reported that Tom's boss, Sumner Redstone, was upset that Viacom had passed on the chance to purchase MySpace for $580 million. Instead MySpace was sold to News Corporation, a move that Rupert Murdoch later acknowledged was a "huge mistake."

site based in Brooklyn, New York. VBS.TV is Vice's broadband tele-
vision network. The reports, which are produced solely by VICE,
reflect a very transparent approach to journalism, where viewers
are taken along on every step of the reporting process. We believe
this unique reporting approach is worthy of sharing with our CNN
.com readers. Viewer discretion advised."

The footage is both surreal and unsparing. It begins with Shane
meeting their local fixer, a Canadian journalist named Myles Estey,
who came straight from the hospital after recovering from yet an-
other bout of malaria. He immediately directs the crew to a jail in
the red light district to meet a former warlord, nicknamed "General
Bin Laden."* After speaking with the warlord, the crew travel to the
poorest slum in the country, West Point, where, without running wa-
ter and sewage, citizens are left to use the beach as a public toilet.
They film children smoking heroin, visit a brothel where sex workers
talk about abuse by UN peacekeepers, and all of this happens before
they meet a warlord turned preacher, who had previously led child
soldiers into battle but now tried to rehabilitate them. The man,
Joshua Blahyi, was known as "General Butt Naked" for charging into
battle without clothes on. On camera, he talks about eating human
flesh during the course of the war. The documentary, which you can
find on YouTube under the title "The Cannibal Warlords of Liberia,"
ends with a church service in which Blahyi discusses his conversion
from being a "general for the Devil" to being a "general for God."

The footage caught the attention of established news outlets,
which, while dealing with the worst of the Great Recession, were
wary of an outsider attempting to do serious news. In an interview
that was immortalized in the *New York Times* documentary *Page*

* To protect their identities, warlords in Liberia fought under assumed
names designed to invoke fear in their enemies.

One, the media journalist David Carr, himself a recovered addict who had lived a "textured life," challenged Shane for criticizing the *Times*' recent coverage of Liberia.*

"Just a sec, time out," Carr said, interrupting Shane. "Before you ever went there, we've had reporters there, reporting on genocide after genocide. And just 'cause you went there and put on a fucking safari helmet and looked at some poop, doesn't give you the right to insult what we do. So continue, continue."

"Sorry. I'm just saying," Shane explained, "that I'm not a journalist, I'm not there to report—"

Carr interrupted him: "Obviously, obviously."

The exchange was glamorized by segments of the press that were quick to discount Vice's attempts to grow up. Those voices only got louder when Vice secured a deal with HBO to produce a newsmagazine for the network, a sort of *60 Minutes* with Shane Smith standing in for Mike Wallace.

Shane explained the criticism when we met at his recently renovated Santa Monica house. We sat in green velvet chairs in a room just off his library, a few months after the house was featured on the cover of *WSJ. Magazine.* "Nobody faulted the news," he said. "They faulted how we looked or how we talked. . . . If you're just talking about the jeans we're wearing, then we're okay. If you're making fun of our stories or poking holes in the facts, then we're in real trouble." Shane told me that competing news networks realized they couldn't weaken the grip Vice had on Millennials, so the only way they could hurt the company was to attack its journalistic integrity. "So we had to be more buttoned-up, more tight, more bulletproof than anybody else."

* The *Times* had run a travel article called "On Liberia's Shore, Catching a New Wave" about the best places to go surfing in the country. The beach in West Point did not make the cut.

But before the HBO series even aired, a controversy erupted about footage Vice was shooting for its season finale, titled "Basketball Diplomacy." Vice had arranged an exhibition game in Pyongyang between the Harlem Globetrotters and the North Korean national basketball team, with Dennis Rodman in tow as guest of honor. The country's new supreme leader, Kim Jong-un, attended the exhibition in one of his first public appearances. During a speech after the game, Rodman turned to the country's young dictator, bowed, and said, "Sir, thank you. You have a friend for life," before shaking the supreme leader's hand. Later, the Vice contingent attended a state dinner with the supreme leader, where they became the first Americans to meet him since he had assumed power.

All of this happened just weeks after North Korea had conducted an illegal underground test of a nuclear weapon, stoking fears that it would one day be able to reach the United States with warhead-topped ballistic missiles. Vice was torched in the press for orchestrating a stunt with a deadly regime and normalizing a brutal dictator; the perception was that the rookies in the news business had gotten played. On CNN, Dan Rather called the report "More *Jackass* than journalism."

"I've done two documentaries in North Korea and gotten kicked out because we were harshly critical of the regime," Shane told me (he was personally barred from going back and couldn't participate in the basketball adventure). "But we knew all their weaknesses because we'd been around, and we knew that they were super into basketball. So we came up with this dodge: let's go and bring the Chicago Bulls there, and we'll get to meet with the most wanted interview in the world. And when we did it, the traditional media lit up with criticism. And two things I'll say about that is: I didn't enjoy it at the time, but in retrospect that made Vice News because it put us on the map."

Shane told me that two things had saved the HBO series from dissolving into scandal. First, the documentary wasn't a glamorized portrait of the country or its new leader; it was critical in its portrayal of Kim Jong-un and the country's government. It took pains to document the absurdity of the regime. In one memorable scene during a visit to a North Korean computer lab, the crew point out that despite the room being full, no one is actually typing or clicking anything. They show footage of a man staring at the Google home page for several minutes while the cursor blinks in the blank search bar.

Second, shortly after their visit, it was revealed that the BBC had smuggled journalists into North Korea on an educational trip by students of the London School of Economics. The students realized that journalists were on their trip only after they'd arrived in Pyongyang. "Okay, you're hiding behind schoolchildren," Shane said, defiantly, "and yet you're criticizing us for actually setting up something that worked and that didn't endanger anybody?"

There was similar hand-wringing when Vice embedded reporters with ISIS for an HBO documentary, *The Islamic State*, shortly after launching Vice News on YouTube. But this time, David Carr—four years after his and Shane's initial run-in—came to Vice's defense in the *New York Times*:

> "The Islamic State" is a win for Vice, but also a win for an audience hungry to understand why some of the world hates us so much. . . . When I was bumping bellies with Mr. Smith over whose coverage was worthier, I failed to recognize that in a world that is hostile to journalism in all its forms, where dangerous conflicts seem to jump off every other day, you can't be uppity about where your news comes from. I'm just glad that someone's willing to

do the important work of bearing witness, the kind that can get you killed if something goes wrong.

The report was filed under the headline "Its Edge Intact, Vice Is Chasing Hard News."

———

Back in Shane's study, I asked him why he thought so many in the news business were willing to write off the Millennial audience. "I think it's because Gen Y grew up at a time when you had tremendous disenfranchisement. It was the time of 'weapons of mass destruction'* and collusion with the government† over Iraq and Afghanistan and just complete dissatisfaction with mainstream media."

That may be why few Millennials turn to the mainstream media for information. According to a 2016 study by the Pew Research Center, half of those between the ages of eighteen and twenty-nine get their news online; just over a quarter get it from TV. For baby boomers, the ratios are flipped; 72 percent of those aged fifty to sixty-four get their news from TV, while only 29 percent seek it out on websites, apps, and social media.

In addition to trust issues, Millennials are often put off by "a language and a tonality that just didn't resonate," Shane said. "The

* A *Washington Post* editorial that ran a month before the start of the Iraq War stated, "After Secretary of State Colin L. Powell's presentation to the United Nations Security Council yesterday, it is hard to imagine how anyone could doubt that Iraq possesses weapons of mass destruction." The editorial ran under the headline "Irrefutable."

† The *New York Times* was heavily criticized for its coverage of suspected Iraqi weapons programs that supported the Bush administration's case for war. The paper later acknowledged that the coverage had been flawed and had relied on sourcing from "United States officials convinced of the need to intervene in Iraq."

voice of God, 'Here's what you should think about this,' language didn't resonate. Whereas the 'We're going to press RECORD, show it to you, and you can figure it out' was much more resonant with Gen Y."

Vice's approach, stretching as far back as those first videos on VBS.tv, has been something the company calls "immersionism." It's an approach focused on embedding in settings and just filming that owes more to documentary filmmaking than "talking head" news reporting and commentary, though there is almost always an accompanying correspondent in Vice's news segments.

"What we found in the daily news was, it generally goes in with a preconception or an angle already set," Shane said. "'We know what's happening in Egypt; the Muslim Brotherhood are to blame. Let's go get the shot.' Whereas we would go into Egypt and say, 'Well, we followed these people and the students split from the radical Islamists and the jihadis split from these guys and these guys and these guys'—it's definitely 'follow the story' more than 'follow the angle.'"

I told him that sentiment sounded similar to the praise YouTube creators got for appearing more authentic than TV. By offering viewers—usually young, thoughtful Millennials who dress and speak like they do—a mostly impartial guide, Vice seeks to build trust with its viewers. The correspondents want to take viewers on a journey and introduce them to new characters, rather than stand there and explain what's happening. "The story is more important than how it looks," he said.

Vice's approach demonstrates a lot of other tactics we've talked about in this book. From its earliest days with *The Vice Guide to Travel*, the company's perspective was global. When launching new online media sites, it has often gone after strong youth cultures that were underserved in traditional media, such as skaters and fans

of electronic music. It has been willing to talk about niche topics such as recreational marijuana and mixed martial arts years before they were discussed on TV. And it has centered much of its programming—from the correspondents it hires to the stories it films—on celebrating diversity, body positivity, and gender fluidity.

"I always say this, but Gen Y is the most savvy media consumer in history and they've been marketed to since they were kids. Cartoons are made to sell cereal. So they have very savvy bullshit detectors. And if something comes in and looks very crisp and is delivered in a very crisp way with lots of graphics, you're, like, well, that's obviously gone through a lot of producers and a lot of cameramen. If you're trying to present that, like, 'This just happened. We're on it, boots on the ground,' it just doesn't feel right. But if someone just captures something—it could be a cell phone video, it could be point and shoot, it could be whatever—but you see it, and you go, 'Okay, well, this guy was there. He saw it. He captured it.'"

The comment reminded me of something that had felt like a turning point in the way the Internet conveyed news: the Green Movement in Iran. In a preview of protests that would erupt throughout the Middle East during the Arab Spring, hundreds of thousands of protesters filled the streets of Tehran and other cities following the 2009 presidential election, demanding the resignation of Mahmoud Ahmadinejad from office and accusing the government of rigging the vote in his favor. Because Iran was closed to the foreign press, it was more effective—and much faster—to learn what was happening on the ground from local posts on social media than it was to watch the news.

When I brought this up to Shane, he told me he had actually been in Iran for a film festival when the protests began. "You could either see what was really happening as posted by people who were doing the protesting, or you could have the voice of God tell you what

you should think about this from New York. Therein lies the crux; because baby boomers would open the *New York Times* or the *Washington Post* or turn on *60 Minutes* or *NBC Nightly News* or whatever; they would hear, 'This is what's happening,' and they would go, 'Oh, good. That's what's happening.'

"Gen Ys look at blogs and look at video and stuff that's coming from that country and from alternative news sources, and they say, 'Well, actually, it's kind of like this.' And they grew up that way. Now you can't just say, 'Here it is.'"

With the Internet providing so many different perspectives of a given event—endless news stories, hot takes, commentaries, and think pieces, all fueled by an endless supply of images, tweets, and videos from eyes on the ground—the definition of what it means to be informed has changed. It's no longer enough just to read one article or watch a news segment.

But with so many potential sources out there, whom can you trust?

——

In the mid-2000s, a couple of Irish foreign correspondents were posted to a city in southern Lebanon during the country's war with Israel. To pass the time between reports, they would often drink by the pool, waiting for dispatches from their news organizations back in Atlanta or Dublin to tell them when fighting might resume so they could sober up and prepare to film their on-air reports. But as they started to spend more time on social media, they noticed something interesting: posts on Twitter would routinely give them a thirty-minute heads-up that action was headed their way, before reports from the AP or other news organizations.

They realized that their industry was changing fundamentally.

The rise of cell phones and social media was eroding the monopoly that journalists had on information, with citizens more likely to scoop news outlets when it came to reporting what was actually happening in a given situation.

In the midst of this profound shift, one of those correspondents, Mark Little, started to think about what a news agency like AP or Reuters would look like if it were founded today. From his perspective, that news agency would live on the social web, analyzing tweets, posts, and videos that were being uploaded from around the world, every second. And from that analysis, it would provide the most value by "separating the news from the noise," sifting through the surge of content to verify and authenticate what was real. He founded that agency in 2010, in Dublin, and called it Storyful.

"It very much was the Wild West when this company started," Storyful's current CEO, Rahul Chopra, told me. "There were literally no rules, responsibilities, or safeguards for eyewitness video." To highlight the various challenges a newsroom faces when receiving user-uploaded content, he told me to imagine a video of a bomb going off somewhere in the Middle East. "I don't know if a video was shot in Aleppo or if it was shot in Iran. How the hell do I know the difference? It's just a bomb going off in the middle of the street. How am I going to verify, is this real? How do I know if this is the original person that shot it and if I can even use the piece of content? What's the context behind it? It's just something blowing up in the background. What do I actually know?"

All those questions plagued newsrooms, but many didn't know how to begin to answer them. Storyful aimed to solve that problem. Its model was to seat experienced journalists side by side with engineers to discover and verify whether a given photo or video was real. The process it used was based on traditional journalistic tech-

niques married to technology. Algorithms would automatically identify "clusters" of activity around a given video; if they detected an event bubbling up on social media, they would automatically scan footage against a database to make sure the video was truly new.

If the raw footage was unique, the journalists would then step in, using Google Earth and Google Maps to identify various landmarks. They'd check the video against local weather data to ensure that shadows were in the right place and the wind was blowing in the right direction. Then they'd enlist the help of experts to identify and translate languages and local dialects, figure out what a siren sounded like in a particular region, and identify which munitions were being used in the footage. Once a video was verified as real, the team would try to get in touch with the original uploader to validate it and clear the rights to use it. "And this all happens very, very quickly," Rahul said.

The goal of the journalist's engineering counterpart is to maximize the efficiency of the entire process, minimizing the clicks and steps the journalist has to go through. "We're trying to make our journalists smarter and faster and allow them to focus on context, accuracy, authenticity, and increase their efficiency rate." I asked him, with so many stories happening around the world, how many journalists it actually takes to verify everything. "It's less than forty," Rahul told me.

I then asked him what role YouTube plays in Storyful's current output, considering the rise of other social networks and messaging apps. "YouTube still makes up the lion's share of the content that we are supplying users every single day," he said. "If you think about it, there isn't a news story in the last six years that hasn't been affected in some way or involved user-generated content in some form or fashion."

———

Even longer back, I'd argue. In 2006, in what felt like a watershed moment for politics, the Republican candidate for the Virginia Senate, George Allen, lost in a narrow upset after footage emerged of him using a racial slur—twice—to describe a staff member of his competitor's campaign.

The rise of the smartphone and the ability of video to spread rapidly on social media are helping redefine what becomes global news. If you heard that someone on the floor of the Chicago Mercantile Exchange had complained about taxpayer money being used to support struggling homeowners, you probably wouldn't think it was newsworthy. But a speech making that point, given by CNBC Business News editor Rick Santelli, was shared all over YouTube and Facebook and gave rise to the Tea Party. If some leftists staged a sit-in on Wall Street to protest inequality, it probably wouldn't make the headlines. But spread their message through social media, and all of a sudden, everyone has heard of Occupy Wall Street. If an officer shoots an unarmed black teen, tragically it rarely makes the front page. But share unsettling footage of the protests that follow, give people a voice and a means to express their outrage, and you have the Black Lives Matter movement.

"I can tell you as a person who has been in war zones," Mark Little told an audience at the University of Florida College of Journalism and Communications, "we've never had that ability to see in real time. If Srebrenica, if Auschwitz, if Rwanda was happening today, the world could not say it didn't know."

With the emergence of videos shot straight from the front lines and their potentially world-altering effects, I asked Rahul whether he thought it eliminated some of the roles journalists have traditionally played in society. "I think the reason that you're seeing UGC*

* User-generated content.

taking off more and more is because it gives people a completely different view on the narrative of what a story is. . . . Why do I want a traditional journalist standing in Tahrir Square telling me what's happening on the ground when I can actually have footage showing me what someone there for that purpose is doing and experiencing?

"But that on its own is not news. It's content. It's that story that a journalist can then take and turn into something powerful. And that's why you've seen news organizations embrace it and do so well with it when it's done right." When I asked him for an example, he cited Vice News. "They did fantastic work with some of our content, faster than many traditional publishers recognized. Younger generations are screaming for authenticity when it comes to their news coverage. And UGC is one very big way to be able to do that."

———

It's also relatively cheap. One of the big hurdles that any video news organization faces is the cost of capturing news footage. Organizations have to either license footage from services such as the AP or Reuters or invest in the camera equipment, satellite uplinks, and permits necessary to capture it themselves. That's one of the reasons why many of the news start-ups that have been successful on YouTube—most notably *The Young Turks*, YouTube's most popular news channel—tend to offer commentary, rather than straight reporting of the day's events.

But a leaner model seems to be emerging. Cheaper cameras and the use of new technologies such as drones and mobile live streaming have brought down some of the costs of capturing high-quality news footage and broadcasting it worldwide. By operating with small crews (such as Vice's three-person Liberia team), news companies can use their own footage instead of licensing it from official

sources. Then, if they need to, they can supplement that coverage with cheaper UGC footage captured by users.

Meanwhile, companies such as Storyful help the original owners of UGC footage get paid for it. In 2016, Zdenek Gazda, a Czech immigrant taxi driver, captured startling footage of Hillary Clinton fainting and being escorted to her car following a 9/11 ceremony at Ground Zero. In the past, a video like that would have spread rapidly and found its way into global news reports, often without any attribution. In this case, Gazda was immediately contacted by news organizations on Facebook and Twitter, asking for permission to use it. At first he allowed the clip to be used freely, but eventually Storyful was able to reach him by tracking down his brother, who still lived in the Czech Republic. On Gazda's behalf, Storyful began working with networks and news publishers to secure fees for the use of the video, earning Gazda a sum Rahul described as "well into the six figures."

——

Although Storyful's main focus is on verifying footage and making sure it's authentic, the company has recently been pulled into a far wider-ranging conversation about the concept of "fake news." In the wake of the 2016 US presidential election, that tag has covered everything from sensationalist stories to clickbait, hate speech, hoaxes, and even CNN. In the aftermath of Donald Trump's surprising presidential victory, many were quick to point a finger at discredited articles asserting false claims, overwhelmingly in support of the Republican candidate. Despite being bogus, those stories gained traction online, where they were quickly shared through social networks.

The phenomenon of fake news grew even more fascinating when reporters from BuzzFeed discovered that more than a hundred of

the sites sharing that news originated from a handful of teenagers in a small town in Macedonia called Veles. The teens would see fake stories online and aggregate or copy them to new sites they had just set up, attracting both views and clicks.

According to a follow-up report in *Wired*, the strategy was originally employed by two young men in Veles named Boris (a pseudonym) and Aleksandar Velkovski. Aleksandar and his brother Boris had attracted more than 10 million unique visitors to a site called HealthyFoodHouse.com by promoting hoax cures. Enterprising teens in Veles saw the model the Velkovskis had employed and applied it to politics, using the massive interest in the US presidential election to attract hundreds of thousands of Facebook shares, reactions, and comments. That in turn allowed the teens to earn thousands of dollars in ad revenue.

Once Facebook and Google realized what was happening, they quickly choked off the source of revenue to those misleading sites, but the issue of fake news lingers. At YouTube, we've worked to push back against its spread, recognizing the responsibility we have to ensure our platform is used to inform rather than mislead.

A big part of this effort is to elevate and digitally highlight videos that come from trusted, authoritative sources, while denying revenue to those that intentionally seek to deceive. Now when news breaks, we highlight a special "shelf" of videos on the YouTube home page, featuring clips of the event only from verified sources. Similarly, we created a dedicated YouTube News channel, featuring content only from partners that have passed through a manual review; it currently has more than 34 million subscribers. And we continue to crack down on the placement of ads on misrepresentative content, so scammers can't earn money by deceiving people.

But separating truth from fiction—what used to be a pretty elementary exercise—now feels almost impossible, with some people

considering objectivity an affront to their politics or beliefs. One only need look at *Time* magazine's recent cover asking, "Is Truth Dead?" to understand the scale of the challenge, borne primarily by the news organizations whose mission it is to inform their readers.

The question of whether something is truthful also coincides with the increasing polarization of news in America. In the era of three networks, political objectivity in news coverage was the norm for most of the twentieth century as broadcasters sought mass appeal. Not only was that smart business, it was legally mandated by an FCC rule called the Fairness Doctrine, established in 1949. The doctrine required radio and TV networks to both cover "controversial issues of public importance" and "endeavor to make . . . facilities available for the expression of contrasting viewpoints held by responsible elements with respect to the controversial issues presented." The rationale behind the doctrine was that in a world of limited shelf space, the holders of broadcast licenses had a responsibility to ensure that their viewers were exposed to a diversity of viewpoints.

As the media spectrum grew, first with the introduction of the FM radio band and later with cable TV, the rationale for the doctrine was weakened; people would have plenty of opportunities to seek out diverse viewpoints, but only if networks were given the opportunity to provide them. In 1987, the FCC eliminated the doctrine, leading to the emergence of more partisan outlets on both radio and cable. Suddenly, with the emergence of conservative talk radio, Fox News, and MSNBC, American news began to look a lot like that in Europe, where media outlets have close connections to political parties, unions, and churches.*

* In Italy, the national broadcaster, RAI, is under the direct control of the parliament, with news programming divided up among political parties.

With the Internet, the opportunity to create ever more polarized media exploded. The recently launched news site Axios mapped the formation of eighty-nine major news websites since the dawn of the Web, finding that almost all of them had partisan leanings. Interestingly, left-wing sites such as the Huffington Post and Daily Kos grew mostly during the Bush administration, while a flood of right-wing sites grew out of the Tea Party movement during the Obama administration.

Although the timing would suggest that the formation of these sites was driven by political polarization, a book written by two Tufts University sociologists, Jeffrey M. Berry and Sarah Sobieraj, examined the growing trend of "the outrage industry" and concluded that it was just good business. "There has been an increase in political polarization in the citizenry, but not nearly enough to account for this development," Sobieraj told CNN. "The technological, regulatory, and media space has shifted into one in which [partisan news] is profitable, and profit is the driving force."

I later asked Shane what he made of all this in a time in which economic pressure seems to encourage the politicization of news to such an extent that it compromises the truth. "I think we're going to enter into a period of lunacy," he said. "Now, is that good for us? Business-wise, yes. I mean, sadly, if you look at the Gulf War, the invasion of Afghanistan—that built CNN. And for us, this lunacy is pure gold. That said, it's not great for humanity. We have to look at all these challenges and say, 'Okay, it's our time now. We'd better do the right thing and do a good job.'"

The argument Shane was making was that in a hyperpolarized environment that increasingly victimizes truth, the objectivity of Vice's "immersionist" approach will become even more valuable to disenchanted Millennials. "The thing for us as a news agency is, when you look at that climate, you say it's important that we get out

181

information that's as centrist as possible, as logical as possible, and get out there and say, 'That's crazy. That's not true. These are the facts.'" Rather than choose a side, Vice would stay in the middle.

It reminded me of something Shane said onstage at one of YouTube's advertising events. He'd been quoted as calling Vice News "the next CNN," but onstage, he amended that description: "With the scale that YouTube offers, we're not going to be the next CNN. We're going to be *ten times* the next CNN."

———

I hope Shane is right, at least about the current climate benefiting objective news sources; for a democracy to thrive, it needs an informed electorate with a press that can separate fact from fiction. In its "State of the News Media 2016" report, the Pew Research Center claimed that financially, 2015 had been "perhaps the worst year for newspapers since the Great Recession."

But since the election of Donald Trump, the news media has shown impressive signs of life, especially those outlets that pride themselves on objective coverage. The first quarter of 2017 was CNN's most watched since the run-up to the Iraq War in 2003. Meanwhile, the *Washington Post*, the *New York Times*, the *Los Angeles Times,* and the *Wall Street Journal* all reported record growth in digital subscriptions.

At the same time, technology is playing a larger role in their reporting, helping lower some of their costs while expanding their reach. Though some people may decry the "BuzzFeed-ification" of news, smart publishers are taking advantage of the techniques the social news and entertainment site has perfected, such as testing the effectiveness of different headlines and photos in real time and serving the results that do best. Publishers are also experimenting

with quizzes, puzzles, podcasts, chatbots, and specialized lifestyle apps for things such as recipes and real estate, all in the hope of providing a more engaging bundle that will draw in subscribers and retain them.

Some publications are even using AI to automatically write routine articles, such as updates on the stock market and shifts in polls, freeing up veteran journalists to focus on higher-value stories. That approach is extending to video news as well, with computers automatically pairing stock photos and clips to text from news articles that appear as captions, perfect for scrolling through your phone with the sound turned off.

The embrace of video will be crucial to the future of news publishing. When Pew asked Americans how they preferred to consume their news, 46 percent said they preferred to watch it versus 35 percent who wanted to read it and 17 percent who wanted to hear it. Not only does video appeal to more people, it holds their attention for longer periods of time. That in turn makes it a more lucrative medium for advertisers, meaning that publishers can earn more by running commercials than by showing banner ads. This means that the growth of mobile content consumption—in which video already makes up more than half of all data usage, according to Cisco—can be even more lucrative for news publishers, as long as they're willing to create videos as well as write articles.

When I asked Rahul what advice he'd give to newsrooms trying to get back onto a solid footing, he told me, "Just take the seat belt off and go. This whole phenomenon of VR, vertical video versus horizontal, storytelling in different formats, there's so much potential. There's so much opportunity to tell stories in ways that are innovative and different and authentic. And audiences are dying for it."

Streampunks

When I was growing up in Prague, we had a different word for fake news: propaganda. The Communist government used its control of the airwaves to shape our view of the West and undermine those who called for more political freedom. It often presented a laughably false depiction of what life beyond the Iron Curtain was like. TV specials—many of which you can find today on YouTube—showed footage from US rock concerts and claimed they were scenes of devil worship, easily identifiable by the presence of male participants with long hair.

Shane told me that this kind of disinformation ran both ways and was what made him so eager to visit North Korea and report from places that are supposed to be forbidden. "It was 'Commies eat babies, and you can buy a house for a pair of blue jeans,' and all this stuff. And we were the capitalists!" But the misinformation persisted on both sides because the two sides weren't allowed to communicate. The people dispensing the propaganda knew that truth was the ultimate antidote.

Luckily, by the time I was a teenager, numerous cracks began to show in the Communist facade. My first concert was Guns N' Roses' historic show in Soviet-era Prague, during the band's "Use Your Illusion" tour; there was plenty of long hair but very little devil worship. And all the stories I'd heard about how terrible life was in America were quickly dispelled after I watched *Beverly Hills Cop*. If you've seen that movie, you were probably focusing on Eddie Murphy's jokes. When I watched it as a teenager, I was marveling at the expensive cars, the fashionable clothing, and the fancy houses.

Only decades later, after finishing our interview and walking past the manicured lawns and tiled entrance to his swimming pool, did I realize that one of the houses featured in the film now belonged to Shane.

11

~~Pardon~~ Welcome the Interruption

Casey Neistat Is Making Ads Great Again

THERE WAS A chance that Vice would end up ahead of its time. In the mid-2000s, when Vice was shifting from print to digital, the economics of publishing free, original content on the Internet were not particularly forgiving. Aggregators—sites such as the Drudge Report and the Huffington Post that would collect, display, or link to the stories of other news publishers—were doing well and growing, but the sites of those actually producing the content weren't making nearly as much with online advertising as they were with print advertising. Not only were the digital versions of newspapers and magazines making less money, they began to siphon away print subscribers by offering the same product online for free.

But as newspapers began closing foreign bureaus, Vice was

opening them and investing even more into video. The secret weapon fueling its expansion? Virtue Worldwide, a full-service creative agency founded by Vice that partnered directly with brands attempting to capture some of the company's irreverence and edge. Unlike newspapers that maintained a "church and state" relationship between editorial and advertising, Vice's editorial voice was put to use in service of brands, helping them create videos and experiences based on Shane's belief that "All brands should think of themselves as media companies."

What that initially looked like was brands partnering with Vice to make the kind of content the company would want to make anyway. In 2009, Vice partnered with the North Face for a video series called *Far Out*, in which Vice correspondents traveled to the ends of the earth (in North Face gear) to meet explorers and hear adventure stories. The episodes don't necessarily feel different, either in quality or in tone, from Vice's other content at the time, but they helped North Face evangelize its philosophy to "never stop exploring."

The most notable brand partnership Vice entered into was with Intel. The chip maker's chief marketing officer, Deborah Conrad, caught wind of Vice after the company threw a party for Intel at the Palais de Tokyo museum in Paris called "Créateurs du Futur." The event highlighted eight French artists and how they used technology in their creative process. It was such a hit that Conrad asked Vice to replicate it at other museums around the world. When a similar exhibition at the 798 Art Zone in Beijing drew 250,000 visitors, Intel began to look for an even deeper partnership.

At the time, only 3 percent of Millennials had a positive image of Intel because, according to Shane, "they saw them as Big Brother, wanting to put chips in our brains." Intel's marketing team asked Vice what it would do to overcome the negative perception. Shane told them, "Look, there is this great and forgotten intersection be-

tween creativity, music, art, and technology. If they're afraid of you, it's because they don't know what you're doing. If they knew that all of these great artists can only make their art by using computing power that you guys make, then they'd see you in a different way."

That suggestion led to the Creators Project, a dedicated sub-brand of Vice with its own website, featuring content about how technology has been used to create art, all of it sponsored by Intel. The brand put on events, brought art installations to Coachella, created dozens of videos, and even put out a short film by Spike Jonze about two robots falling in love. The gambit worked: Intel's positive perception among Millennials shot up from 3 percent to 38 percent in one year and up to 64 percent the next. "They'd never seen a more successful campaign, including 'bong-bong-bong,'"* Shane said. "That was the beginning of large-scale bespoke native advertising, meaning, rather than come up with a spot or a dot or a display† or whatever, we are going to come up with a strategy and a bespoke program and have all the KPIs‡ that we can meet with that program. Kids are smart. They're, like, 'Oh, I like Spike Jonze. You brought me a film by Spike Jonze. I get it.' You don't have to go 'bong-bong-bong' and stick the fucking Intel thing in there.'"

The Creators Project and other corporate collaborations became a core part of Vice's revenue stream, leading to several multimillion-dollar global partnerships with brands such as Dell, Nike, Unilever, Anheuser-Busch InBev, ESPN, and more. "Underneath it all was the power and the mission of the Vice brand that people thought was cool," Tom Freston told me. "It was an old card trick we had back in the early MTV days, when we really didn't have any ratings or

* The Intel "sound mark," which debuted in the company's commercials in the 1990s.

† TV commercials, print ads, or online banner ads.

‡ Key performance indicators.

anything. Because we were thought to be a hot place to be, if advertisers wanted to make a statement about themselves, they would spend some money."

"Our forte is to do weird stuff that people haven't done before that therefore gets a ton of earned media,"* Shane said. "Creators Project was very successful in getting a lot of earned media because everybody wanted to write about it and everybody wanted to talk about it. And so [Intel] are, like, "Holy shit! How much do we owe you for that?' And it's free."

———

The first video ever to go viral on YouTube was called "Touch of Gold." In it, grainy footage from the sidelines of a soccer stadium shows the star athlete Ronaldinho trying on a new pair of cleats that have been brought to him in a golden suitcase. After lacing them up, he starts to juggle a nearby soccer ball, and for the next minute, he never lets it touch the ground. The feat is even more impressive because he juggles the ball from the sideline to the arc of the penalty box and then proceeds to launch the ball off the crossbar and back to himself four times in a row.

The video is just over two and a half minutes long, and when it was released, it set off a frenzy of speculation about whether it was real.

Sadly, it wasn't. Not only was the video itself faked, the premise was deceitful, too. It wasn't illicitly captured footage smuggled out of the Maracanã stadium in Rio; it was an ad for Nike. A million views later, and advertising would never be the same.

* Content that's organically sought out, watched, and shared by people online, rather than paid advertisements that run before other content.

"Touch of Gold" was YouTube's first successful piece of branded content—a video that was meant to advertise a brand but could still be enjoyed as entertainment in its own right. Prior to "Touch of Gold," there certainly were entertaining commercials that felt more like art than advertisement, most notably Apple's "1984," directed by Ridley Scott. There were even experiments by companies that wanted to use the Internet to make something longer than an average thirty-second spot. Four years before YouTube started, BMW recruited major directors such as John Frankenheimer and Ang Lee for a series of shorts called *The Hire* that it posted directly to its website for download.

But Nike's experiment showed marketers that turning commercials into content didn't have to be just a stunt or a prestige marketing ploy. YouTube, with its unlimited video lengths and open access, made content marketing available to everyone. And because sharing and commenting were such a huge part of online video culture, if an advertisement created a buzz or started a conversation, people would actually watch it *by choice*. To paraphrase the reporter James O'Brien, instead of the commercial, advertisers could now be the show.

The trend toward content marketing was reinforced by the introduction of a feature we called TrueView, better known to most people as the skippable ad. Viewers would watch an ad for five seconds; then, if it didn't appeal to them, they could click or tap to skip it. In turn, an advertiser wouldn't pay a dime unless someone chose to watch its ad. When the format was first introduced, many advertisers were incensed. But soon the value of knowing when a user *chose* to watch an ad became clear. Although we do run unskippable ads on YouTube, the vast majority of our ads are TrueView ads, incentivizing advertisers to produce compelling spots that can quickly grab someone's attention.

Procter & Gamble, the world's largest advertiser, took the challenge presented by content marketing and ran with it, quickly becoming a social media powerhouse while making some of the most iconic ads of the digital age. One of the most notable was for Old Spice, called "The Man Your Man Can Smell Like." Realizing that the majority of people who bought men's body wash were women, Old Spice created an ad that spoke to them. Literally.

"Hello, ladies," the ad begins, before taking the viewer on a surreal journey from a shower to the deck of a boat to the back of a white horse on a beach, all in one take. The ad on its own was enough to vault it into pop culture. But to really help the video fly, the team at Old Spice recruited the actor, a cameraman, and a few writers to film and post more than 180 personalized responses to fans who left comments and questions on YouTube, Twitter, Reddit, even Yahoo! Answers. The original ad got over 50 million views, but many of the reactions broke a million on their own.

Amid lighter fare, P&G also made longer, more personal films, such as its "Thank you, Mom" campaign for the 2010 Vancouver Winter Olympics, showing the dedication of the mothers who stood behind Olympic athletes.* The campaign was so successful that it ran updates of it for the London, Sochi, and Rio Games.

YouTube also became a laboratory for companies such as P&G to test advertising before investing in big media buys. A film it made for Always, called "Like a Girl," demonstrated that a girl's confidence plummets once she hits puberty. The directors asked teens what it meant to run, fight, or throw "like a girl." Each considered the phrase an insult and pantomimed a flailing, halfhearted performance. But when they posed the same question to elementary

* That ad hit me personally. I skied with the Czech Olympic team when I was in college in Prague, something I never could have done without my mother's constant trips with me to the Ještěd ski center.

schoolers, each replied that the phrase only meant to do something with full resolve and effort. The three-minute film became a massive hit online, resonating so widely that the brand decided to run a thirty-second edit of it as a spot during the Super Bowl.

Before I joined, it was unthinkable that big brands would run their Super Bowl spots ahead of the big game; now it's a routine play. Brands recognize that the online conversations they start with their ads can be just as important as the exposure they get in over a hundred million households on game day.

Increasingly, starting those conversations involves advertisers' expressing their values and points of view. During the 2017 Super Bowl, nearly every advertiser used its spots to address social issues. Audi provided a meditation on gender equality staged at a soapbox derby. Airbnb showcased its company's diversity in an ad showing its employees faces' with the tagline "The world is more beautiful when you accept," a motif similar to one employed by Google, which advertised its new intelligent speaker being used by a series of diverse American families ("Okay, Google. What's a substitute for cardamom?").

And of course, there was the journey of a young girl and her mother trying to reach the US border, only to find a newly erected wall in their paths. The spot was considered so political that Fox rejected it, forcing the advertiser, 84 Lumber, to cut the ad in half and run the rest on YouTube. It became our most watched ad of the 2017 Super Bowl.

The forces that are driving athletes and celebrities to become less guarded about their views and values (as I explained in chapter 4) are having the same effect on brands. Millennial viewers now fully expect corporations to be more authentic, more honest, and more socially conscious. Just a few years ago, we were routinely watching ads that reinforced gender stereotypes and objectified

women ("And twins!").* Today, advertisements are seen as an opportunity to enlighten and empower underrepresented groups, not degrade them.

That opportunity can occasionally become a minefield. Pepsi was widely panned for a commercial starring Kendall Jenner that seemed to borrow imagery from recent #BlackLivesMatter protests, suggesting (intentionally or not) that the soda might be able to heal deep civic wounds. But for every misstep, there have been several more examples of poignant ads that help elevate social understanding and empathy.

One of the pioneers of this trend was Dove. In 2004, the brand looked at the results of a global survey that revealed that only 23 percent of women felt they had decided for themselves what it meant to be beautiful, rather than having those standards imposed on them by society. In response, Dove made a video called "Evolution" in which a young woman sits down in a makeup chair, the camera steadily focused on her face. Suddenly, the video shifts into time lapse as a team of stylists applies professional makeup before a photographer's flashbulb fires off multiple times. The video locks in on one of those pictures before it is digitally retouched. Then the model's neck is extended and narrowed, her eyes are lifted and then enlarged, and her cheeks are slimmed down. The camera then pans out to show the Photoshopped image on a billboard advertisement for a new cosmetic. Although the product is fake, the billboard seems all too real to the passersby. The commercial fades to black before the closing message appears: "No wonder our perception of beauty is distorted." The seventy-four-second video was uploaded to YouTube, where it received 2 million views in its first two weeks.

Dove followed that ad years later with a video called "Dove Real

* From the Coors Light ad, "Love Songs."

Beauty Sketches." Another study the brand conducted had shown that only 4 percent of women worldwide thought they were beautiful. In the film, women are told to sit behind a curtain while a sketch artist asks them questions about their appearance and draws their faces. The women leave the room and then the artist resketches them, this time based on descriptions provided by strangers the women have just met.

The results are stark. The sketches based on the input of the women themselves are sullen and unflattering; the sketches informed by the strangers are warmer, happier, and more attractive. They are also far more accurate. The video ends with the words "You are more beautiful than you think." It was released in both three-minute and six-minute versions, and within a week the spots had more than 15 million views between them. Both "Evolution" and "Dove Real Beauty Sketches" were part of Dove's multiyear advertising effort called "Campaign for Beauty." It was declared by *Advertising Age* to be the Top Ad Campaign of the 21st Century.

———

Amid all these changes—longer formats, skippable ads, branded content, a desire for empowering messages—perhaps nothing has pushed advertisers out of their comfort zone more than partnering with Internet creators. And there is no creator who knows more about partnering successfully with brands than Casey Neistat.

Casey, a vlogger and filmmaker, has worked with some of the world's biggest brands to create videos that consistently catch fire. When people talk about Casey's brand work—high-profile partnerships with Nike, Samsung, Mercedes-Benz—they tend to use phrases such as "magic touch" to describe his ability to create content for companies that goes viral. But the more you get to know

Casey—the more videos of his you watch and the more of his back-story you learn—the more you realize that magic has nothing to do with it.

Before Casey ever posted his first video to YouTube, in 2010, he had produced two films, been nominated for an Emmy, won an Independent Spirit Award, had his short films showcased in international art exhibitions, and sold a series to HBO that he, along with his brother, wrote, starred in, directed, edited, and produced. Before that he was a teenage dad living in a trailer park. His familiarity and success in nearly every visual medium, from independent cinema to Snapchat, were born of years of hard work and dedication to overcome adversity. And all of it was done in an effort to find a megaphone.

"I was the forgotten child," Casey told me when we met on a Tuesday morning in his lower Manhattan studio,* the same one he's occupied for more than a decade. It was a summer day in New York, and Casey was in a white T-shirt, modified Wayfarers perched on top of his head. As we spoke inside, a line of tourists had already gathered outside his building, waiting for a glimpse of him whenever he left for the day. ("That's nothing. It'll quadruple by two o'clock.")

"You've got the firstborn, then the only girl, and then the baby, and you know, like, this fuckup in the middle that was third, born thirteen months after my sister, that was a total accident. . . . I was always the loudest when I was a kid because I was just starving for attention."

That desire didn't serve him well in school, where he frequently

* Casey's studio is itself a rich creative statement, a study in controlled chaos where every camera lens, every tool, every skateboard is displayed out in the open, arranged and labeled in its own assigned place. I could spend thousands of words describing it to you, but I highly suggest viewing one of the many studio tours Casey has done over the years.

found himself in trouble. In ninth grade, his teachers were calling him a loser, telling him that he'd be working at a gas station or end up in jail because he didn't follow the curriculum. "I knew that they were wrong to say that, and I knew there was another path in life to find happiness and fulfillment in one's career and one's personal life. I knew that. But they completely disagreed. And they threw me out of school because they knew they were right."

After his parents divorced, he got into a heated argument with his mother and left home for good, at fifteen years old. After staying with some friends, he moved in with two girls, one of whom would become his girlfriend. When she later had a fight with her roommate, she and Casey decided to leave their Connecticut town and move to Virginia, where Casey's older brother, Van, was attending the College of William and Mary.

Van legally adopted his brother so that Casey could attend a local high school, but three months later, he had to drop out—he had gotten his girlfriend pregnant. She and Casey moved back to Connecticut, where he got a job at a seafood restaurant in Mystic called Jamms, working evenings as a dishwasher for $8 an hour. When his son, Owen, was born, Casey was just seventeen.

After a year and a half of living in a trailer park and saving some money, Casey and his girlfriend took Owen on his first vacation, to New York, where his brother Van now lived. The family took Owen to the zoo, an excursion Van filmed and edited with Casey on his new iMac. Casey was so taken with the process that when he returned to Connecticut, he immediately maxed out his credit card to buy his own iMac, along with a video camera.

That was the beginning of Casey's moviemaking career. His first videos were family videos of Owen riding on a train, playing in a lake, and breaking into a can of Ovaltine with a wooden spoon. With Owen as his subject, Casey told me, "for the first time ever,

I found a way to share my voice." Many of those films, though, he had to record over because he couldn't afford new DV tapes. "You have no idea how much I kick myself in the ass for doing that now."

A few months later, Casey and his girlfriend broke up and he moved in with a friend from the restaurant. Realizing he had little reason to stay in Connecticut, he decided to move to New York to pursue his dream of becoming a filmmaker, coming back to visit Owen every weekend.* He boarded a train to Penn Station with a duffel bag of clothes, his iMac, and $800 to his name. After starting out in the city as a bike messenger, he began working in the studio of the artist Tom Sachs, where his brother worked as an assistant.† While he and Van worked for Tom during the day, they spent their nights and free time making videos together, in addition to taking on film and editing work on the side.

Then in 2003, something life-changing happened: Casey's iPod died. Eighteen months in, its battery had lost the ability to hold its charge. When he visited the Apple Store to buy a new battery, he was told it was irreplaceable and he would have to either pay $250 plus shipping to have the battery replaced or spend another $300 to $400 to purchase a new iPod. Frustrated, he decided to make a movie about it. In "iPod's Dirty Secret," Van films Casey while he goes around New York spray painting over iPod ads with a stencil that says, "IPOD'S UNREPLACEABLE BATTERY LASTS ONLY 18 MONTHS." The video, just over two minutes long, is sound-tracked first with Casey's call to Apple's customer care line and then with the Public

* He did so every week for fourteen years.
† Casey had heard that Tom was willing to pay a bounty of $10 each to anyone who brought him police barricades that he could use for a sculpture. He spent an entire evening on foot, single-handedly tracking down barricades, disassembling them, and loading them onto a hand truck he had borrowed. He took them to Tom's studio, where the artist, impressed with his effort, instead offered him a job.

Enemy song "Express Yourself." It ends with a title card imposed over a dead-battery screen that says, "a public service announcement from the Neistat Brothers."

After posting it on the website ipodsdirtysecret.com (this was pre-YouTube), the video went viral, drawing over 6 million views. It was covered by the *Washington Post, Rolling Stone,* and the BBC and even led to an interview with the brothers on Fox News. A little over a month later, Apple announced both a battery replacement policy and an extended iPod warranty program. "'IPod's Dirty Secret' is a very literal example of me being a frustrated kid and not being able to scream loud enough," Casey said. "So I make a video about it, and then the whole world can hear me scream."

Soon interest in the Neistat brothers grew, and the two set out on their own. At first they gained exposure mostly in the fine-arts world, the only industry that knew what to do with their short films. A series of shorts they created called *Science Experiments* was featured at the São Paulo Biennial.* But then in 2006, Tom Scott, one of the founders of Nantucket Nectars, reached out to the brothers with a proposal. He had seen "iPod's Dirty Secret" and some of their other films, liked their aesthetic, and wanted them to make content for a new cable network he had created called Plum TV (geared toward wealthy viewers in resort areas such as Martha's Vineyard and Sun Valley).

The brothers agreed and the initial results were so encouraging that Tom offered to bankroll them to make a TV show. That offer became *The Neistat Brothers,* an eight-episode series that the three sold to HBO in 2008.

It is an understatement to call the show unique, especially for its time. Every episode of *The Neistat Brothers* is an intricately crafted collection of short films of varying length, with Casey and Van each

* You can still view those movies on Van Neistat's Vimeo page.

responsible for fifteen minutes of content. Every part of every episode is considered, from the stop-motion animations that introduce every episode to the end credits that close them out, different each time. The intricacy of the show calls to mind a Wes Anderson film, but without the smooth edges or high polish. If Anderson's bespoke filmmaking felt like a three-piece suit, the Neistat brothers knitted you a homemade sweater.

Some of their short films were fun, digestible snippets, such as when Van talks about how everyone stopped listening to him once he shaved his beard into a mustache. Others are personal meditations, such as Casey discussing the struggle between his ego-driven desire to remain single and his love for Candice Pool, the woman who would eventually become his wife. Perhaps the most memorable episode documents the brothers selling the show to HBO days after the company's head of programming—the one who had initially showed interest in their work—was fired.

Van films himself nervously pacing around his hotel room in a bathrobe after their meeting with HBO has just gone well. But the good news is tempered by the fact that he's about to get a divorce, his greatest professional success arriving at just the moment when his personal life begins to unravel. As he realizes the enormity of how his life is about to change, in some ways for better and in some ways for worse, he thinks out loud, unable to look directly at the camera. "I gotta go back home and do some very difficult things. . . . So this is just a glimpse of what happens"—he pauses, registering what he's saying before continuing—"what happens when your dreams actually start to come true."

While working on the series, Casey also produced two films with Tom, both of which premiered at Cannes. The second of those films, *Daddy Longlegs*, about an irresponsible young father torn between

childhood and adulthood, won the Independent Spirit John Cassavetes Award, an honor for the best feature film by a first-time director with a budget under $500,000 (it was previously won by *The Blair Witch Project* and *The Station Agent*).

Casey also worked on a series of short films for the *New York Times*, one of which, "Dinner Plans," was nominated for an Emmy. It lost to the viral movie created in support of Barack Obama's candidacy by will.i.am, "Yes We Can."*

But those career highlights were followed by the two years Casey spent embroiled in what he calls the "politics of mainstream media." Although HBO bought his show, its new head of programming thought it was too low-budget for the direction in which she wanted to take the network. After HBO sat on it for two years, *The Neistat Brothers* eventually ran on Friday at midnight, perhaps the worst possible time slot in existence. It took those same two years for *Daddy Longlegs* to find distribution and premiere in theaters. "And in those two years I did nothing," Casey says. Not having created any new work in that time left him emotionally "destroyed" and disillusioned about his dream of becoming a big-time filmmaker.

"That was the inflection point," he told me, "where I said, 'No, no, no. The thing that I love is not the politics. It's not being at these fancy parties. It's not the tuxedos and the limousines. What I love is the act of creation.' And by embracing the wrong aspects of this media world—that is, the mainstream one—it's actually pulled me away from that and sent me into something else."

* In a hilarious scene in *The Neistat Brothers*, Van is racked with anxiety as the names of the nominees are read while he and Casey sit in tuxes at the Emmys. "Nobody told me we were up against the fucking Barack Obama movie!" he says before lighting a cigarette in the theater and getting kicked out.

And so, rather than chase another TV deal, rather than run the production company he had formed with Tom Scott, rather than collaborate again with his brother, Casey once again set out on his own, into "the warm embrace of YouTube."

I asked Casey how it had felt to turn away from those collaborations in favor of going it alone on YouTube. Despite the big decision, he said, "it wasn't a very difficult or a long-considered assessment to look around and see that my very best option was the Internet. But I can tell you, I vividly remember the first video that I made that I put my name, Casey Neistat, on, instead of the Neistat Brothers, and it felt weird."*

Over time, though, the more he worked on his own, the more he came to like it. "When you have a partner, you have somebody to blame all the failures on and attribute all the success to. And when you're on your own, everything falls on yourself, and that's something I absolutely love."

The movies he first made on his channel reflected the care and attention he had demonstrated in his TV show, each taking about a month to film and edit. His ninth video, called "Bike Lanes," was his first solo viral hit, showing him crashing into numerous obstacles that were obstructing bike lanes in New York after he got a ticket for riding his bike outside one. The video ends with him crashing into a police car, emphasizing just how hypocritical he thought the ticket was.

But the success of "Bike Lanes" could not have prepared him for his next big hit, "Make It Count," a movie he made in collaboration for Nike's newly launched FuelBand fitness tracker. Once again, a piece of handheld tech was about to change his life.

* "Chatroulette," in which he experiments with the briefly popular site.

———

"So far this trip is off to an irresponsible start," Casey says in the beginning of the spot. He's referring to his late arrival at the airport, but the line has a larger resonance. Casey and his friend the filmmaker Max Joseph had already made two films for Nike to promote its new wearable. They were supposed to make a third, based on Nike's tagline for the product, "Make it count." But instead Casey called an audible and decided to use the budget for the two of them to set off on a global adventure instead. They would head to the airport without a plan and keep traveling until their money ran out. It took them ten days, during which they visited thirteen countries on three continents.

It sounds more irresponsible than it looks. The four-and-a-half-minute film is a beautiful collection of jump cuts from scenes around the world, as Casey runs, jumps, backflips, and skateboards through Paris, Cairo, Bangkok, and Rome. He and Max visit the pyramids of Giza, go to Zambia to see Victoria Falls, visit the wreckage of the *Costa Concordia* cruise ship in Italy, and in one scary sequence, Casey jumps off a cliff into the Bimmah Sinkhole in Oman, a sixty-five-foot drop. He also gets a tattoo on his forearm that says "DO MORE." And all this starts with Casey unboxing a brand-new Nike FuelBand.

Upon seeing the edited film, Nike was smart enough to realize the potential of the film. Casey premiered the video on his YouTube channel before Nike uploaded it to theirs. It reached nine million views in less than three days. A story that ran in Mashable asked if it was the best branded story ever told.

The media was quick to play up the fact that Casey "went rogue," but although he didn't reveal any footage to Nike until he had finished the film, he said he had acted with the brand's trust. "Don't burn me" was the only thing his contact had told him.

"There's a reason why Nike has the brand identity that it does," Casey told me. "And that's because they take chances. They're real creatives who understand you sell an idea and then everybody will buy the product. You never sell the product because no one gives a shit."

Since then, the phone calls from big brands haven't stopped. He made a film for J.Crew to promote its wrinkle-resistant suit, providing tips on how to travel in style with scenes of him surfing in Italian wool. He filmed a Mercedes commercial for the company's new CLA model, racing it on the Bonneville Salt Flats with a female model wearing an American-flag bikini. And he made a film to advertise Ben Stiller's remake of *The Secret Life of Walter Mitty*, using the ad budget to buy and deliver relief supplies to victims of Typhoon Haiyan in the Philippines. All were massive hits.

Alongside his brand work, Casey started his own technology company, called Beme. The Beme app was designed for people to quickly share videos of whatever they were seeing, unedited, by holding their phones up to their chest. The app would automatically record for four seconds and then immediately share the video on the app without giving the user a chance to review it. To help document the progress of his new company and challenge himself creatively, Casey committed to becoming a daily vlogger.

———

It's impossible to watch Casey's channel and not feel inspired to start filming the world around you. The way he's able to render his environment—through time lapses, through beautiful aerial drone footage, through the window of whatever flight he happens to be on to wherever his life happens to take him—helps you appreciate just how visually interesting the world around you really is, if only

you'd bother to capture it. It's difficult to know how many people his visual style has inspired, but his impact can be detected throughout the channels of dozens, if not hundreds, of other YouTubers.

In addition to that beautiful footage, Casey's channel is just a lot of damn fun to watch, punctuated by several memorable films. He went snowboarding on the streets of New York City after a winter blizzard, towed by a jeep. He helped his friend and fellow YouTuber Jesse Wellens dress up like Aladdin and ride a flying carpet through New York City (really an electric skateboard hidden beneath a frame of fabric—pretty convincing, though).

And of course, there are behind-the-scenes videos from the various films Casey has shot for Samsung. They include hosting an Oscars' red carpet special in 360 degrees, hanging from a rope ladder on a helicopter as it flies in front of the Hollywood sign, and snowboarding over a Finnish skiing village while attached to a massive custom-built eight-rotor drone.

Later, when I told John Green that I had recently met Casey at his studio, he told me, "It's hard to believe that he and I have the same job."

———

Recently Casey visited YouTube for a day of meetings with our team, and he was kind enough to sit down with me for a question-and-answer session with our staff. He wore a gray T-shirt over a white long-sleeved thermal shirt, torn jeans, black-and-white-striped socks, and the same pair of modified Wayfarers on top of his head. Our conversation was wide-ranging, but soon his work with brands came up. One of our employees asked him what the hallmarks of a successful brand partnership are.

"As a daily uploader, the opportunity to work with brands is

tremendous because I'm uploading anyway, so let's figure out how we can integrate. Great for you, great for me. But the reality is pretty far from that." He began telling a story of how just the day before he visited YouTube, his agent had come to him with an opportunity from a large, well-known brand with a specific vision for a collaboration and a tremendous paycheck. He had taken a look at the offer and begun to write his agent back.

"You can share this e-mail with them if you want to," he wrote to her. "This is the stupidest campaign I've ever heard of. And here's what's going to happen. They're doing this with ten YouTubers. I'll say I'm passing. The other nine will say, 'Yes, this is a great paycheck.' They'll do exactly what is being asked of them. They'll have, like, a million comments saying 'This is stupid, you're a sellout.' They'll have a million dislikes. Their viewership will dip temporarily. The agency will go and they'll pull all the raw numbers and they'll go to the client and say, 'Look how many media impressions we had—great!'" Here Casey put both his thumbs up in the air. "And the reality is that the client doesn't win, the agency looks dumb, and the YouTube creator loses.

"Tell them to find the creators that they actually like, create a dynamic relationship with them, and then empower the creator. 'Here's our product, here's what we're trying to accomplish. What can you do? How can you organically work this in a way that your viewers will find to be meaningful?'"

He sent the email off to his agent. She called him the next morning after having forwarded his email to the client. "Hey, so they're ready to double the budget and let you do whatever you want."

Casey acknowledged that the story reflected a cynical attitude. "I don't mean to throw clients or agencies under the bus," he said. He sympathized with the rapid changes that were occurring in the advertising world after decades spent doing things a certain way.

The danger, he argued, was that kids would reject partnerships with creators who seemed forced and inauthentic.

Later, in his studio, he explained why people had become so allergic to forced integrations between brands and creators. "The nut of it is that we, today, human beings, we're just absolutely saturated with media. Literally as I'm talking to you, out of my right eye I see one screen and out of my left eye I see another and there are two more screens there. And what that's done is, it's sort of refined our bullshit detectors to a degree that, if it's bullshit or it smells at all, we don't see it; we ignore it. And I always say: the only thing worse than bad is invisible. That's how I describe 99.9 percent of all advertising; it's just invisible. You didn't even see it. You didn't even know it exists. So in order to be effective, you have to penetrate that."

He explained that in a world where everyone has his or her guard up, "influence is the only thing that matters in marketing. Who has all of the influence right now? It's people that are in the social game. What is the hierarchy of the social game? You have everybody else, and then at the top you have YouTube. In the world of the marketing, there is no higher authority than YouTube and YouTubers."

Even I was a little skeptical of that, but he continued to make his case: "Never in the history of humanity have we had the opportunity to communicate to the world the way that the Internet has enabled us. And when it comes to the most effective way of communicating to that world . . . video is the ultimate means of communication. With video being the ultimate means of communication, the absolute ultimate conduit for that medium is YouTube. And that's easy to substantiate with really hard, quantifiable methods. Kim Kardashian has sixty million people that follow her on Twitter. What that means is, when she tweets something—how many of them scroll by it? And when they scroll by it, how long are

they looking at it? And even if every single one of them pays attention and reads through it, she has an opportunity to communicate a message with 140 black-and-white characters.

"I have ten minutes a day of audio, of video, of compelling ways to communicate a message. There is *nothing* that has that authority. Not television, not anything in the history of communication. And that is the opportunity."

Still, some companies are reluctant to trust their brands to social media stars whose success they may not fully understand. Many of the world's biggest companies got that way by carefully shaping and controlling their brands over decades. And if they've worked with celebrity endorsers in the past, they've still controlled the message and the medium. When George Clooney appears in a commercial for Nespresso, he doesn't have creative control over the content; he plays a role in a commercial.

But most YouTubers have built their followings by being themselves and demonstrating their authenticity. Their Millennial audience, many of whom are inherently distrustful of corporations, may see any sponsorship deal as inauthentic, especially one that feels forced or discordant with that creator's identity.

Ultimately, every brand has to figure out its own level of comfort when working with influencers. Nike or Mercedes may be perfectly happy to put its trust in a creator and let that person come up with his or her own vision. For older, more traditional brands, that may feel too risky. But the only way a company will discover its own limits is by taking chances with its creative.

I want to be very clear that when I say that advertisers should get more comfortable with risk, I am by no means suggesting that they make compromises about where their ads appear. YouTube recently endured some well-deserved criticism from advertisers and agencies when it was discovered that our algorithms were

placing advertisements beside content that violated our own policies. In a few unfortunate examples, brands found their ads running in front of videos that displayed hateful views, leading some to temporarily suspend their advertising. Since then, we've taken major steps to address the problem, reengineering our algorithms to better identify ad-friendly content and increasing safeguards so that brands have tighter control over where their advertisements appear.

So what does it actually mean for an advertiser to push itself out of its comfort zone?

Well, for the Brazilian fast-casual food company Spoleto, it meant turning an embarrassment into an opportunity. One Christmas, the YouTube comedy troupe Porta dos Fundos made a video poking fun at the chain's reputation for poor customer service. In the clip, a woman who visits the chain has trouble deciding which ingredients she wants in her pasta. Her impatient server becomes enraged, throwing hearts of palm in the woman's face and insulting her, causing her to break down in tears. "No one told you to dine in hell!" he screams at her.

The group assumed that Spoleto would hate the video. Instead, the company decided it would be better to be in on the joke. It contacted Porta and asked it to make a few sequels, in which the server is fired, seeks anger management counseling, and returns to the company under the watchful eye of management. The new videos were still pointed and funny, but with the overlying message that customers could expect better service at the chain. It was a gamble for Spoleto, but all three of the commissioned videos drew millions of views. No other video on Spoleto's channel has more than 300,000.

The good news is that the potential for creator partnerships to be successful is quite high. Brands that want to partner with social influencers have the luxury of working with people who have already proven their ability to get and keep attention, generally for far less than a celebrity endorsement. And because creators interact directly with viewers through comments and tweets, they blur the line between celebrity and friend, giving them a powerful ability to influence opinions.

It's important to note that creators have a legal responsibility to clearly disclose any material relationship to brands when promoting or endorsing products on social media. But even with that full disclosure, creators still act as powerful advocates for brands. When we surveyed our teen and Millennial subscribers, 60 percent of them told us they would follow their favorite creators' advice on what to buy.

So, how do you choose the right creator to partner with in the first place? "You do your homework," Casey said. "You don't pick someone based on their numbers. You want to know what it's going to be like working with Tyler Oakley? Go watch the six hundred videos that are online. Get to know exactly who he is and what he's like. Because the time when you get to sort of dictate and exercise control is not after the commitment's been made; it's prior.

"You have twenty million creators to choose from. Find one that is the exact fit. And then everything after that has to be based on trust." He paused. "And that is terrifying to advertisers."

When I speak to advertisers about the challenges of managing their brands in the digital age, I tell them it should feel as though they're raising a teenager. When my daughters were younger, it was easy to get them to listen to their mother and me. We could exercise some measure of control over their lives, telling them when to do

their homework, when to go to bed, and where they could spend their time outside of school.

Now both our daughters are teenagers, and we constantly find ourselves in situations where we want to be in control but know that we can't be. My elder daughter just started driving, so she has way more autonomy than she did just a few months ago. As any parent of a teenager can tell you, the tension between a parent's desire to demonstrate authority and the child's need to express his or her growing maturity and freedom can feel deeply uncomfortable. But that discomfort is a necessary part of allowing a child's identity to flourish.

Brands that want to partner successfully with YouTubers need to adopt the same attitude: they need to be willing to let go from time to time, to hand over the keys. They occasionally have to be comfortable with not knowing what's going to happen next.

12

Streampunk Rock!

The Fall and Rise of the Music Industry

I'M ABOUT TO introduce Scooter Braun to the audience, and I have no idea what he's going to say. I've invited Scooter to speak during a keynote I'm delivering at CES, the massive consumer electronics conference that takes place every year in Las Vegas. And though my team has spoken to his and we suggested he address the influence YouTube has had on the success of his artists, it's not clear what he'll talk about. He's made a career out of defying convention, and it's obvious that he's approaching his speech the same way.

Since discovering Justin Bieber on YouTube in 2007, Scooter has built one of the most successful music management businesses in history. In addition to representing Justin, he now manages Usher, Ariana Grande, Vic Mensa, and Kanye West, among others. He also launched Schoolboy Records, an independent label that has had

several Top 40 hits by artists including Tori Kelly and Carly Rae Jepsen. And in his latest act, he's producing digital videos, films, and TV shows, including CBS's *Scorpion*, a thriller about a group of white-hat hackers that's been a hit among Millennials.

"Ladies and gentlemen, please welcome the founder of SB Projects, Scooter Braun," I tell the crowd before walking toward the wings.

After a clip of his company's greatest hits plays, Scooter walks onto the stage in a leather jacket over an unzipped black hoodie and T-shirt. He has a few days' worth of stubble and keeps his hands in the pockets of his jeans while he talks. "I'm the music guy, so I'm not wearing a suit," he tells the audience. After thanking YouTube for inviting him to speak, he says, "I got up here and I thought, What am I actually going to say? So I decided, What is Robert trying to convey? He's trying to convey how you can use YouTube to change people's lives and how the world is changing because of it. And then I realized, that is my whole life. I'm pretty much a living example of how this service can change your life."

———

The story of how YouTube changed Scooter's life began in Atlanta. As a student at Emory College of Arts and Sciences, Scooter became an incredibly successful party promoter, throwing bashes that drew hundreds of college students as well as local artists such as CeeLo Green, Ciara, and Lil Jon. People took notice, and soon Scooter was planning parties for Britney Spears, *NSYNC, and Ludacris when they came to town. At one of his parties, he met Jermaine Dupri, a rapper and the head of the Atlanta label So So Def Recordings. Dupri was so impressed with Scooter that he asked him to become his label's head of marketing. The collaboration lasted

three and a half years, a period that included some of the best years of Jermaine's career.

Eventually, though, Scooter and the label had different ideas about how artists could be marketed in the digital age. Having seen the popularity of MySpace, Facebook (Emory was one of the first few colleges where it launched), and a new service called YouTube, he thought he could use the emerging tools of social media to break an artist without the support of a major label. When he tried to push for that approach at So So Def, he found himself ignored.

"Not out of spite," he told me when I met him in his office months later, "but just because they were, like, 'Look, you're really good at what you do, but this has never been done before. And you're young. What do you know about this?'" Looking relaxed in a brown leather jacket, jeans, and white sneakers, he told me he had sought advice at the time from an unlikely source: Lil Jon.

Lil Jon had worked for So So Def before breaking out as an artist, and he told Scooter it had taken him twelve years to leave the label and chase his dreams. "Don't take twelve years," he told him.

Soon after the conversation, Scooter parted ways with So So Def, and in between some freelance marketing* he began to devise a strategy to put his belief in social media into practice. "I started thinking to myself, More people are consuming on YouTube than they are on television, and they're consuming in an intimate manner. Television, you sit in a room, people are walking in, you know millions of people are watching something at the exact same time

* In a particularly bold move, he impersonated a college journalist in order to line up a meeting with a Pontiac marketing executive. During the meeting, he admitted that he was there not to write an article about the executive but to pitch her on a sponsorship deal with Ludacris. The marketer was furious, but Scooter convinced her to attend the premiere of Ludacris's new film, *Crash*. After seeing his performance in the movie, she agreed to a $12 million endorsement deal.

as you. On YouTube, it's on your own time, one-on-one with you on your phone or your laptop."

He told me about how his father would discover music at record stores on vinyl, while he personally had grown up on cassettes and mixtapes. "I just thought, This social media thing, this is the new mixtape, this is the new vinyl."

And then, in 2007, he saw a YouTube video of a twelve-year-old Canadian kid at a talent show named Justin Bieber. Following an extensive search, he was able to reach Justin's mother, Pattie Mallette, on the phone. After speaking with her for two hours, he convinced her to bring her son down to Atlanta, where he put them up in a town house and began working on launching Justin's music career.

For a year and a half, he worked on building Justin's YouTube channel into a massive online presence. The first videos featured Justin singing covers with an acoustic guitar, as well as snippets showing off his drumming. Some were three minutes long, some as short as thirty seconds, but Scooter enforced the same rule in all of them: "I never let Justin say, 'My name is Justin Bieber, I am about to play.' I said, 'Just play. You don't even need to look in the camera.' I wanted to make it feel voyeuristic. I wanted people to think they were seeing something maybe they weren't supposed to see, so it would feel even more intimate. Because if you were friends with him, he wouldn't say, 'My name is Justin Bieber. I'm going to play you 'Cry Me a River.'"

The videos slowly started to gain views, but none really connected the way Scooter had thought they would. They filmed video after video, until finally, their sixteenth video together, of Justin singing a cover of Chris Brown's "With You," went viral. Overnight, it reached a million views, which led to a halo effect on all his other videos. Soon they all crossed a million views, too. "We were Net-

flix," Scooter said. "We gave you a whole season. We had a catalog to binge-watch, and that's what people did."

Once Justin's total view counts climbed to around 60 million, Scooter began taking him around to labels in search of a deal. Everyone turned him down. "Literally everyone thought I was crazy," he said. They told him that YouTube artists don't become stars and views don't lead to sales. When he'd protest that Justin had a bigger audience online than other acts on their label, they'd disagree. He's not more popular, they told him; he hasn't released any records. "No, he is," said Scooter. "Look what I'm doing with YouTube. Look how I'm using this!" When he tried to pitch Justin to the legendary music executive Clive Davis, Davis's team told Scooter that Clive didn't use the Internet and wouldn't check out a YouTube channel. "Can you give us a DVD?" they asked.

As the rejections piled up, some of Scooter's friends tried to stage an intervention. They told him he was going to destroy the career he had built as a young up-and-comer in the industry. They told him he had wasted a year on this project and he was too obsessed with it. But Scooter couldn't believe that people weren't seeing what he was. Every day he would wake up and see that Justin's view counts had grown. He told his friends, "No. I've dedicated my life to this. I'm right about this."

Eventually, with the help of Usher (a friend of his from his time at So So Def), he was able to secure a deal for Justin from L. A. Reid, the chairman and CEO of Island Def Jam Music Group at the time. According to Scooter, it was a deal Reid didn't want to do but agreed to in the hope of signing Usher when his existing contract was up. "The kid's not going to work," Reid reportedly said.

"I respect where those guys came from," Scooter told me. "And I will probably be them someday, sooner than later because things are moving so fast. I won't be in my sixties and my seventies; I'll be

out of touch probably in my forties and fifties because of how quick technology is moving, if I'm not out of touch next year. But what I do know is that what has become the absolute norm and status quo today—people thought I was nuts."

Discovering new artists used to be a business with literal shoe leather costs. Emerging musicians would play free gigs in the hope of getting heard, while the only way A-and-R reps had to discover something new was to attend endless gigs or listen to mixtapes in search of the next big thing.

Now audiences can do much of that work for them. One music video that catches fire online is enough to turn an aspiring artist into a signed one, representing the best chance that many have for a big break. Prior to Justin, that model didn't exist. YouTube was seen by the music industry as a place for solely two things: official music videos from major artists and clips from amateurs. It wasn't considered a place to discover a superstar until Scooter did it.

I asked Scooter when he thought this mentality had finally shifted. "When Michael Jackson died," he said matter-of-factly. "That week, the iTunes chart was all Michael Jackson, except for two music videos. Taylor Swift, with one of her biggest hits to date,* was number four. One, two, three, five, six: Michael Jackson. Eight, nine, ten: Michael Jackson. Number seven was a new video from an artist that no one had ever heard of, called "One Time." That was Justin Bieber. And it had no promotion. No one had ever heard of him. Why was Justin Bieber staying in the top ten when every other major artist in the world was evaporated by Michael Jackson?"

The video, Justin's first ever, was made for $25,000, a budget that Scooter had to beg the label to provide. The label's publicist similarly gave him the cold shoulder. "The YouTube kid?" he asked.

* "You Belong with Me."

"I don't want that." But when the official video was announced on Justin's YouTube channel, demand for it skyrocketed on iTunes. Scooter met with L. A. Reid to explain what had just happened. L.A. told him, "I don't know marketing; I know music. Just keep doing whatever the fuck you're doing."

So he did. Scooter released acoustic versions of every song on Justin's upcoming album on YouTube a month before the official release date. The acoustic versions built up demand both for the album and for concert tickets. By the time the official singles were released, they shot to the top of the sales charts, while fans who attended Justin's shows already knew all the words to the songs.

That effect wasn't limited to the United States. When Scooter saw the numbers Justin's YouTube videos were doing in the United Kingdom, he urged the label to send him to England. They turned him down, telling him that no one there would know who he was because his songs hadn't hit the radio. Scooter flew Justin there on his own dime and announced on Twitter that he'd be performing in front of the Universal Music Group's* London office. You can now see videos on YouTube of hundreds of young British girls singing along as Justin serenades them with an acoustic guitar. "They had never seen that many people turn up at the Universal building *ever*," Scooter said. The next day, Justin's music hit the UK airwaves.

For Scooter, it wasn't just the songs that attracted people to Justin; it was also the backstory. "We're in a recession, and when you turn on the TV, the biggest show on for kids was *The Hills*," he said. "It's not realistic. A bunch of kids from Laguna Beach showing off their cars and their mansions, while your mom and dad are losing their job?

"I had to give them a story about hope. I had to give them a

* The parent company of Island Def Jam.

story about a kid whose mom was a teenager when she had him and they lived in the projects. And he put a video up on YouTube, never imagining he'd ever get out of his own town. And now he's living his dream. You can, too."

———

Prior to Justin's YouTube-driven ascent, it was nearly impossible for an artist to find mainstream recognition without first having a record deal. In order to become a famous musician, you needed your song on the radio and your album in stores. Only major labels could finance the dauntingly expensive recording, pressing, and nationwide distribution of an album. And similarly, you needed label support to crack the strictly controlled playlists of the nation's popular radio stations.

In 1981, things started to change, when MTV launched in the United States. The channel's initial approach challenged the grip that radio held on record sales, playing videos from artists that hadn't yet hit the FM dial. That was primarily out of necessity; music videos were a new concept in the United States, so there weren't many popular acts that had made them. In the United Kingdom, however, shows such as *Top of the Pops* had been airing music videos for years before MTV was created. As a result, many of the first artists that MTV broke were British bands, such as the Human League, Billy Idol, and A Flock of Seagulls.*

As cable TV spread throughout the United States, MTV also played a critical role in bringing hip-hop and grunge to mainstream

* The first music video MTV ever played was "Video Killed the Radio Star" by the Buggles. That song wasn't written for MTV's debut; it had been released two years earlier as a critique of the way music videos led the British music scene to favor aesthetics over musicianship.

America for the first time, when many regional radio stations refused to carry those formats. "We were a national radio station," Tom Freston told me. "We piped in music that people had never heard into millions of homes throughout Middle America."

But just like pressing an album, filming a music video was expensive. And unlike an album, music videos didn't directly earn an artist any money—MTV didn't pay to air videos because they served as such a powerful promotional tool for artists. As a result, MTV eventually served to strengthen the importance of record labels and their promotional budgets. The competition to get a video on MTV became even more intense than cracking the Top 40.

"Every Tuesday when we came together to decide which videos to broadcast," Tom Freston said, "the level of anticipation was like the entire recording industry waiting to see the smoke coming out of the chimney." As a result, music video budgets shot up into the millions of dollars, putting them out of reach for most artists.

Those dynamics also led labels to prioritize artists who had on-camera appeal, because at that point they were essentially making short films.* Iconic music videos from "Thriller" to "Sabotage" set a precedent that artists needed a style and an image that connected with people, in addition to a great hook. Naturally, labels that wanted to discover the next big thing turned to musicians who already had experience on camera. Britney Spears, Christina Aguilera, and Justin Timberlake were all members of the Mickey Mouse Club before they dominated MTV in the 1990s.

But Scooter showed the record industry that that model of discovering pop superstars could be flipped on its head. Not only could

* This trend would also transform the movie industry, giving several young directors their start. Spike Jonze, David Fincher, Antoine Fuqua, Gore Verbinski, and Michael Bay all directed music videos before becoming big-screen directors.

new musical talent be discovered on the Internet—as some labels had done by signing artists directly from MySpace*—but the wisdom of the crowd could bring camera-ready artists directly to them. Because YouTube was inherently a visual medium, it meant that successful artists would have both musical and visual appeal. And best of all, it was global: stars could come from anywhere, and their music had the potential to resonate everywhere.

———

At CES, Scooter told another story about YouTube changing his life, when his COO and friend since college, Scott Manson, sent Scooter an email with a link to a new YouTube video. A Korean American friend of Scott's had watched it and thought it was hysterical, so Scott sent it to Scooter as a joke. "Isn't this hilarious? I love this guy," Scott wrote.

Scooter banged out a two-word response: "Find him."

It was the start of summer 2012, and the video Scott had just shared was "Gangnam Style" by the K-pop artist Psy. At the time, the video had around 60,000 views. But Scooter immediately recognized something in the video that no one else, not even Psy himself, had seen. Scott was confused. "Do you want to do it in English?" he asked.

"No," Scooter replied. "We're doing it in Korean."

As he relayed the story at CES, Scooter explained what he had seen in the video. "There was a song, which some of you may re-

* That was how Adele was discovered: a high school friend of hers posted some songs Adele had sung for a class project to MySpace. The songs caught the attention of Richard Russell, the head of XL Recordings, who eventually signed her.

member, called 'Informer,' by Snow.* Does anyone remember it?"
There were some murmurs of recognition, but one person in the
crowd of hundreds clapped. Scooter trained his focus on him. "Why
don't you stand up for me?" Reluctantly, the man in the audience
stood up. "So, if you can," Scooter requested, "try and sing 'In-
former' by Snow."

The audience chuckled as the man summoned up his courage.
"Uhh," he started, "In-fooorrrr-mer, baddah-baddah-baddah-
baddah-bah-dah." The crowd erupted into laughter as Scooter led a
round of applause from the stage.

"Brave man," Scooter said. "That's exactly why I signed Psy. Be-
cause I also have no idea what he was saying in 'Informer.'† I don't
speak Korean. I did not know what 'Sana-i' meant. But I knew that
when I was a kid and 'Informer' came out, that I memorized all the
gibberish that he was saying and thought I was the coolest kid that I
could go and do 'Informer' for all my friends. So I started to imagine
kids who couldn't speak Korean, would just learn Korean."‡

Back onstage, Scooter also talked about his childhood spent at-
tending bar mitzvahs, dancing to songs such as "Cotton-Eyed Joe"
and "Macarena," "so I knew what 'Gangnam Style' was," he said. He

* In 1992, "Informer" spent seven consecutive weeks at number one on the
Billboard Hot 100. Snow, a Canadian reggae musician, would never record
another hit.
† Just for fun, I looked up the actual lyrics:
 *"Informer, ya' no say daddy me Snow me I go blame / A licky boom boom
 down."* According to the lyric site Genius, what Snow is essentially
 saying here is, "Stop snitching."
‡ Later, Scooter told me this is how he tries to market all his artists, by
comparing them to someone who's come before, even though they hate it.
At the start of Justin's career, he compared him to Michael Jackson. "Do
you think Justin deserved that early in his career to be compared to Michael
Jackson? Absolutely not. But I made the comparison, and I have this Prince
of Pop thing go out there. People compartmentalize things."

had Scott track down Psy in Korea and flew him and his translator to LA within a week. The three sat in Scooter's backyard and discussed Scooter's desire to sign Psy to a global record deal and acquire the rights to "Gangnam Style" outside South Korea. He told Psy that "Gangnam Style" could be a massive hit in the United States and abroad, solely because of YouTube. Psy wouldn't even have to leave Korea.

Through his translator, Psy told Scooter, "Look, if you think you can even get it in the Top 100 in the United States, I'll give you the song for free." Scooter told him that was ridiculous and said he wanted to make a good deal. After thirty minutes of translated negotiations, Scooter was ready to close.

He asked, "Do we have a deal?" and looked to his translator to convey the message. But he sat silent.

Psy paused, looked at Scooter, and said, in English, "If you come drinking with me tonight, we have a deal."

Scooter was shocked. "You speak English?" he asked.

Psy looked at Scooter. "I went to Berklee."*

They shook hands and sealed the deal over *banchan* and *galbi* at Parks BBQ in Koreatown.

——

When I asked Scooter why he thought "Gangnam Style" had become such an unstoppable force, he explained that a lot of it had to do with timing. When the song was released, both Korea and the United States were experiencing a brutal heat wave, breaking decadelong records for temperature highs. On top of the heat, the world was still in a hangover from the Great Recession, with eco-

* The elite school of contemporary music in Boston.

nomic growth largely stagnant. "People were absolutely miserable," Scooter told me. "They were sweating their ass off. And Psy made the song to, hopefully, give a smile to the people of his country. But if he could make them smile, maybe the whole world needed to smile."

On top of that, Scooter calls Psy one of the best live performers he's ever seen. "He could back it up. You put him on TV shows, and people are blown away. The energy of this slightly overweight Asian man was just mind-blowing—people go crazy." He told me that when they booked Psy on the *Today* show, he asked to have the performance outdoors. The producers turned him down, telling Scooter they were doing him a favor because Psy wasn't big enough to draw a crowd. "Okay, we'll see about that," Scooter said. A couple of tweets later, he got a call back from NBC explaining that the performance was going to be moved outside. "We're getting more calls for this performance than Katy Perry," the producers told him.

It was a funny anecdote at first, the kind of "No one believed in us" story that has defined much of Scooter's career. But as he went on, it took on a more emotional tone. Scooter began speaking more slowly. "Thousands and thousands and thousands of people showed up," he said. "But the thing that moved me the most was how many of them were waving Korean flags. They were Americans. And they were New Yorkers. But they had been forgotten. They were the people that you walk by every day in the city and you don't notice them. Because no one had ever catered to them. No one had ever thought to make music for them. No one ever thought to make programming for them. Our Asian population is constantly ignored, yet they continue to work hard and provide to this economy.

"And my family are immigrants. My dad was a refugee kid from Queens, New York. And when I'm sitting there watching this, I just broke down because I understood from a human point of view how

important this was to them, to hear their own language on the radio, to be acknowledged, to be celebrated."

A Korean American man who saw Scooter with Psy approached him at the concert. "I was born and raised in the United States," he told Scooter. "English is my first language. But my son is also a Korean American. And my little boy smiles so big when he sees this person who looks like him dancing on TV, dancing on YouTube."

"All streaming is an opportunity for us to spread our humanity," Scooter said. "It's an opportunity for us to share information and understand that our raw emotions and reactions are human. Cultures will make us react to certain things because they'll remind us of certain things. But at our core, we all share the same values. Music shows that. What streaming has done is put a loudspeaker on the fact that that is true. Because now you don't have to explain that to the music industry, which always would have said 'Gangnam Style' would have never worked outside of Korea. Well, it worked worldwide. It became the most viewed video in the world.* In every country, it went number one."

———

Actually, in the United States, "Gangnam Style" charted only as high as number two, despite going multiplatinum. That is because the song was released before YouTube views factored into the music charts. Scooter told me he had rerun the numbers to see how well "Gangnam Style" would have done if *Billboard* had included the YouTube numbers. It would have become the longest-leading Top 100 hit of all time, at twenty-six weeks.

* As the time of this writing, the video has 2.88 billion views and will likely surpass 3 billion by the time this book hits the shelves.

The fact that Psy doesn't hold the record is a shame, but since then YouTube has become a major force in helping artists populate the charts. We partnered with Nielsen and *Billboard* in 2013 to include both official and user-generated video views in their chart tracking, which led to Baauer's "Harlem Shake" becoming only the twenty-first song to debut at number one on the Hot 100, the week our deal went into effect. The success of Macklemore & Ryan Lewis's video for "Thrift Shop" helped them take the number one spot as well, becoming the first independent artist in nearly twenty years to do so.* And most recently, Rae Sremmurd and Migos had back-to-back Hot 100 hits with "Black Beatles" and "Bad and Boujee" based on the use of those songs in popular video memes.†

These emerging artists have joined the dozens of established artists who've used music videos to accelerate, redefine, and even revive their careers in the YouTube era. As MTV's audience aged up and the network focused on original content and reality programming, there was a brief period when the music video was in serious decline. But the visual ingenuity of artists such as Beyoncé, Lady Gaga, Kanye West, Katy Perry, and Sia has led to a renaissance of the medium online.

At the same time, the economics of both making music and making videos has become more favorable. Artists such as OK Go showed that you didn't need to spend millions of dollars to make a viral music video, just some creativity. Their video for "Here It

* Though still independent, they do have a deal with Warner Music to help secure radio airplay.

† The fact that *Billboard* counts views of songs featured in user-generated videos leads to some surprising results. In 2013, Kanye West's "Gone" climbed to eighteenth place on the charts after the then-eight-year-old song was featured in a viral video of a girl quitting her job. In 2016, Simon and Garfunkel's "The Sounds of Silence" rocketed all the way to number six on the Hot Rock Songs chart fifty years after its debut, thanks to its use in the "Sad Affleck" meme.

Goes Again," which featured the band performing complex chore-ography on treadmills, was shot on the cheap in one take. It won the Grammy for Best Music Video in 2007. Then in 2010, CeeLo Green showed that you didn't even need a video, just lyrics. His song "Fuck You" started gaining traction before he had the chance to film an official video. To take advantage of the buzz, he produced a video composed solely of the song's words that earned millions of views before the official version debuted a month later.

The ease with which music videos can now be made means that their potential as a promotional tool is greater than ever. "You used to spend $500,000 to $4 million on a video, and you used to beg MTV to play it," Scooter said at CES. "Now you're just giving it straight to the consumer and letting them decide." He told the au-dience that Justin Bieber's most popular video ever, "Sorry," was filmed for $5,000 with a group of dancers in New Zealand. Justin never even appears in the video. It now has more than 2 billion views.

"Sorry" was one of thirteen music videos that Justin released in support of his latest album, *Purpose*. The multivideo release helped him break the all-time record for simultaneous tracks on the *Bill-board* Hot 100 with seventeen (previously held by the Beatles and since broken by Drake). I asked Scooter about that release strategy and how he felt about helping artists have a sustainable career in an environment in which hits burn brighter but seem to flame out more quickly. Artists such as Drake and Future have drastically short-ened the album release cycle, dropping new material seemingly ev-ery few months. In between albums, there are mixtapes and singles and guest verses—it all creates an environment where the pressure to stay on everyone's mind is enormous.

Scooter's advice was to ignore the pressure. "Number one, you have to stay consistent. But number two, you have to understand

human behavior. When you have the hot spot, sometimes it's good to pull back a little bit. We, as humans, love to build and then destroy. Watch a child. . . . When I watch my son play, you know what he does? He builds a tower. And what do kids do when they build a tower? They knock it down.

"That instinct is in us from the very beginning. We like to build, but we also like to watch things crumble. And then we want to build again. Knocking down the tower isn't the end of the tower; you're allowed to build it again. There's an arc to a story. If someone just stays like this," he said, holding his hand high in the air, "it's a very boring thing. Understand that this"—he dropped his hand low—"is allowed. And if you embrace it, you can make it work for you."

Rather than advocate Drake's model, he cited Justin Timberlake, who, he says, "disappears, comes back, and is huge." Our conversation naturally transitioned back to Bieber, who had gone three years between albums as a series of embarrassing stories made the rounds on the Internet, leading to more attention to his behavior than to his music. Justin had reached a point where many in the music industry were writing him off. I asked Scooter if his build-destroy-build strategy was the reason Justin had gone quiet for as long as he did.

Scooter said that actually the timing had been a result of his concern for Justin's health. "As much as Justin at the time said, 'I'm ready, I'm ready, I'm ready,' I wouldn't let him go until I knew, one hundred percent, there was no chance of him not being ready. In the end, I said, as long as we get him back on track, we'll make the situation work to our advantage because people want a story. They want a story of redemption."

And Justin did redeem himself. His reemergence on the Skrillex-and-Diplo-produced track "Where Are Ü Now" in 2015 led to his first-ever Grammy. It was quickly followed by "Purpose," which

went triple platinum and became the best-performing record of his career.

———

One of the points I always try to make to the recording industry—and one that Scooter ribbed me for on the CES stage—is that, unlike on MTV, music videos on YouTube offer promotion and money. As with any YouTube creator, we pay the majority of the ad revenue that an artist's video generates to whomever owns the rights to the song (typically an artist's label).

But despite YouTube's value as both a promotional tool and a means of earning revenue, several established artists, from Nelly Furtado to Debbie Harry,* have argued that we don't compensate artists fairly. They argue that music fuels YouTube's success, yet payouts are too small compared to view counts. They also express concern that YouTube allows unlicensed copies of their music to stay up on the platform, draining away revenue that should go to rights holders. And perhaps most worrying, they say this dynamic hurts emerging artists most of all, depriving them of the money they need to invest in their career just as it starts.

These concerns deserve to be taken extremely seriously. People who work at YouTube do so in large part because they believe they are helping all creators and artists—especially up-and-coming creators and artists—build their careers and get rewarded fairly for their work. The charge that we are building a business at the expense of artists, rather than in their service, is one that would jus-

* This one stings; Blondie was one of my favorite groups to listen to over the scrambled airwaves of Radio Free Europe.

tifiably keep many of us up at night. But the more we study these concerns, the less evidence we find for them.

The first concern, about payouts from advertising, is similar to the concern creators have expressed that I discussed in chapter 9. Here I think it's important to understand that the record industry has never made much money from advertising, even though you've probably been hearing ads on the radio your entire life. Just like MTV, radio, which accounts for a quarter of all music consumption, pays nothing to labels and artists in the United States, even though it generates $35 billion of ad revenue a year. Outside the United States, radio does pay royalties to the recording industry, but at a rate less than half of what YouTube currently pays.

In contrast, streaming music videos account for only 8 percent of music consumption, but YouTube pays the music industry more than a billion dollars a year. It's easy to dismiss digital advertising as a viable model for supporting artists while it's still relatively new. But with time, advertising could mean as much to the recording industry as commercials mean to TV. For instance, if the money advertisers currently pay to radio stations shifted to support digital music consumption instead, it would double the current size of the record industry.

As for whether music fuels YouTube's success, it's unquestionable that songs are core to our platform. According to Nielsen, more than half of all teenagers use YouTube to find and listen to new artists. And most of the videos with the highest view counts ever are music videos. But high view counts can be misleading; YouTube is first and foremost a place for entertainment. Although many people enjoy music on YouTube, they actually consume far more non-music content. The average YouTube user spends just an hour watching music videos on YouTube *a month*. Compare

that with the four hours of music the average American listens to a day.

I understand why some people might be concerned that unlicensed versions of a song deprive an artist of money. In addition to official versions of a music video, YouTube hosts content that fans upload, too, from concert footage to live performances to tribute videos to remixes to covers. But YouTube's proprietary Content ID technology ensures that the people who own the rights to the music used in those videos earn the ad revenue, no matter who uploads it. We've secured licensing agreements with thousands of labels and rights holders so that fan-uploaded videos don't have to be taken down; they can be left up, and artists can earn money from them.

And these clips don't have to be identified or claimed manually. Content ID automatically compares uploaded videos against a database of reference files that anyone can easily supply to us, a process that is 99.7 percent accurate. While providing a reference file requires some initial work on behalf of the label or artist, it pays off significantly. More than half the money we pay to the music industry comes from advertising run against fan-uploaded videos.

That leads to the final concern, that our current relationship with the music industry hurts emerging artists most. Today, YouTube is one of the only platforms that allows anyone to have his or her music heard by a global audience of more than a billion people. If anything, it *helps* emerging artists most.

"I go to these conferences and people say, 'How do I get noticed by you?'" Scooter told me. "I say, 'Get noticed by *them*,'" pointing to an imaginary crowd. "Because then I have to beg for you. I'm not a gatekeeper anymore. All the tools have been given to you.

"Whether it be YouTube or whether it be Snapchat or whether it be Instagram or whether it be musical.ly," Scooter told me, "you're given an extraordinary tool. The hard work was the people who developed

these things. Millions of dollars and time and effort are spent making sure these things work properly. They don't break down. If you put up a video on YouTube, you know it's not going to crash. And it's *free*."

But how you do get noticed by *them*? I asked. "Be great," he said simply. "You know why you're not being noticed? Because you're not being great yet. Justin wasn't noticed in his first video."

———

To me, the arguments some people make about YouTube and other streaming services are just the latest sign of the tension that's existed between artists and distributors since the invention of recorded music. In 1906, John Philip Sousa, who wrote "The Stars and Stripes Forever," penned an essay for *Appleton's Magazine* about the evils of recorded music. In "The Menace of Mechanical Music," he wrote that music had to be performed live in order for people to truly appreciate it. "The nightingale's song is delightful because the nightingale herself gives it forth," he wrote. Sousa worried that recorded music would prevent children from picking up instruments since they could just hear songs easily on the radio. "I foresee a marked deterioration in American music and musical taste, an interruption in the musical development of the country," he wrote.

Instead, more people picked up instruments than ever before, inspired by the music they heard on the radio. Yet the essence of Sousa's argument—that distribution technology harms both artists and art—has lived on, leveled at every major invention in recording history from wax cylinders to vinyl to cassette tapes to CDs.

What gives this argument particular resonance in the age of streaming music is that the record industry unquestionably suffered grave damage with the advent of the Internet. Because music files were relatively small, CDs could easily be ripped and shared

illegally, even at slow Internet speeds. After music industry revenues peaked in 1998 at nearly $29 billion, they declined for sixteen straight years, to $14.5 billion, before they finally began to grow again. By 2002, 80 million people were using Napster, the file-sharing service, to pirate music.

Faced with such grim math, the industry had to embrace a new model: iTunes. The sale of digital copies of music through iTunes was designed to stop piracy. In negotiations that were immortalized in the pages of *Rolling Stone*, Steve Jobs argued that people would be perfectly willing to pay for music as long as the industry was willing to make it easy and cheap: 99 cents for a song that anyone could download to his or her computer. But although iTunes may have been crucial in getting people to value music again, it couldn't stop CD sales from cratering. And in fact, the sale of digital singles caused a massive drop in revenue because it allowed people to "unbundle" CDs. Most people stopped buying full albums—which usually cost between $10 and $20—and instead just bought the singles they knew they liked for a few bucks.

So it's no wonder the industry is approaching streaming with trepidation, harmed as it was for nearly two decades by the transition from physical sales to digital distribution. But I would argue that now is actually a time for optimism in the music industry. I predict that its brightest years are actually ahead of it, not behind it, for three reasons.

First, at a time when there's never been more competition for people's attention, the industry has a product people love. The hours that people spend every day listening to music represents the type of engagement that millions of newspapers, TV networks, mobile app developers, and social media platforms are desperate for. Though everyone competes for our eyeballs, the music industry has a hold on our eardrums.

That love explains the second reason to be bullish about the music industry: the rapid growth of paid subscriptions to music-streaming services such as Spotify and Apple Music. It took Spotify seven years to reach 10 million subscribers; Apple Music reached that number in a few months. Before them, no digital subscription service had reached 10 million subscribers in fewer than ten years.

The public's embrace of digital subscriptions—including our own video offering that includes music, YouTube Red—led digital music sales revenue to outpace that of physical music sales for the first time ever in 2015, a transition that helped return the record industry to growth.

At $120 a year, a music subscription represents more money than the average consumer has traditionally spent on music, even at the peak of CD sales. That means that at current prices, the industry has the potential to earn more revenue per customer than it did even in its heyday. And unlike the money earned from CD sales, revenue from subscriptions is predictable and stable; subscribers spend $10 on music every month, not just whenever they decide to visit a record shop.

But although a healthy music subscription business may eventually sign up 200 million to 300 million people around the world, that still leaves another 2.7 billion people who are currently online but can't or won't pay $120 a year. What about all those people?

That's the third reason to be optimistic about the music industry's trajectory. These casual fans—typically those who are very young or lack disposable income—have historically satisfied themselves by listening to the radio. They never bought CDs or paid 99 cents for a digital download, and many live in emerging markets where $10 a month is an unimaginable price to pay for music. That's where digital advertising comes in. As these casual consumers enjoy more of their music through ad-supported services online (or

on their phones), the industry will earn a greater share of the ad revenue that targets them.

That is the road map to the music industry's most profitable years ever: subscriptions that lead to a significant amount of stable revenue from its highest-value customers and advertising that monetizes everybody else. If that dual-track model sounds familiar to you, it should. It's the one that doubled the size of the US TV business to $200 billion between 1998 and 2014, the same exact period during which the music industry's revenues were cut in half.

"Innovation is always going to happen," Scooter told me. "The progress of something new is always going to come. But if you actually take a step back and look at what you know, the core behavior is the same. If someone's older, like my father, they used to find that sensation in vinyl. The same sensation you got when you discovered that record—it felt like it was yours because it wasn't on the radio yet, and when it finally hit the radio, you felt validated—that's what streaming is. There's a validation of finding that artist on YouTube before it goes mainstream. And when it does, you feel like you own it for the rest of their career. All YouTube has done is given a new generation a new way to find that sensation."

The music industry has had to survive some devastating battles—against piracy, against the unbundling of albums, against the belief that no one would ever pay for music again. But the truth is, it has won the war.

13

What to Watch Next

Just When You Had Millennials Figured Out, Here Comes Gen Z

"SO THIS SHOW would be *Kiss the Cook*," says Dave Grant, the head of unscripted content at the digital network AwesomenessTV. "Two people compete—it's a dating show, but they're competing for the person's love by making food. And so at the end of the show, they decide, do they want their plate or do they want their date? And we can at least make it influencer-focused based on the host, but I don't know how many influencer singles are going to be going on dating shows."

Brian Robbins, the founder of AwesomenessTV, sits back in his chair and mulls the idea over. Brian is tan and fit, a picture of LA health in a black T-shirt and jeans, his black Apple watch visible as he raises his hands in thought. He's invited me to sit in on a

pitch meeting for new shows on the teen-focused network. After several ideas have been floated, this one seems to spark something in him. "So hold that for a second," he tells Dave, "and think about *The Bachelor* and *The Bachelorette*. Why can't we do our influencer-driven version of *The Bachelor* and *The Bachelorette*? Why can't we get Lauren Elizabeth or whomever, I'm just saying—six, eight, how many are there on those shows?"

"I've never watched that show in my life," says Joe Davola,* the longtime TV producer and Brian's partner and cofounder.

"Okay, but if you took one of our teenagers, right, and you made it about 'Can you take *X* girl to the junior prom as your prom date?' There's six teenage boys trying to take the Merrell Twins to the prom. Or vice versa, there's six girls trying to take Hayes Grier† to their prom."

The room falls silent for a second before Brian sums things up. "*That* show," he says, "would be a home run."

The three, in agreement that the show could be a hit, discuss the ways it would obviously have to be different from *The Bachelor* for their teen audience. They also rifle through a few more names. Joe asks about a creator who's recently found some popularity on YouTube. Dave politely informs him that the creator probably wouldn't be interested in a female prom date. Eventually their conversation shifts to where their show should air: on YouTube; on go90, a subscription service recently introduced by Verizon; somewhere else?

"Geez, we should sell it to prime time!" Brian says. "It's a great spring prime-time show, going into prom season, you know?" But

* In addition to developing a long roster of successful shows such as *Remote Control*, *In Living Color*, and *Spin City*, Joe is the namesake of the Seinfeld character Crazy Joe Davola, who stalks Elaine, kicks Kramer in the head, and tries to attack Jerry during the filming of his pilot for NBC.

† Lauren Elizabeth, the Merrell Twins, and Hayes Grier are all young, photogenic social media influencers with millions of subscribers on YouTube.

then he stops himself. "Aww, forget it. I'm not in the TV business anymore. I forgot."

———

I can see why it slipped his mind. Brian got his major break in Hollywood while still a teenager, as an actor on the TV show *Head of the Class*. He played Eric Mardian, a bright, rebellious high schooler who wore leather, rode a motorcycle, and hated school. For five seasons, Brian played the tough kid, disrespecting authority while sporting a mullet, and the experience of working on a show aimed at teens had a formative effect on him. As his career progressed, he developed into a prolific director and producer, mostly of films and TV shows aimed at a younger demographic. He directed the high school football film *Varsity Blues*, produced shows aimed at teens such as *Smallville* and *One Tree Hill*, and was at one point programming the entire live-action lineup on Nickelodeon.

In 2010, Brian met someone he had never heard of before, a young YouTube star who went by the name Fred Figglehorn. Fred was the hyperactive, chipmunk-voiced alter ego of Lucas Cruikshank, a young teen from Columbus, Nebraska. Lucas was just thirteen years old when he uploaded his first video to YouTube, in character as Fred, in 2007. It was shot on a low-quality webcam, set in one room, and roughly edited. Fred's first words in the first video are "Is this on?"

If the video felt like an experiment, it was. Fred was one of many personas Lucas developed to try to connect with the masses of YouTube viewers. Unlike all the others Lucas tried, the Fred persona clicked, at a time when the platform was still in its infancy. In less than two years, *FRED* became the first channel in YouTube history to draw 1 million subscribers.

The night of their meeting, Brian went home and asked his kids if they had heard of Fred. "Of course we know Fred," they told him. As someone who had built his career in live entertainment aimed at teens, he was surprised at the difference between what he knew and what his kids watched. Sensing an opportunity, he asked his kids a hypothetical question: "If there were a Fred movie out in theaters, would you want to go see it?"

His kids lit up at the question. "Tonight?" they asked.

"My kids were living in this whole alternative universe that no one in Hollywood was paying attention to," Brian told me. "Back in 2010, none of the agencies had digital departments and no one knew the kind of demand that existed. But if this kid from Nebraska can build this franchise in his bedroom, what would happen if we came along and supercharged this space?"

At the time, Brian had a film deal with Paramount, but he knew if he tried to get a Fred movie made in Hollywood it would take years. So even though he had never financed anything himself before, he put up his own money. He filmed *Fred: The Movie* and sold it to Nickelodeon within a year. The movie drew nearly 9 million viewers and helped make Nickelodeon the highest-rated cable network in 2010.

The success of the Fred experience gave Brian an idea. He realized that the future of teen talent would be discovered online, but rather than creating one-off films or series, he wanted to create an entire network from the ground up. "When cable came along, all these new brands were born on the back of this new distribution model," he told me. Brian saw the same opportunity to create a new brand, a teen-oriented digital network he called AwesomenessTV. I met Brian shortly after joining YouTube, when he gave me his pitch for the network. "With Awesomeness, we don't want to just make a bunch of content," he explained. "We want to build a brand on the back of YouTube."

With some seed funding, AwesomenessTV began producing a handful of new shows, all aimed at young teens and all distributed for free on YouTube. Within a month, his new channel had cobbled together 100,000 subscribers with videos such as "7 Best Excuses for Missing Your Homework" and "5 Best Ways to Defeat Bullies." The demand for AwesomenessTV content became so great that Brian sensed another opportunity. Over Thanksgiving weekend in 2012, the channel put up a video asking viewers a simple question: "Do you want to be a YouTube star?" He expected to get a few hundred applications. Before the end of the weekend, AwesomenessTV had received four thousand.

Today, AwesomenessTV produces more than eight hundred hours of original content a year—more than most cable networks—and the number of young creators affiliated with the brand is in the tens of thousands. That sounds staggering, but it shows how easily digital brands can scale, especially when they have global reach. Each one of those thousands of creators brings her own stars and his own community of fans who share, comment on, and like the content. Together, these channels both benefit from and build the AwesomenessTV brand.

In 2013, about a year after Brian had launched AwesomenessTV, I was in Park City, Utah, with Jeffrey Katzenberg, the CEO and founder of DreamWorks Animation. He had one question for me: "Who on YouTube is really doing something special?"

Jeffrey has a legendary eye for new trends in media. It was during his tenure as head of Disney's motion picture unit that the company turned around its sputtering animation division, releasing a string of hits from *Who Framed Roger Rabbit* to *Beauty and the Beast* to *The Lion King*. At the same time, he sensed the rising importance of independent cinema in the early 1990s and led Disney's acquisition of Miramax Films, months before the studio released *Pulp Fiction*.

And he was one of the first to see the potential of digital animation, striking Disney's partnership deal with Pixar and green-lighting the production of *Toy Story* before founding his own successful digital animation studio. YouTube had sparked his intuition once again, and he wanted in.

I told Jeffrey about Brian and the amazing growth he was experiencing with AwesomenessTV. It didn't take much explanation before Jeffrey asked me to put him in touch. Jeffrey is notorious for moving quickly—Brian called him a "heat-seeking missile"—so I figured it was a good idea to call Brian from the slopes. Luckily he picked up. "Hey, can I share your number with Jeffrey Katzenberg?" I asked him.

He seemed a little surprised. "Uhh, sure," Brian said.

"No, really. He's standing right here, and he's going to call you in two seconds after I hang up," I told him.

"Oh, okay. Uhh, yeah, that's fine."

"Just know," I told him, "your life is going to change."

Two seconds later Jeffrey gave him a call. The next morning, the two were having breakfast in LA, and they met every day for the following four days. When the dust had settled, DreamWorks Animation had bought AwesomenessTV for $33 million. Just over a year later, DreamWorks sold a 25 percent stake in AwesomenessTV for $81 million to Hearst; the company's value had appreciated nearly tenfold in nineteen months.

When I recently asked Jeffrey about the acquisition, he told me it was Brian's creative vision that had really interested him. "If you look across the entire enterprise on YouTube, to me, I think there have been three really great brands that have not been built on a personality but on a concept and a brand: Vice, BuzzFeed, and AwesomenessTV," he said.

"All three are really singular and unique talents, Shane being that

rebellious-news perspective, Jonah* in terms of what he's created around the brand of BuzzFeed. But Brian's the one who's actually the storyteller. I'm not saying [Vice and BuzzFeed] are not creating great content; their content is based on re-creating the world around us, documenting it through a curated point of view, and a strong one. That's their superpower. Whereas Brian actually has to create out of whole cloth."

He also pointed out that Brian had come to YouTube out of "curiosity and ambition," as opposed to needing a new outlet for his content. "He was at the height of his career. He was doing well where he was. He didn't need to do this. But he did it because he watched his kids and was seeing where their interest was and said, 'Well, wait a minute. Why aren't I working in that space?'"

I initially sat in on Brian's pitch meeting because I wanted to get a glimpse of the future. While this book has largely focused on the Millennial audience and the content that caters to it, Brian's work at AwesomenessTV is all about the next generation of consumers, known collectively as Gen Z. Though Millennials have grown to become the largest demographic in the United States and will soon make up 50 percent of the global workforce, the generation that follows them is also quite large. And unlike Millennials, members of Gen Z have never known a time before the Internet. According to a study by Influence Central, a marketing firm, on average those in Gen Z get their first smartphone around their tenth birthday (though anyone who's currently raising a child will tell you that they become

* Jonah Peretti, who founded BuzzFeed after cofounding the Huffington Post.

comfortable with the devices much earlier). What media landscape will that generation—to which my two daughters belong—inherit? Who will be their celebrities?

Brian was unequivocal: the next generation of stars that will appeal to Gen Z, he said, will be found online, on networks such as AwesomenessTV. "What we do is way more important than what's happening on television or film because that's where they're engaged," he told me. "When I made *Varsity Blues* nineteen years ago, I looked to television to cast it. I cast James Van Der Beek because he was the star of the hottest show on television at the time, *Dawson's Creek*. Couldn't have been hotter; biggest TV phenomenon.

"Today, if I was making *Varsity Blues*, where would I go to find James Van Der Beek? I'd probably look in the digital world." But he pointed out that today, movie studios wouldn't even make *Varsity Blues*. "Movies have really become a tentpole business. It's up to me to make *Varsity Blues*, my way."

Brian is right that the major studios have largely abandoned the low- and middle-budget films that used to populate the Cineplex. Today, studios fill their slates mostly with movies that have "four-quadrant" appeal; that is, movies that appeal to both males and females, both under the age of twenty-five and over the age of twenty-five. As noted in Anita Elberse's book *Blockbusters*, the economics of the industry favor movies with mass appeal since the average filmgoer sees only five films a year. Massive, high-profile releases are therefore more likely to draw people away from their phones and into theaters. And if those movies are sequels or based on well-known comic books, the math is even better, since both come with built-in audiences who don't have to familiarize themselves with a movie's plot or tone.

But though increased competition has led to more of the same

at the cinema, it has led to an explosion of original series on TV. In 1999, HBO kicked off this new golden age of television with *The Sopranos*, but since then, gripping, prestige series have cropped up everywhere. With *Mad Men* and then *Breaking Bad*, AMC became the first nonpremium cable network ever to win a Primetime Emmy Award for Outstanding Drama Series. That success has led nearly every cable network to search for its own prestige series, from USA Network's *Mr. Robot* to FX Networks' *The Americans.*

Whereas previously channels farther down the dial could earn a healthy profit simply by airing reruns and collecting advertising dollars and affiliate fees, now each network needs to prove its value in the cable bundle with original content good enough to tweet about.

That's because TV ratings are declining. According to Nielsen, Americans watched sixteen fewer hours of television a month in 2016 than they did in 2010. Among Millennials and teens the declines are much sharper: they watch around forty fewer hours a month. The only demographic that watches more TV today than before is those over the age of sixty-five.

Still, those numbers belie the fact that TV content is incredibly popular on digital streaming services such as Netflix, Hulu, and Amazon. Even as those services develop their own brands of original programming, users still flock to them to catch up on shows they missed on TV.

That's true on YouTube, too. The consumption of TV content continues to grow on our platform as more networks upload clips from their shows. I mentioned earlier that the battlefield of the late-night wars has shifted online, with nearly every show sharing new clips on its YouTube channel within hours—sometimes minutes—of their airing on TV. But it's not just late-night hosts who are finding new audiences on YouTube; daytime stars such as Ellen DeGeneres

and Wendy Williams do the same, as do reality competitions such as *The Voice* and *America's Got Talent*. You can even watch daily segments from SportsCenter on YouTube.

Though it seems counterintuitive that networks would give away their TV content online, a custom Nielsen poll showed that people who see a TV show on YouTube are actually *more* likely to watch it on TV. And because YouTube is global, it gives the producers of shows an entry point into new markets, creating demand that they can use to license the show abroad.

James Corden, whose Carpool Karaoke segment with Adele became YouTube's top trending video of 2016, has become such a global phenomenon online that *The Late Late Show with James Corden* is now carried in more than 150 markets around the world. YouTube has helped turn him into the world's first global talk show host. Les Moonves, the CEO of CBS, told me that James's experience on YouTube entirely changed the network's view of what it means to have a successful talk show today.

The popularity of television programming on our platform is exactly why we launched YouTube TV in April 2017. We recognized that the decline networks were seeing in ratings had less to do with content and more to do with accessibility. It's not that people weren't interested in the shows on broadcast and cable; it's that they couldn't view them the way they'd grown accustomed to watching everything else: on demand and on their phones.

By working with networks to offer their content in an app that works as well on their phones as YouTube does, we believe we can give the so-called cord-cutters and cord-nevers—Millennials who either have cut their cable or never subscribed in the first place—an experience they'd be willing to pay for.

To me, this is what the future of media looks like: more sequels

at the Cineplex, more prestige programs on every streaming service and network, and more digital delivery of TV. As more TV consumption shifts to Internet-delivered services, TV show producers and traditional celebrities alike will increasingly look online to reach new audiences and expand their reach beyond whatever time slot they happen to occupy.

At the same time, Internet creators and digital networks such as AwesomenessTV will continue to grow and mature, as more favorable economics encourage them to create more ambitious videos that more closely resemble what we see today on TV. As the two media race to adopt each other's best traits, they'll evolve in such a way as to become indistinguishable.

That evolution is already well under way. Lilly Singh's channel is full of collaborations with mainstream stars such as Priyanka Chopra and the Rock, right alongside those featuring popular YouTube creators; she's a star comfortable in both worlds. Tyler Oakley struck a partnership deal with Ellen DeGeneres to create digital content that lives on both his YouTube channel and hers, helping extend her already large digital presence. Shane Smith has brought his digital-honed aesthetic to television, launching a new TV network called Viceland where even the ads feel like short films. And Casey Neistat sold his technology company, Beme, to CNN, as part of a deal that will lead him to create a daily digital news show for the network. Each of these Streampunks is taking a different approach, but all of them are accelerating the collision of old media and new, helping push YouTube into the future in the process.

For his part, Jeffrey envisions that future as offering "superpremium" content online that's offered in small chapters and produced at a similar cost per minute as a prime-time TV show. "I've never been more convinced that the day that people are offered that level

of writing and storytelling, delivered in chapters that are short form, under ten minutes, native to mobile, it will be explosive."[*]

In August 2016, Jeffrey sold DreamWorks Animation to Comcast for nearly $4 billion, and he recently started a new technology and media venture called WndrCo to realize his vision. "I'm starting over," he told me. "I'm not starting over in the movie and TV business."

When I asked him where he thought online video was in its evolution as a storytelling medium, he told me he thought it was where TV was in the 1950s. "The volume of content, the quality of content, the consumption of content, pretty much the whole thing, I think, is still pretty basic, and it's got a huge future ahead of it. . . . I think it's going to evolve in some extraordinary and exceptional ways in which there's going to be tens and tens and tens of billions of dollars of value that's going to be created, on all sides of it: on the distribution side of it, on the advertising side of it, on the subscription side of it, and most importantly on the content side of it."

———

Clearly I share Jeffrey's optimism. For as much as streaming video has done to transform the media landscape, the reality is that TV is still the major way people consume video today. As impressive as YouTube's growth has been, its potential to be major source of entertainment is even greater. And because we are an open

[*] Jeffrey made a bit of a buzz when he offered to pay the creators of *Breaking Bad* $75 million for three more episodes of the show after its slated finale on AMC. The media portrayed the offer as though Jeffrey didn't want the show to end, but actually he wanted to offer them as thirty six-minute pay-per-view episodes, as an early proof of concept for the value of premium short-form video. Unfortunately—spoiler alert—the show's ending left this potential experiment moot.

platform—because we can be as welcoming to a kid who just got her first smartphone as to a major media company—we can offer an unparalleled mix of content.

But that openness also means we have a lot of people to satisfy. Our continued success depends on making sure that we provide a compelling experience for viewers, creators, and advertisers, all of whom have far more options in today's media landscape than they did just ten years ago. When YouTube is successful, it's gratifying for everyone; creators draw in viewers, viewers draw in advertisers, and advertisers support the whole ecosystem. But when one set of partners is unhappy, the reverberations can be felt across the whole platform.

Our openness also makes YouTube's future more difficult to predict. Earlier in the book, I mentioned how Scooter always likes to compare his rising artists to other successful figures, a shorthand for critics and fans alike that helps build hype. It's a tactic that's common in new media. Shane has called Vice everything from "the next MTV" to "the next CNN" to "the Time Warner of the streets." Brian has said that AwesomenessTV is the new Nickelodeon. And Ted Sarandos, my old boss, said that Netflix's ambition was to become HBO faster than HBO could become Netflix.

But despite the PR value of this approach, any comparison we try to create for YouTube doesn't hold. We don't want to be the next HBO; we don't want to be the next MTV; we don't even want to be the next Time Warner. The truth is, the world has never seen what YouTube is becoming.

Conclusion:
A Window to the World

IN 2015, MY WIFE and I decided to take a trip to Cuba. The country held a certain fascination for us both. For my wife, who grew up in the Dominican Republic, just fifty miles away, Cuba seemed like a slightly distorted mirror image of her own country. Both have similar geographies and around the same number of people. Their economies are about the same size, and the populations of both love rum, cigars, and baseball. While it took tremendous sacrifice by her mother for my wife to be able to study in the United States, the Dominican Republic is relatively free and open; Cuba remains one of the last closed societies in the West, limiting freedom of expression, the press, and—until 2013—travel.

That closed posture lay behind my interest in visiting the country. Having grown up in Communist Czechoslovakia, I wanted to see what life in Communist Cuba was still like and see whether I could detect any resemblance to my own upbringing.

At first, tropical Havana looked nothing like icy Prague. If anything, Havana looked more like Paris—though, if the city had mostly been left unattended for fifty years. Walk off one of the beautiful

restored squares such as the Plaza Vieja or the Parque Central and down a side street, and you'd see crumbling three-story art deco facades, unpaved roads, and standing water. Look past the gleaming '50s-model Chevys that drive tourists around town, and you'd see the same Soviet Ladas giving off fumes that I learned to drive as a teenager. Walk out of the privately owned *paladares* restaurants and into the public markets, and you'd see spare shelves stocked only with bags of rice and jars of olives. Despite the palm trees, the mojitos, and the beautiful stretch of waterfront along the Malecón, there was plenty to remind me of my childhood.

And then, on one of our final nights, a teenage boy approached me outside the Saratoga Hotel, where my wife and I were staying. He asked if I had the code to access the Wi-Fi in the hotel. The Internet is relatively unavailable in Cuba, aside from the few hotels that cater to international tourists and sell access by the hour. I gave the boy a card I had received earlier from the front desk and followed him to a small group of teens who were standing just outside the hotel walls, using their phones and computers to access the Internet. They were all watching YouTube.

One was watching highlights of Cristiano Ronaldo. Another was watching Latin music videos. One kid in American-flag shorts was actually watching recent skits from *Saturday Night Live* (and this was pre–Alec Baldwin impersonating Trump!). And one teenager, covered in tattoos up to his neck, was watching an instructional video on making clothes. My wife, who translated for us, explained to me that he wanted to start his own business selling T-shirts.

Sometimes it's easy to get lost in the details of what it takes to run the business of YouTube. From the endless negotiations that are necessary to bring new content to the platform to the constant pitching one has to do to attract advertising dollars to ensuring that our creators have a platform that helps them thrive, there are mo-

ments that leave you overwhelmed by the complexity of a company that serves 1.5 billion people.

But in moments like that one in Havana, you take a step back, reminded of just how important access to information and entertainment is to people who don't otherwise have it. You remember what a force for knowledge, enjoyment, and common understanding YouTube can be.

I was in exactly the same position as those Cuban teens when I was younger. My version of it involved fiddling with the antenna on my family's old radio, trying to catch a scrambled signal coming in from West Berlin or gathering in the apartment of a family friend to watch bootlegged films on a small TV.

Even though I got only a glimpse of the outside world, it was enough to make me doubt the things I was being told by my own government. It was enough to make me want to leave Prague and move to the West. And it was enough to make me want to work in entertainment, taking me on a journey that began in the mailroom of the J. Michael Bloom talent agency in Beverly Hills and led to a charmed career spanning three of the most influential media brands in history.

Today, YouTube is providing a much larger window to the world to millions of people who could never previously dream of accessing the entertainment, news, and educational content our platform is able to provide to them for free.

I originally wrote this book to help tell the story of our unique business; to explain the journey of a new generation of creators and entrepreneurs to people who either didn't realize their impact or didn't think it mattered. I wanted to demonstrate the importance of the communities that Hank and John and Tyler and Lilly and Jenny are building. I wanted to be honest about the challenges that Adande and Matt and Jack and countless others have faced in

building their audiences. And I wanted to show how the pioneering work of Shane, Casey, Scooter, and Brian was changing the foundations of the media industry.

But while writing this book, I've come to realize that perhaps the greatest value in telling these stories isn't in simply changing people's existing perceptions of YouTube but in giving a new class of independent creators and entrepreneurs a guide to navigating the future of media. The next generation of entertainers, educators, directors, and entrepreneurs is out there right now, trying to trace their path through a world that is full of opportunity. I hope one of them picks up this book and comes away with a new understanding of the role YouTube can play in his or her journey.

Video used to be the highest walled garden in entertainment; it was the most expensive and most difficult medium to penetrate. But the global distribution of free platforms such as YouTube, combined with the ubiquity of smartphones, has turned it into a free market, where nearly anyone can throw his or her hat into the ring. Some people who witness that phenomenon see only a fame-obsessed culture full of people who just want attention. But those critics see only an unflattering reflection of a far more meaningful picture.

YouTubers are improving the way students are taught in classrooms, elevating and empowering underrepresented groups in societies throughout the world, expanding our view of humanity beyond our own borders, building the next generation of thriving small businesses, elevating authenticity above fame, getting a new generation interested in news and politics, making ads more engaging and expressive, giving aspiring musicians a new path to the top, and turning online video creation into one of the fastest-growing industries in the world.

Not bad for a bunch of punks.

Acknowledgments

Robert and Maany would like to thank, above all, the millions of streampunks whose ingenuity, creativity, and talent inspire us daily.

We'd also like to thank Susan, Scott, Neal, and the thousands of YouTube employees around the world; they are the ones behind the big red play button who make sure it always leads you somewhere fascinating.

We'd like to give special thanks to those whose voices echo throughout this book: John Green, whose support was crucial to making this book possible in the first place; Hank Green, who was generous with his time on the busiest days of his year; Tyler Oakley, who must be tired of being described as "authentic" at this point but whose genuine nature really is unmistakable; Lilly Singh, who happily put down her book to help us write ours; Lee Soo-man, who is so forward-thinking, he may actually be from the future; Jenny, Al, and the entire Doan family, whose hospitality, warmth, and resolve form the heart of this book; Conan O'Brien, who may forever be the funniest person to visit our offices; Bassem Youssef, who beats back oppression with a smile; Hayla Ghazal, who is infectiously irrepressible; Adande Thorne, whose insights could (and should!) honestly fill their own book; Michelle Phan, one of the original streampunks

Acknowledgments

and an inspiration to many (including us); Jack Conte, the kind of thoughtful CEO Silicon Valley needs more of; Matthew Patrick, whose dedication is outmatched only by his kindness; Shane Smith, who continues to live one of the most interesting lives on record (and who really should write his own book, too); Tom Freston, who understands where culture is heading better than we could ever hope to; Casey Neistat, who gave us more great quotes in forty minutes than we could have written in forty books; Scooter Braun, whose introspection and extroversion make for a deadly combination; Brian Robbins, who almost risked his life to speak at a YouTube event, so boundless are his friendship and commitment; and Jeffrey Katzenberg, whose mentorship and wisdom continue to change lives and industries, including ours.

We'd also like to thank those who helped us shape many of the ideas in this book, even if we weren't talented-enough writers to get their quotes in it: Matthew Ball, Rich Greenfield, George Strompolos, and Shahrzad Rafati.

We'd like to thank all the people who helped in countless ways to make this book possible: Rosianna Rojas, Korey Kuhl, Lisa Filipelli, Jenny Dominguez, Mike Sweeney, Scott Mason, Nora Long, Eric Meyers, Penny Makras, Heather Drucker, Paul Marvucic, Zoë Di Stefano, and Courtney Barmack.

And we'd like to reserve special thanks for Lisa DiMona, who shepherded us into the world of content creation, and Hollis Heimbouch, who understood our streampunk vision from the very start, and without whom this would be a very boring book with a very boring cover.

Maany would like to thank his wife, Abby, for her patience and guidance, and his family for their encouragement and endless reservoir of warmth and support. He'd like to thank Kevin Allocca for commiserating with him and Chris Dale and Matthew Teper for

backing him. He'd like to thank Kendra Desrosiers, Kevin Montler, Elizabeth de Luna, Jim Habig, Brandon Feldman, Alex Diaz, and Marc Ellenbogen for their thoughtful feedback on early drafts. And he'd especially like to thank Michael Rucker, who first said, "Someone should write a book about this."

Robert would like to thank his wife, Luz, the first author in his family and the one who showed him how it was done. And of course he'd like to thank his daughters, Adriana and Isabella, who are his pride and inspiration every day, and who understand the subject of this book better than he ever will. He'd also like to thank his father, mother, and sister for being incredibly supportive all of their lives.

About the Authors

Robert Kyncl is the chief business officer at YouTube. He was previously vice president of content at Netflix, where he spearheaded content acquisition for streaming TV shows and movies over the Internet. Robert holds a master's degree in business administration from Pepperdine University and a bachelor of science in international relations from SUNY–New Paltz. He lives in Los Angeles with his wife and two daughters.

Maany Peyvan is a lead writer at Google, where he creates editorial and social content, advises on executive communications strategy, and leads speechwriting for YouTube. He was previously an appointee in the Obama administration, serving as chief speechwriter at the US Agency for International Development. He holds a bachelor of arts in behavioral biology and a master's degree in international relations, both from Johns Hopkins University.